DIGNITY

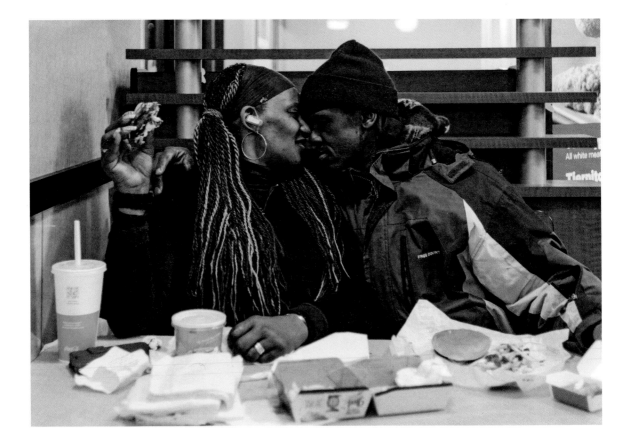

DIGNITY

SEEKING RESPECT IN BACK ROW AMERICA

Chris Arnade

SENTINEL

SENTINEL

An imprint of Penguin Random House LLC

penguinrandomhouse.com

Most Sentinel books are available at a discount when purchased in quantity for sales promotions or corporate use. Special editions, which include personalized covers, excerpts, and corporate imprints, can be created when purchased in large quantities. For more information, please call (212) 572-2232 or e-mail specialmarkets@penguinrandomhouse.com. Your local bookstore can also assist with discounted bulk purchases using the Penguin Random House corporate Business-to-Business program. For assistance in locating a participating retailer, e-mail B2B@penguinrandomhouse.com.

ISBN 9780525534730 (hardcover)
ISBN 9780525534747 (ebook)

Printed in the United States of America
1 3 5 7 9 10 8 6 4 2

BOOK DESIGN BY MEIGHAN CAVANAUGH

CREATIVE DIRECTION OF PHOTOGRAPHY CHAPTERS
BY CHRISTOPHER SERGIO

Penguin is committed to publishing works of quality and integrity. In that spirit, we are proud to offer this book to our readers; however, the story, the experiences, and the words are the author's alone.

Some names and identifying characteristics have been changed to protect the privacy of the individuals involved.

To Marjorie and Wolfgang

CONTENTS

AUTHOR'S NOTE

When interviewing people for this book, I took notes on paper but did not record the conversations. How exact the notes were depended on the situation. On the streets, I jotted down what I could on the spot and filled in the rest later, usually just moments after while my memory was fresh. Inside churches or McDonald's or people's homes, I was able to take more extensive immediate notes.

I tried to record as accurately as possible each person's words, and if they said something particularly important, I asked them to repeat it to make sure I got the exact phrasing. At the end of each day I typed my notes into my computer, expanding on them and recording my own observations.

Conversations re-created here in the book are quoted as exactly as

possible, though they may not be verbatim, since I edited them for clarity.

Due to the sensitive nature of many of the conversations or the precariousness of interviewees' circumstances, I have changed the names and identifying details of some of the people I interviewed. For those in Hunts Point about whom I've already written, I use the street names I used in those pieces.

When those I interviewed requested assistance, I did my best to provide it. Usually this meant buying them a meal at McDonald's, a few cigarettes, or a sandwich at the deli. If they asked instead for outright cash, I either declined or gave them five or ten dollars. In extreme cases, I offered to bring someone to detox or rehab. My rule was to help people I was writing about the same way I would have helped them had I not been writing about them.

The people in this book deserve more than a meal at McDonald's or a fiver or an hour using my computer, though. I am donating part of my proceeds from this book to groups working with addiction and homelessness, as well as setting aside money, to be administered by a third party, to help with housing, food, or medicine for those featured in the book and those I met during my trips.

DIGNITY

Introduction

I first walked into the Hunts Point neighborhood of the Bronx because I was told not to. I was told it was too dangerous, too poor, and that I was too white. I was told "nobody goes there for anything other than drugs and prostitutes." The people directly telling me this were my colleagues (other bankers), my neighbors (other wealthy Brooklynites), and my friends (other academics). All, like me, successful, well-educated people who had opinions on the Bronx but had never really been there.

It was 2011, and I was in my eighteenth year as a Wall Street bond trader. My workdays were spent sitting behind a wall of computers, gambling on flashing numbers, in a downtown Manhattan trading floor filled with hundreds of others doing exactly the same thing. My home

life was spent in a large Brooklyn apartment, in a neighborhood filled with other successful people.

I wasn't in the mood for listening to anyone, especially other bankers, other academics, and the educated experts who were my neighbors. I hadn't been for a few years. In 2008, the financial crisis had consumed the country and my life, sending the company I worked for, Citibank, into a spiral stopped only by a government bailout. I had just seen where our—my own included—hubris had taken us and what it had cost the country. Not that it had actually cost us bankers, or my neighbors, much of anything.

I had always taken long walks, sometimes as long as fifteen miles, to explore and reduce stress, but now the walks began to evolve. Rather than walk with some plan to walk the entire length of Broadway, or along the length of a subway line, I started walking the less seen parts of New York City, the parts people claimed were unsafe or uninteresting, walking with no goal other than eventually getting home. Along the walk I talked to whoever talked to me, and I let their suggestions, not my instincts and maps, navigate me. I also used my camera to take portraits of those I met, and I became more and more drawn to the stories people inevitably wanted to share about their life.

The walks, the portraits, the stories I heard, the places they took me, became a process of learning in a different kind of way. Not from textbooks, or statistics, or spreadsheets, or PowerPoint presentations, or classrooms, or speeches, or documentaries—but from people.

What I started seeing, and learning, was just how cloistered and privileged my world was and how narrow and selfish I was. Not just in how I lived but in what and how I thought.

This was a slow and shocking revelation to me, one I kept trying to fight. I certainly already knew I was privileged. I had a PhD in theoretical physics. I worked as a bond trader at a big Wall Street firm. I

lived in the best part of Brooklyn. I sent my kids to private school. But like most successful and well-educated people, especially those in NYC, I considered myself open-minded, considered, and reflective about my privilege. I read three papers daily, I watched documentaries on our social problems, and I voted for and supported policies that I felt recognized and addressed my privilege. I gave money and time to charities that focused on poverty and injustice. I understood I was selfish, but I rationalized. *Aren't we all selfish? Besides, I am far less selfish than others, look at how I vote (progressive), what I believe in (equality), and who my colleagues are (people of all races from all places).*

I also considered myself to be different from those immediately around me. I hadn't grown up wealthy. I had grown up in a tiny working-class southern town. Sure, my father was a professor of international relations, my mother a librarian, but we didn't have much money, certainly not by the standards of the NYC I was now part of. I hadn't gone to boarding schools, or private high schools, and then to Harvard or Yale. I went to the local public high school, and then to the state college, paid for by money I had made working jobs since I was thirteen. Of course, I had ended up getting a PhD in theoretical physics from Johns Hopkins. But, I told myself, that is physics—it is rational and erudite. That is different. It isn't Harvard Business School.

But I began to realize I hadn't ended up much different at all. I had done pretty much what successful Americans do, regardless of their politics. I had removed myself from the realities of the majority of Americans. I was a member of an exclusive club, one requiring an elite education to enter. I was sitting in my expensive home, in my exclusive neighborhood, forming opinions and casting judgments about what was best for others largely just from what I read.

After a few years, the walks, the pictures, the people I met along them, started becoming more important to me than my job. I began

spending less time at the office, taking the odd Friday off, or leaving early in the afternoons, something I was able to do because I had reached a level at work that gave me flexibility. And honestly, I just didn't care much anymore.

T he Hunts Point neighborhood is on a tongue of land jutting into the East River from the South Bronx. It is a neighborhood of thirty thousand cut off from the rest of the Bronx, isolated on three sides by water, and where it connects to the Bronx by a six-lane elevated expressway (the Bruckner), running next to a half-block-wide trench filled with railroads.

At the tip of Hunts Point, enclosed behind gates, is a massive market for meat, vegetables, fruit, and fish. Almost any food served in New York City first passes through this market, brought in by semis, trucks, and vans and brought out again by semis, trucks, and vans. The route to the market is lined with warehouses, scrapyards, junkyards, and auto body shops, many leaking fluids into the streets. When there is a lull in traffic, seagulls flock into the street to pick at food scraps spilled from trucks out of puddles of oil. At night, when most of the warehouses close, the seagulls compete with feral cats, dogs, raccoons, skunks, rats, and others who feed off the food thrown away or bumped off a truck.

Most of the residents live in a small section of the neighborhood on a slight hill filled with brownstones, co-ops, barbershops, bodegas, more auto body shops, more auto repair shops, schools, and a few non-profits. This residential part is surrounded on all sides by truck routes to the market, filling it with the rumble of shifting gears. The neighborhood is poor (roughly 40 percent beneath the poverty line) and almost entirely black or Latino.

On my first walk into Hunts Point I was immediately drawn in. Although it was loud, dirty, and filled with exhaust, it also had a strong community and sense of place. It was a small town of thirty thousand, and everyone seemed to know everyone else.

There was also a lot beauty and creativity in Hunts Point, cobbled together from things other parts of New York saw as junk or useless. When I stopped and looked, I saw people making the best of what was available and doing so in a way that not only elevated life but also provided a community.

The auto body shops and junkyards were lined with colorfully painted tin fences, or walls filled with murals, or parts of cars assembled in beautiful arrangements, creating industrial artwork.

There were flocks of pigeons flying in swirls, their loops choreographed from below by men on rooftops that were filled with handmade coops. On the weekends, small parks filled with bike clubs of adults riding lovingly cared for old Schwinn bikes—the bikes wealthy New York had moved beyond, thrown out, or grown out of.

It wasn't just bike clubs and pigeon keepers—in the back of the bodegas, on the sidewalk, in empty lots, or really wherever, people set up dominoes tables to play. While the game might have been the excuse to get together, it was the connections and community formed that maintained them. The same was true of barbershops, which were spaces to gossip and just hang.

This part of Hunts Point wasn't what I was told I would find—it was welcoming, warm, and beautiful, not empty, dangerous, and ugly. The depth of that difference kept bringing me back, and all my walks became devoted to Hunts Point.

Hunts Point does have the things people said to stay away from, the things that the media focused its attention on. It does have a market for drugs and sex work, neither hidden. The drugs are sold openly on various

corners, or out of various auto shops, or out of the lobbies of various buildings. The dealers are well-known and not shy. They all have nicknames—Simple, Escrow, Heavy, $Mere (Cashmere), Bishop, Sexy, Black Widow, Mosquito—and some even come with business cards advertising "Street Services," with Microsoft clip art of dice, or pigeons, or tires.

The sex work is also open, but unlike the drugs, it takes place in only a few locations. One is outside a corner bodega nicknamed Hero City and the other along a truck route heading into the market nicknamed the Track, or the Hoe Stroll, or just Stroll for short.

Being in the neighborhood means regularly seeing and dealing with both. I had initially chosen to ignore them, partly out of respect for their business, partly from the stigma attached to them, and partly because of who I was. I was a gate-crasher, an outsider, a white guy, a banker with a camera. This wasn't my neighborhood, and I wasn't going to just jam a camera in someone's face who didn't want the camera jammed in their face.

I also understood that the neighborhood had long been unfairly stigmatized, and even glamorized, for the drugs and sex work. HBO had done an early and salacious reality show called *Hookers at the Point*. Others had also focused only on the drugs and sex work, not the lived realities of the bulk of the residents.

So for the first half year in Hunts Point I focused on the bike clubs, pigeon keepers, graffiti artists, and the work of the nonprofits. On how the community coped with being stigmatized. Yet that focus wasn't fair because it wasn't a full picture of the neighborhood. Most of all it wasn't fair to those caught up in the drugs and sex work, who were portrayed simply as cartoonish losers and not as members of the community.

My focus changed during a rare quiet moment in the industrial part of Hunts Point on a Sunday afternoon. The truck traffic was light and most of the shops closed. Takeesha was standing alone by a trickling fire

hydrant, washing her face. She was working, wearing thigh-high faux-leather red boots, leopard-print tights, waving at whatever car or truck passed by. I had seen her before, and she had always smiled at me or waved, but I had never stopped to talk to her. This time she looked over at me, and with a big smile she yelled, "Hey, take my picture!" When I asked why, she said, "Because I am a sexy, beautiful prostitute."

We talked, and over the next half hour she told me her life story. She told me how her mother's pimp put her on the streets at twelve. How she had her first child at thirteen. How she was addicted to heroin. I ended by asking her the question I asked everyone I photographed: How do you want to be described? She replied without a pause, "As who I am. A prostitute, a mother of six, and a child of God."

I spent the next three years being guided by Takeesha and the street family she was a member of—roughly fifty men and women who lived under bridges, in abandoned buildings, in sheds, in pits, in broken-down trucks, on rooftops, or, if they scored enough money, in per-hour motels. Some had grown up in the Bronx, some elsewhere, but all had fled abuse, dysfunction, or stigma and ended up in Hunts Point for the comfort of drugs.

They took me under bridges and into abandoned buildings, drug traps, burned-out apartments, basements filled with raw sewage, courtrooms, jails, prisons, police stations, rehab centers, detox units, emergency rooms, per-hour motels, and many trips to McDonald's. I heard gut-wrenching stories of abuse, helped some find homes for a night, and helped others find drugs and then a safe place to shoot up. I watched as friends disappeared, died, or bounced between hospitals and prisons.

It was three years of seeing just how messy life really is. How filled with pain, injustice, ambiguity, and problems too big for any one policy to address. It was also three years of seeing how resilient people can be, how community can thrive anywhere, even amid pain and poverty.

Most of all I ended up finding what is often overlooked in stigmatized neighborhoods: dignity.

Roughly three years after entering Hunts Point I am sitting in a McDonald's late at night with Takeesha and Steve, who are taking a break from looking for drugs and looking for a hotel. They are married, legally for a year, but by the measure of the streets for more than a decade, and they have been arguing like a married couple for hours, fights over logistics that swelled into fights against each other. Now they sit in a booth, nuzzling, laughing, swapping sweet talk, making up.

There is no music, no TV. This McDonald's in the Hunts Point neighborhood is, in Takeesha's words, "cheap ass and skimpy." The only sounds other than theirs is the *bling-bling* warning of a deep fryer left unattended and the yelps of a table of teens flipping from one jarring YouTube hit to another.

We sit for about an hour. I mostly leave them alone, listening to them, taking a few pictures, slipping out of my role as friend and into my role as photographer/documenter. For the last few hours I have been a mixture of the two, driving them around as they look for place to stay, which for them means finding money, which means finding work for Takeesha, or a "date," which means finding drugs first, because "you can't do that work without being fucked-up."

This—hustling to find money, to find drugs, to find a place to crash, to find a man who will pay her for sex—has been Takeesha's life for close to thirty years. She started this at twelve, or thirteen, or eleven, or fourteen, depending on when and who is doing the telling, working beside her mom, who did it until she died before forty. Helping her hustle, lifting crates of soda or beer from unattended semis and trains, breaking

into and fixing up boarded-up or abandoned homes, and keeping Takeesha from doing too many drugs has been Steve's life for about a decade. He is sober—"I quit that stuff long ago"—but that doesn't stop him from dealing now and then. In his mind it only makes him a more natural dealer: "You can't let a monkey sell bananas, and I am no longer a monkey."

They work, Steve and Takeesha. Viewed at night from afar in McDonald's, they don't seem to. They look a mess. Takeesha is between hits of heroin and on methadone, so she is nodding at times, but now and then a hit of crack, smoked outside with a friend passing through (there is always someone passing through this McDonald's) brings on a manic energy, or the heroin wears down and she is just a giddy girl happy to be having a Big Mac, something she is OK to shout out to the McDonald's.

Viewed up close, though, sitting across from them and having known them for three years, they work. They complement each other. Steve's sobriety ("not so much as a beer") is the guardrail Takeesha needs to stay alive, and Takeesha's smarts, humor, and volatility are the attention and drama Steve needs to keep himself sober. They have almost always been there for each other, able to understand the depth, complexity, and craziness of each other's problems.

This night they almost have everything set up. Takeesha has her date, a regular, a "white guy from Queens" who is a sanitation worker and the best possible date—"Yo, he likes it straight up, nothing weird, no fetish, no foot thing, nothing kinky"—and the dealers are around and have stuff to sell. It is set up to be a good night, but they can't find a per-hour motel that will have them. They need the room for

at least nine hours, for her to entertain while Steve waits nearby and then for both of them to shower and sleep. All the usual hotels—the Sheridan, the Days Inn, the Capri-Whitestone—are either closed for renovation or have banned them.

Earlier in the evening I had picked them up from the Hutchinson-Whitestone Motel, which had kicked them out. Well, kicked Takeesha out, for running men and drugs out of her room. In her mind she had kicked herself out, and it was not a loss: "Yo. Look at these sheets— thin, scratchy, and filled with cigarette holes. I'm not giving them my money." I had taken them to the Sheridan and at their request had gone in alone to try to book a room for nine hours. "They don't know you with us, and you are a respectable white man." I pointed out that they probably saw through that, saw them and me together in the van on the security camera's monitor, but went in anyway. The clerk, a well-dressed South Asian man behind plexiglass, sat flanked on either side by monitors flashing security camera footage. One showed Takeesha pacing outside smoking a cigarette.

I place $109 in small bills in the tray. "I would like a room for nine hours."

"We are filled."

"Your sign says vacancies."

"The sign is not working."

A young couple walks up with no luggage. They are giggling and tipsy. I step aside as they put cash in the tray. They get a room.

"What about that couple?"

"They have reservations; they booked ahead of time."

"How could they have? They paid in cash and didn't even give you a number."

"You leave, or I call the police."

I go outside and talk Takeesha into the car. I don't need her causing

a scene, bringing the police. She is carrying drugs, and we just don't need the police.

We get back in the car and head to McDonald's. I turn on the radio, which starts the usual bickering between Steve and Takeesha over which station to listen to. Steve is a classic rock fan—Pink Floyd, the Who, the Stones—which Takeesha teases him over: "You white inside—no rhythm." I let them choose, having long ago given up. Early on they had gotten in the car when I was playing a compilation of classic blues music, and Takeesha immediately ripped into me: "What the hell is this music? Sounds like some weird African shit."

As we drive, she calls her dealer, Mosquito, and puts him on speakerphone while she fiddles with the radio, trying to find a station. She pivots between yelling at her dealer: "Yo, I told you, Faile and Hunts Point. In five minutes. I need two cat foods and one dog food. You hear me?"; yelling at the radio: "Can't you play anything but sorry-ass music?"; and yelling directions at me.

"Yo. I told you right. Right, motherfucker."

"The GPS says left. I am following that."

"Fuck your GPS. It ain't hood."

She takes another call, from a friend who just finished eight months of rehab. Takeesha stops talking for a few minutes, this time just listening, before saying, "You get abused that much as kid, you create different personalities to deal with shit." She listens again, before screaming a shout of joy into the phone. "I am so proud of you! Now hug the phone! Hug it! I can't hear you hugging it. You need to be hugging it so hard you out of breath."

Fifteen long minutes later we are at the McDonald's, and she and Steve are in the booth eating Big Macs.

I leave them. They go back to their lives, Takeesha to buy drugs and then wait for her sanitation worker to pick her up. Where they will end

up finally sleeping is unknown. Maybe they will find a per-hour motel, maybe under the bridge (but that is crowded), maybe the Honeycomb hideout (an empty building used as a drug trap), maybe just on the subway.

This is just another normal night for them.

I go back to my home after stopping in a bar near my apartment to get drunk—something I find myself doing almost every night.

At home I turn off my phone. When I wake up, I have a text from an unknown number: "Me & Takeesha had a spat last night and now she won't tell me where she's at. By the way, hello Chris. This is Steve. I'm depressed."

A year after entering Hunts Point, I left my job in banking. Or they asked me to leave and I didn't do anything to fight it or find another role. It wasn't an easy choice—walking away from money and security is never easy—but it was the clear choice. The prior four years I had been sleepwalking, doing the minimum needed, just there to pay the bills.

Wall Street pays well, and after nineteen years, I had the luxury of not immediately needing a weekly check, so I was able to immerse myself fully in Hunts Point. I spent almost every day there, with Takeesha and Steve or anyone who came into their orbit: Shelly, Ramone, Sarah, Beauty, Tiny, Millie, Erik, Sonya, Ironman, Prince, Roland, Fernando.

I got pulled in further than I had expected, and although I tried to maintain strict boundaries, I started abusing drugs heavily—not their drugs, but my world's drugs of alcohol and anxiety meds. I was drinking far too much, staying in bars until closing, and mixing the drinking with an ever-increasing amount of pills. When my prescription for

Xanax ran out, I was deluged with offers to buy it from the streets—something I did. I justified it as being simpler than getting a new prescription (it was) and something that would give me street legitimacy (it did). As I started using more and more, it became clear I was buying it for the same reason everyone else was—I was addicted. It was a problem, but one I justified as trivial compared to the problems I was seeing.

Their problems also started becoming my problems. On the streets people share; that is just what they do. If you score big, if you jack a john's wallet and pull in $300, you go back to the drug trap with drugs for everyone. Sure, you do you and your person first, take all you want, squirrel away a little for tomorrow (which you never keep), but you do your best to bring back enough for everyone. That is just the way it is. If I was gonna be part of this world, well, then I was gonna help. I had money—lots of it by their understanding—but everyone appreciated that my real money was off-limits. That was my wife and kids' money, not theirs or really mine. "You got to do right by your family."

But I could help in other ways because I had four things most didn't: a computer, a phone with unlimited minutes, a car, and no habit to get in the way (well, I had one, just not as deep as theirs).

I could help, and since I was there, I had to. I started doing more than just buying everyone McDonald's or sliding someone $20 now and then or buying Xanax from them at inflated prices. I started driving Shelly to detox, or visiting Sarah in Rikers, or finding out where Tiny was in the system, or seeing which hospital Millie ended up in, or taking Takeesha to the hospital, or getting someone out of the hospital, or whatever. I would wake each morning to texts for help or walk into requests the minute I got to Hunts Point.

I tried my best to answer each text, to respond to each reasonable request, but no matter how much I did, nothing seemed to change. Certainly not for the better as I then measured it. If I spent a day driving

around getting someone into detox, I would find them in Hunts Point the next day, having run away or been kicked out. If I showed up to collect someone to make sure they appeared for court, I often ended up hearing nothing but excuses, if I could find them at all. After two years of this, nobody close to me got out or succeeded. Nobody got clean or sober or ended up in a "little home with a white picket fence." The only way anyone seemed to leave the streets was being sentenced to an upstate prison, or thrown in Rikers, or mandated to rehab, or killed.

In the middle of 2015, I stopped going regularly to Hunts Point. I was drinking too much. While I could understand my friends' drug use as forged from trauma, mine was simply about selfishness. I could no longer be around easily available drugs and daily dramas that made my mistakes seem minor; the contrast unmoored me.

Also, Takeesha and her friends didn't need me trying to save them, something I found myself explicitly and implicitly trying to do, either through constant attempts at helping them get into detox, get into rehab, or get off the streets. They could handle themselves—they had thirty years on the streets proving that. If I had an obligation to them, it wasn't to assume what was best for them; rather, it was to listen and try to understand what they valued, what they wanted, and not get in the way.

I also stopped going to Hunts Point because I wanted to see if what I had seen in the Bronx was representative of the rest of the country. To find out, I got in my minivan and visited other places across America. In each place I focused on the communities and neighborhoods that, like Hunts Point, I was told not to go to.

I didn't do much research before I visited each place, beyond looking for areas with a reputation as "a place you shouldn't visit" or a place

that "sucks" or where "everyone who can leave has left" or was the butt of jokes. I didn't want to go with a prejudice beyond knowing that others considered it unworthy of attention and so went with no goal beyond listening to the residents.

I stayed in a town for as long as it took to force me to rethink what I believed. I slept in motels that charged by the hour, or by the month, with parking lots of cars packed with possessions or trucks packed with tools and work supplies. The other guests were often families that had recently lost their homes or had come into quick cash and wanted—and could afford—a room and shower for a week.

In these communities I didn't go to the nonprofits or the official community centers or talk to the local politicians. Despite the very good intentions of all of them, I had found many were still detached from those they advocated for, especially the politicians.

Instead, I first went to the busiest McDonald's in the community and hung out, eventually talking to the morning regulars. Then I walked and wandered with no clear goal beyond meeting people and letting their suggestions guide me. I often walked the entire day, stopping in at a McDonald's to rest and talk to more people.

Some nights, and on weekend mornings, I attended religious services, not in big beautiful churches but in the smaller ones, many that had taken over spaces designed for something else—an evangelical church in an old furniture store in a strip mall, or in an old fast-food restaurant, or in living rooms of a refurbished home. I tried to go to as many denominations as possible—Pentecostal, Baptist, Catholic, Muslim, Evangelical. I was warmly welcomed into all of them despite rarely looking as though I belonged.

When I began my trips, I spent some nights in dive bars and bonded with strangers over a shared love of drinking. By the start of 2016, I had quit both anxiety meds and drinking. Then I began spending my eve-

nings at McDonald's, sitting at the same table every night, writing notes, eating an ice-cream cone, and talking to whomever until closing time. Often it was during these nights when I would meet people who were struggling the most, people without a permanent home, people who used the safety and warmth of McDonald's until it closed.

I helped people out if they seemed desperate or if they asked. Mostly this meant buying them meals at McDonald's or a pack of cigarettes. Sometimes this meant giving them money. If they asked directly for money, I tried to keep the amount below $10, the cost of most drugs. If I slid them $7 and they asked for three more, I knew what it was going for and told them I could buy them a meal but I couldn't give them more cash. Most probably spent the money on drugs regardless.

Most people didn't ask for money, even the most desperate. Most just wanted to sit and talk with someone who wasn't trying to save them, didn't scold them, and didn't judge them. I tried to do that, often for hours, listening to long stories of wrongs, mistakes, and injustices. What most wanted wasn't money but to use my computer or phone, to look up friends on Facebook or call for social services info or family or street friends. Almost everyone wanted to look and sort through the pictures I had taken of them and then have me send them the best one.

I did this for roughly three years, putting 150,000 miles on my car. Each trip lasted weeks or months, depending on how far I needed to drive. Between trips I returned home to my family and writing and focused on understanding what I had seen and where I should go next. I initially focused on black neighborhoods—places like Buffalo's East Side; Selma, Alabama; Milwaukee's North Side—places that, because of racism, had long been stigmatized. To give myself a greater balance, I added poor white communities, like Prestonsburg, Kentucky; Bristol, Tennessee; and the Ozarks. I tried to select places that, taken together, were as diverse as America, both by race and by location.

What they had in common was that all were poor and rarely considered or talked about beyond being a place of problems. All had been described as left behind, despite some, like Hunts Point, being adjacent to rich and successful neighborhoods. Residents growing up in these communities faced immense structural obstacles, and some, like minority neighborhoods, had for a very long time.

Despite their differences—black, white, Hispanic, rural, urban—they were all similar to Hunts Point in one important way: despite being stigmatized, ignored, and made fun of, most of the people I met were fighting to maintain dignity.

They feel disrespected—and with good reason. My circles, the bankers, business people, and the politicians they supported had created a world where McDonald's was often one of the only restaurant options—and we make fun of them for going there. We pretend that the addicted take drugs because of bad character, not because it's one of the few ways they have to dull the pain of not being able to live good lives in the economy we've created for them. We tell them that their religion is foolish and that they shouldn't expect to be able to earn a living unless they leave their hometowns. We say the white working class is racist while the policies we endorse hurt the bulk of minorities. It is not surprising some have responded with cynicism or apathy, or rebel in anger.

This book is not a book about "how we got Trump," though learning to see the country differently may help answer questions about the 2016 election. Rather, it's a book about reconsidering what is valuable, about honoring aspects of life that cannot be measured, and about an attempt to listen and look with humility.

New York City

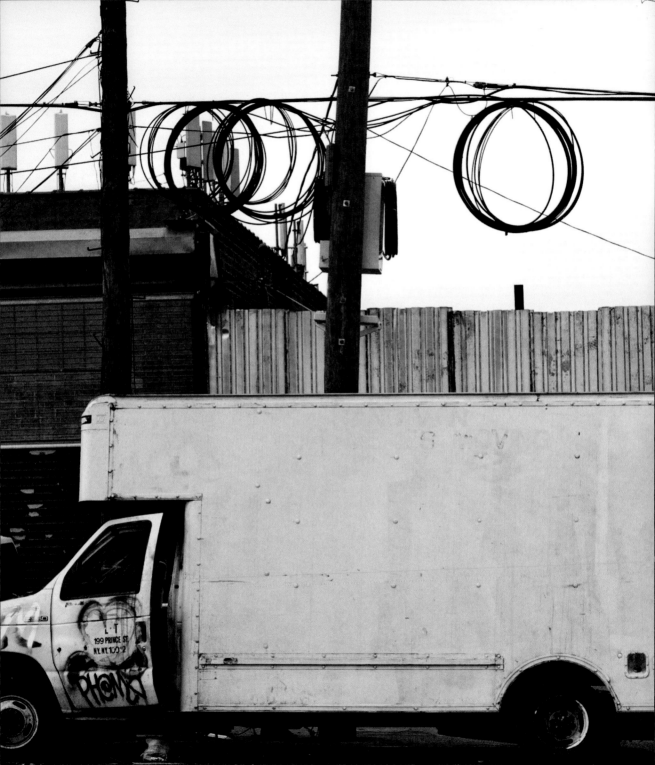

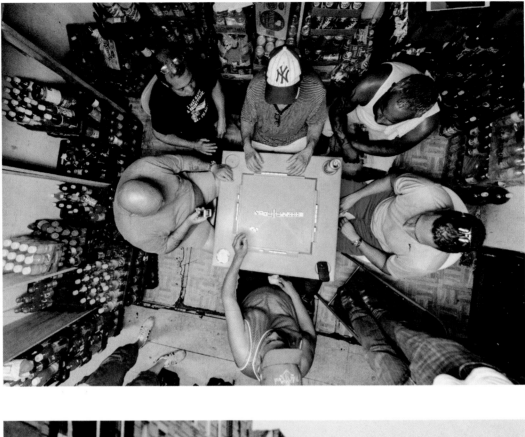

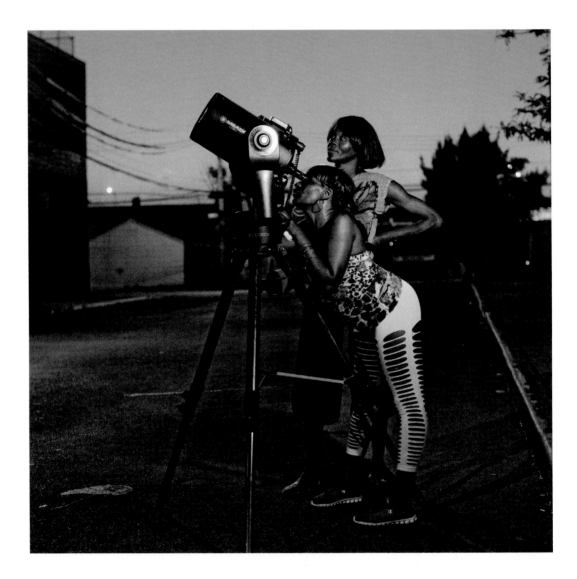

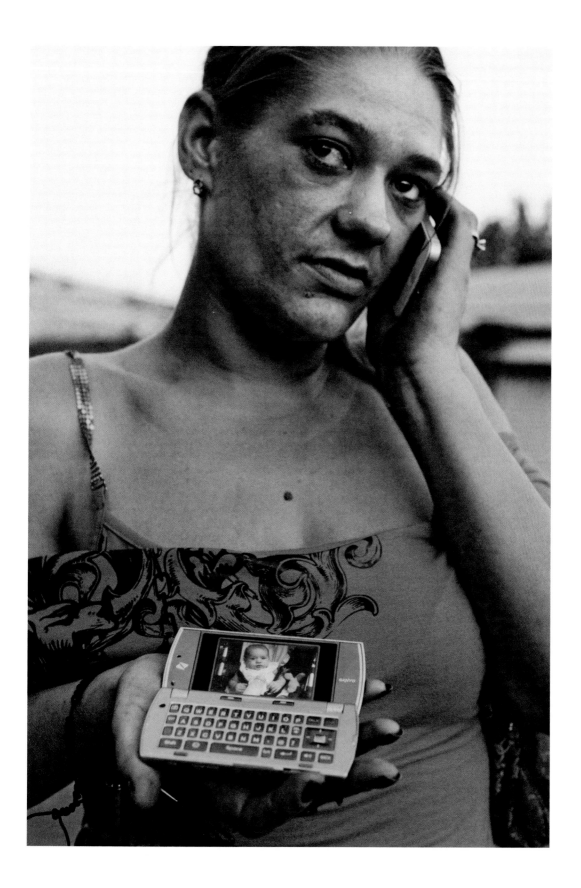

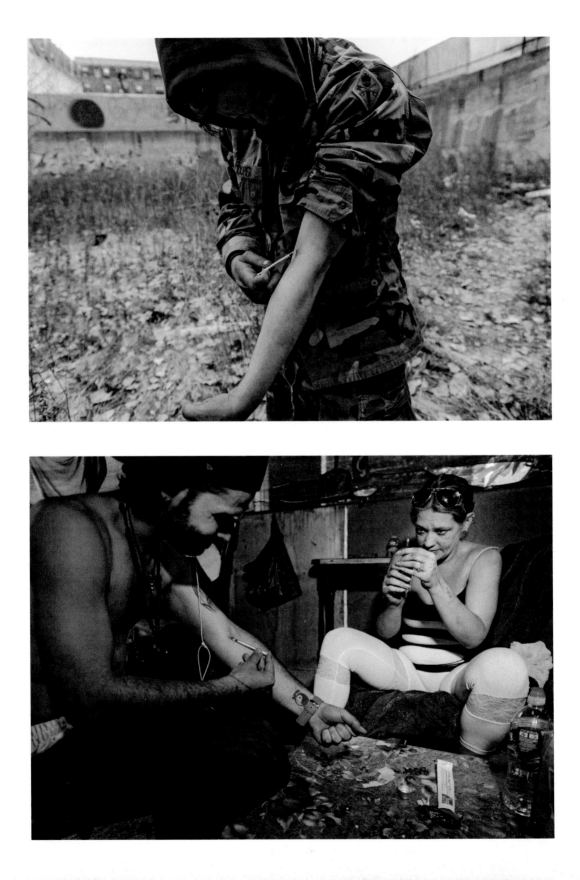

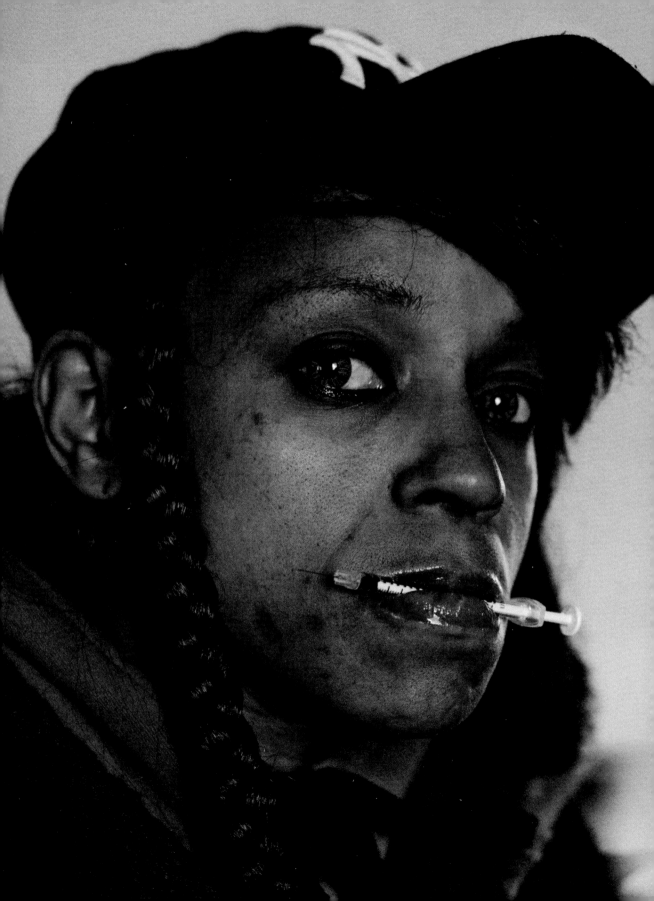

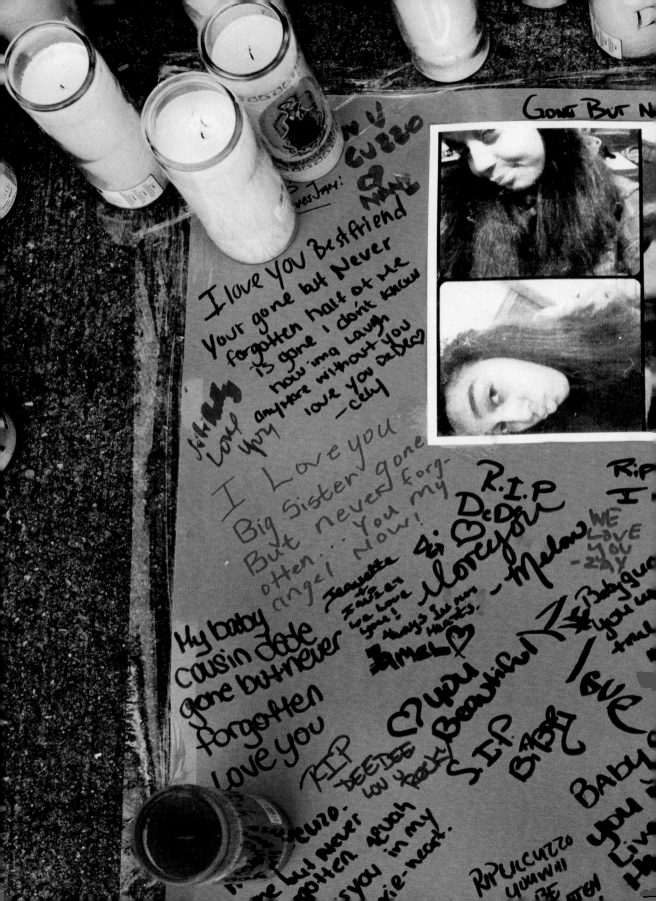

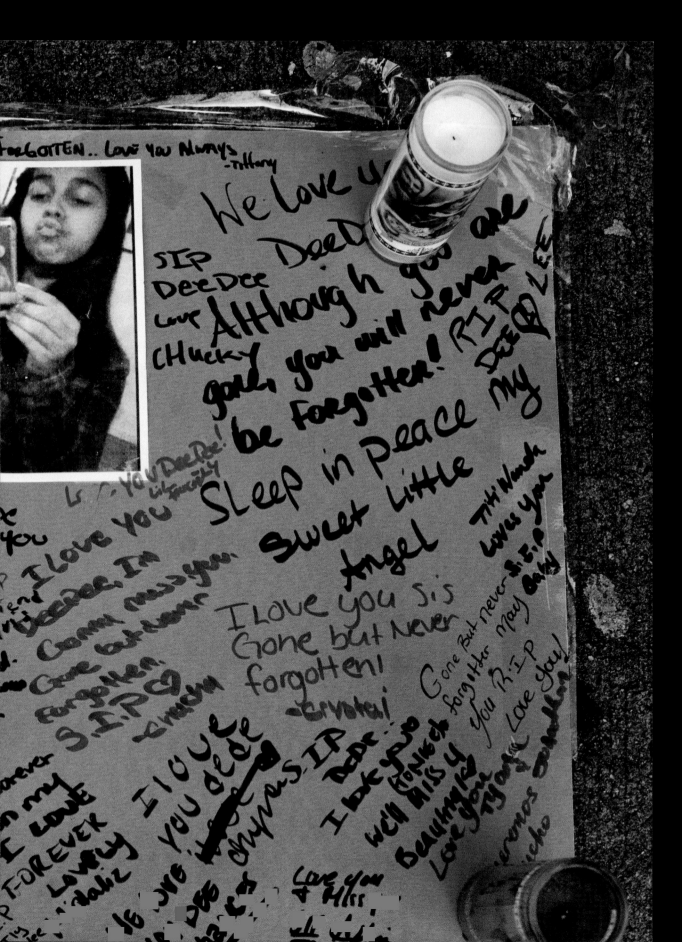

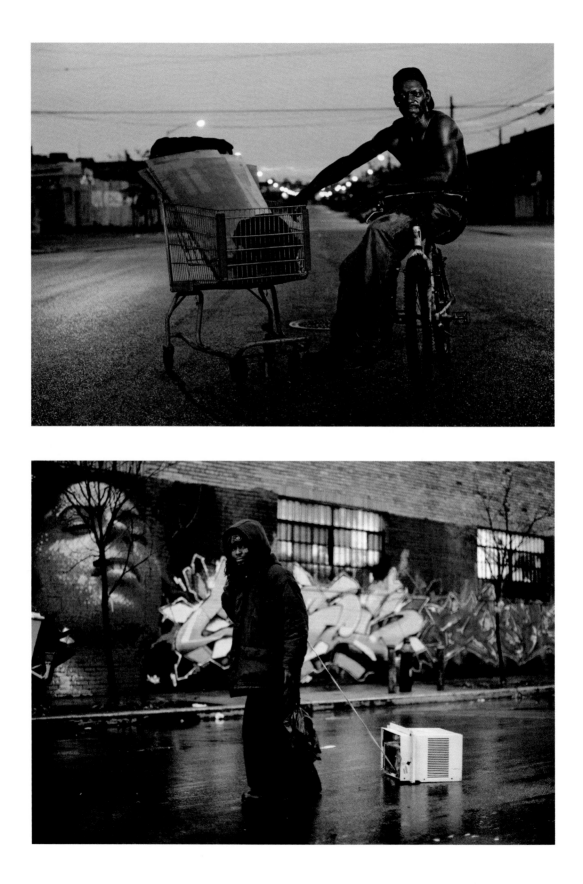

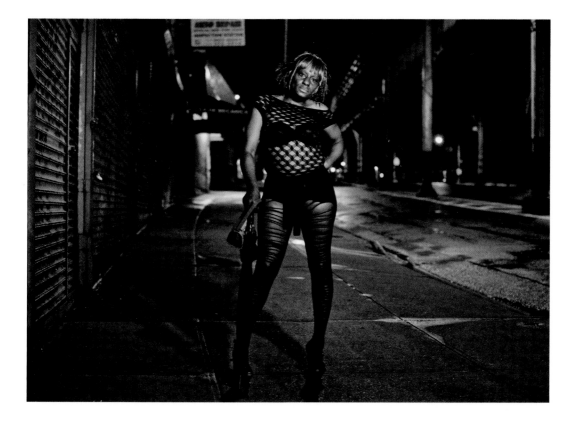

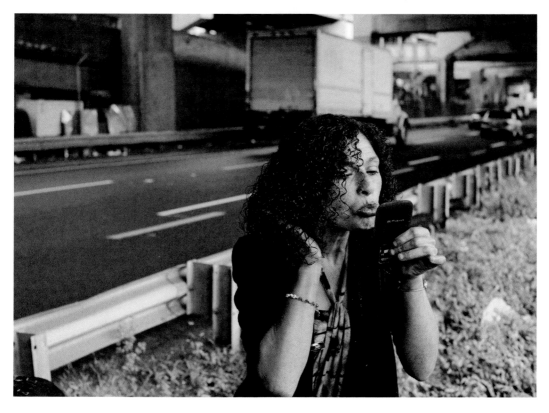

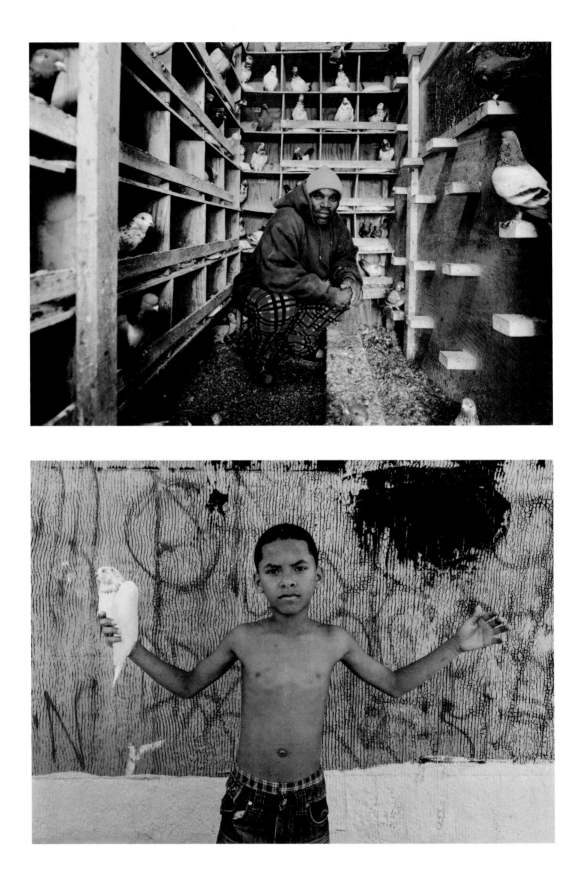

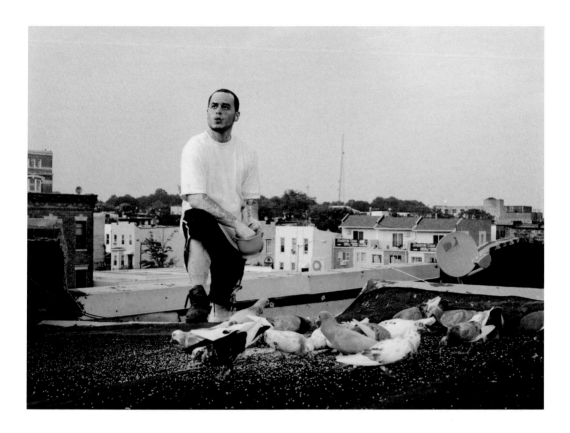

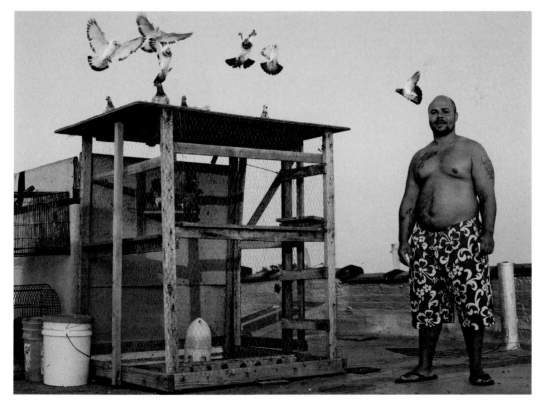

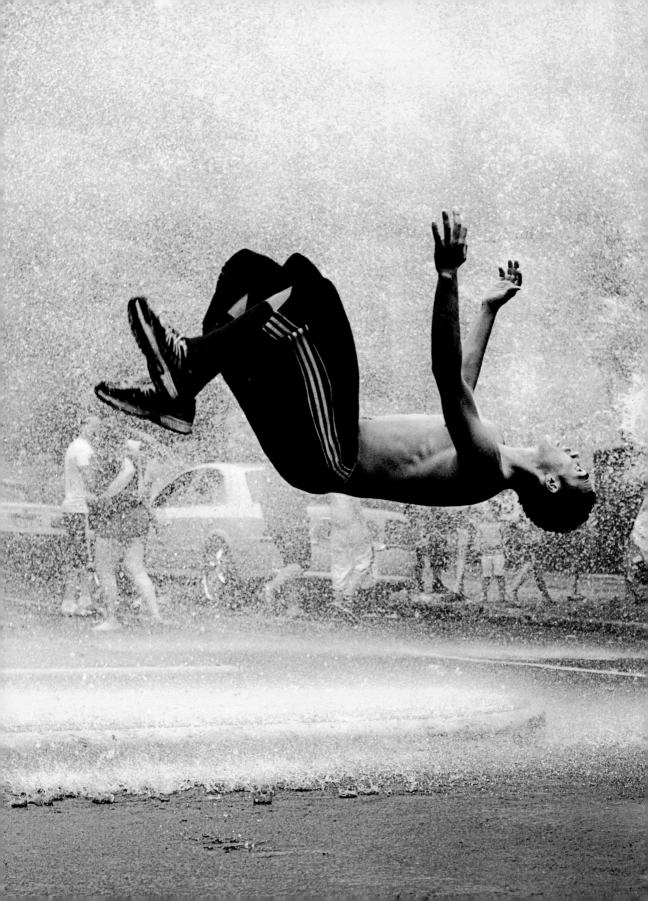

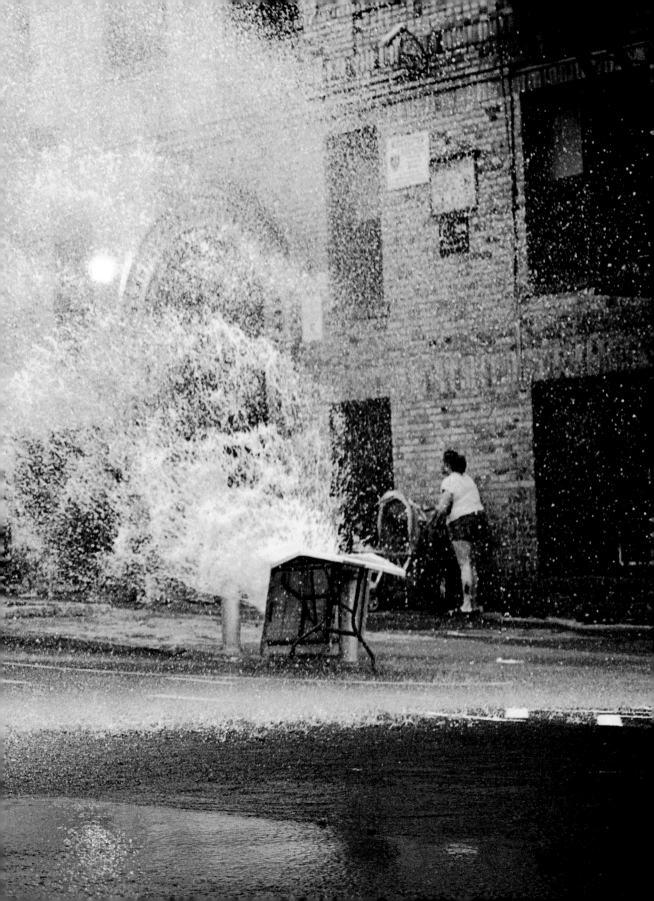

If You Want to Understand the Country, Visit McDonald's

When I first walked into Hunts Point, I never intended go to the McDonald's, much less spend hours each day in it. I hadn't visited a McDonald's much since my childhood, when it was as a treat for birthdays or after a Little League victory. When the first McDonald's opened near my hometown in the rural South, I went to the opening celebration of marching bands and local sports stars. By high school it had become an integral part of my town's life, with the parking lot a hangout spot, especially on weekend nights. I didn't go there then since I was focused on leaving my town, not trying to fit in.

Once I started college, and then moved north for grad school in Baltimore, and then farther north for my Wall Street career, I went to McDonald's only for a bathroom on long trips or when back home vis-

iting my parents and wanting to sit in peace while my kids played in the ball pit.

Beyond that, I'd never thought of McDonald's as anything other than something people around me joked about, often outright mocking those who went there. I didn't join in on the jokes, but I got where they were coming from. Most fast-food franchises and other stores like the Walmarts, Dollar Generals, and Big Lots that started filling my hometown were also places to ignore or joke about. They were something to avoid, or to visit only out of boredom, or to "slum it" for fun.

In Hunts Point, I found myself going to McDonald's every day because everyone did. It was an essential part of my new friends' life. Without a stable home, they needed clean water, a place to charge a phone, a place to get free Wi-Fi. McDonald's had all of those, and it also had good cheap food. ("Coffee with fifteen packs of Sweet'N Low, pancakes covered in syrup and sugar. Extra syrup. An addict's breakfast.")

They started their day in the McDonald's, often around noon, cleaning up and sometimes shooting up in the bathrooms and, since the bathrooms didn't have mirrors, putting on makeup in the sideview mirrors of cars in the parking lot. Then they spent hours off and on hanging at a table, escaping the heat or the cold.

McDonald's was a space where they could be themselves on their own terms. It was a place to momentarily escape the drama and chaos of the streets, a place that allowed them to rejoin society on the same terms as everyone else. They needed and appreciated that far more than I did.

McDonald's wasn't just central to my friends, it was important to everyone in the neighborhood. It was always packed with families and older couples, especially on weekend mornings. In the evenings, it was filled with teenagers or young couples going out.

There weren't really many other options. McDonald's was one of

the few spaces in Hunts Point open to the public that worked. While wonderful and well-intentioned nonprofits serve Hunts Point, whenever I asked anyone where they wanted to meet or grab a meal, it was almost always McDonald's.

When I asked why not the nonprofits or the public parks, the answer would be some variation of "What is that?" or "They always telling you what to do." The nonprofits came with lots of rules and lectures about behavior, with a quiet or not-so-quiet judgment.

By the end of my three years in Hunts Point, I'd been spending part of each day in the McDonald's. It had become central to me because it was central to the neighborhood. McDonald's was Hunts Point's de facto community center, and if I wanted to understand Hunts Point, I had to spend time in the McDonald's.

Three years after I left Hunts Point, after driving 150,000 miles back and forth across the country, I pulled into Portsmouth, Ohio, looking for another McDonald's. There wasn't one in the historic downtown, where a series of twenty-foot-high murals on the floodwall against the Ohio River depict past scenes of Portsmouth.

Portsmouth has suffered dramatically since its peak in the 1940s, when it was home to forty thousand people who manufactured steel, shoes, and bricks. Now the factories are mostly gone, and with them the jobs, and it is a town half the size, filling with drugs.

As the factories, jobs, and many of the people left, those remaining in Portsmouth have done their best to keep the city together, hold tightly to the past, and stay proud. That pride is reflected in the murals, a well-intentioned attempt to sell Portsmouth as a quaint place to visit, but they are also a distraction masking a larger decline. The bulk of the down-

town area is mostly empty, beyond county and city services, and a few local businesses holding on.

Our country is split into two worlds. In one, the downtowns are filled with nightlife, restaurants, well-maintained bike paths, and pedestrian crosswalks. You can tell you're in this world by the kinds of grocery stores there are and by how many and what kind of vegetables they stock. You can tell by whether the convenience stores carry diet drinks.

In this world the residents told me of challenges overcome and plans for the future. There were fears and frustrations, but they were mostly about compromised dreams or juggling too much. Should I move to the West Coast to be an intern or go to grad school in DC?

Portsmouth is part of the other world—the world of Hunts Point, where the stories told are about wrongs endured, frustrations that seem truly insurmountable, and a longing for what once was. The anxieties here come from having limited options: *My company changed ownership, and there are rumors it will move to another state. With my sisters gone, there will be nobody to take care of my parents if I move. I've got symptoms that scare me, but I don't have the money for the doctor. I can't apply for school because I've got an outstanding charge and don't want to be found.*

In this world the energy is found outside of downtown, and in Portsmouth that is where I find the McDonald's. It is on a busy road heading out of town, one lined with fast-food franchises, shopping malls, vape stores, check-cashing stores, and auto shops. Anchoring the area is a massive Walmart, surrounded by acres of parking and next to a railway filled with cars of coal. This is where the steel mill once was. Now only a tall, slender smokestack at the edge of the parking lot remains.

It's a Sunday evening, and I find a quiet spot toward the back of the McDonald's parking lot to sit and rest from the drive. After a few minutes, a beat-up car, gray and rusting, pulls in quickly, parking oddly

close to my van in order to be hidden in its shadow. I watch as the passenger—a middle-aged woman—pulls out a syringe and injects the driver in the neck. The driver stays still, his head tilted to expose a vein as she works the needle in. Two boys, about seven years old, play in the back seat.

In the morning, the McDonald's is busy, and not just with families getting food. There are regulars who take over a corner table and booths nearby. Some collection of them are there all day, although it is busiest in the morning. They are mostly retired men born in Portsmouth who spent their lives working union jobs as firefighters, ironworkers, construction workers, and truck drivers, providing for their families.

They gossip about politics and one another and note each passing siren, often prompting speculation about where it is going and if it is another overdose. There are lots of sirens passing by and lots of shaking heads.

Everyone has a story of a relative, or friend, or someone close who has died from drugs or is currently fighting drugs. "Everybody at this table has some family member impacted by drugs." A nephew "in and out of rehab" or a brother "dead early after a lifetime of abusing drugs."

A woman dressed in pajama bottoms and a tank top sits yelling into an iPad with a broken screen, "He doesn't respect my issues. He doesn't understand my anxiety attacks. They come at me and take me over. I ain't me no more when that happens. I am done with his shit. I am done with everybody's shit." The voice that comes back just says, "Nobody ever understands us."

Seven hundred yards down from McDonald's, by the entrance of a Burger King, two dirty kids sit in a shopping cart filled with cans, children's toys, and blankets smelling of piss. Their father leans against the cart, and the two-year-old girl and three-year-old boy stare at me with blank expressions. The girl holds a crumpled bag of potato chips, the

boy an empty Mountain Dew bottle. A dirty Barbie doll sits tangled in filthy blankets, its leg jammed into a pop bottle.

By that point, I have seen a lot of frustration, a lot of pain, and a lot of desperation. I have seen countless adults pulled low by their addiction, sometimes pulling down those around them. I have become somewhat numb—out of necessity—to the chaos that seems to be now normal for much of the country.

Yet seeing two dirty kids in a shopping cart jolts me: it's a visible level of despair that I hadn't seen since Hunts Point, and I can't just walk past. I go over to talk to the father, who leans against the cart.

The father, James, politely answers my questions with no sense of desperation in his voice, no anger. He is straight-up, speaking with a calm that clashes with the whoops and yells coming from a handful of others loitering by the entrance.

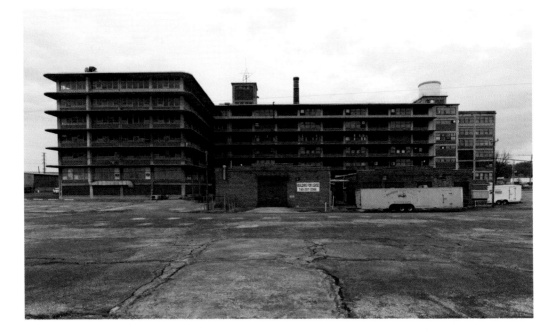

James has been living this way for a while, and some kids have come into his life, and he is gonna do the best he knows how for his kids. That means keeping them around him all the time, and that means pushing them in his shopping cart as he collects cans and bottles, tracking close to their mother. She stands nearby, wearing pajama bottoms, a jacket, and a tiny pink Dora the Explorer backpack. Her eyes are vacant and glassy as she holds a cardboard sign, written in crayon, that reads, "Homeless Hungry / Anything Helps."

James tells me that they've been homeless for a year and a half after getting evicted for nonpayment. Right now they're staying in a shed behind the house of an old friend. "We have a cord ran out to the shed; it has been warm the last three nights, so that's good," he says.

A few days later, I see them again. James is filling plastic bottles with water in the McDonald's bathroom to clean the children. Their mother is on the roadside. A few people in stopped cars hand her some change. One woman pulls into the parking lot and gives her two slabs of bottled water before running into the McDonald's. Otherwise everyone just passes the family by.

"You use drugs?" I ask.

"I used to, both of us did."

"Do you still use?"

"No, I don't. Well, only Suboxone. I buy it from the street since I don't have a prescription."

He says that he started drinking as a teenager, then started on Percocet when he was nineteen. From there he went on to harder stuff like Oxy 80s, then heroin. "I was born in Portsmouth and raised around drugs. Everyone used them."

"Anybody mess with you out here? Police? Social services?"

"A minister comes by to try and help us," James says. "Otherwise nobody has made much of a fuss."

James and his kids are a dramatic example of the pain I found in the world of Hunts Points and Portsmouths. It was a pain I found in every town I visited, from Buffalo to New Haven to Cleveland to Selma to El Paso to Amarillo. In each of these places, there's a sense of having been left behind, of being forgotten—or, even worse, of being mocked and stigmatized by the members of the world who are moving on and up with the GDP.

In many cases, these areas are literally left behind by people like me. I spent most of my life focused on getting ahead by education. Putting education first and going to college and then grad school were expected, so I applied myself. I left my rural hometown and got into elite schools, which got me into elite jobs, which got me into an elite neighborhood.

I was hardly alone. My office, my neighborhood, and most of my adult friends were like me and like the residents of most successful neighborhoods across the country, ones filled with bankers, professors, and lawyers. Almost all of us had used education to leave a hometown that we saw as oppressive, intolerant, and judgmental—often aggressively so. Education was the way out, so we dedicated ourselves to doing everything the system asked of us, starting with focusing on building a résumé for access to the right college. As we progressed, we gathered credentials—college degrees, summer internships, memberships in exclusive groups—building a larger and larger résumé. We had all navigated through a series of small, elite educational institutions that had gained us access to elite jobs, which gained us access to exclusive neighborhoods.

In many ways, we were akin to the kids who sat in the front row, always eager to learn and make sure the teacher knew they were learning. We wanted to get ahead—and we had. We were now in the front row of

everything we did, not physically but hierarchically. We were at the top of our class, we went to the top colleges and top graduate schools, and we landed jobs in the top law firms, banks, universities, media companies, tech companies, and so on.

The shared experience and the rules necessary to succeed had left us with the same worldview. We were dedicated to knowledge, learning as much as we could but almost always from books. We saw the truth as something that could be figured out with enough study, with enough devotion to science and rational thought. Given enough time, enough data, enough experiments, enough computers, we believed we could figure out most anything.

We were mobile, having moved many times before, and we would move again. Staying put was seen as failure. You advanced in your career, and that required not being tied to one place. Our community was global, allowing us to proclaim it to be diverse, despite every resident sharing a similar path beyond high school.

We used our dominance to change the world. The desire to change the world came from a good place since many of us were well-intentioned. We generally understood we were privileged and fought to make our country more inclusive for minorities. This meant dismantling a system that demeaned, denied, and dehumanized so many based simply on the color of their skin, their sexuality, or their views.

Yet we didn't get just how deep and pervasive our privilege was. We were well intended, but we had removed ourselves from the lived experiences of most of the country, including the places and people we wanted to help. The vast majority of minorities and the working poor were excluded from our club—by a lack of credentials and by a system rigged against them getting any.

Our similar path to success, our education, and our isolation from the bulk of the country, left us with a narrow view of the world. We

primarily valued what we could measure, and that meant material wealth. The things that couldn't be easily measured—community, dignity, faith, happiness—were largely ignored because they were hard to see—especially from so far away.

We had compassion for those left behind but thought that our job was to provide them an opportunity (no matter how small) to get where we were. We didn't think about changing our definition of success. It didn't occur to us that what we valued—getting more education and owning more stuff—wasn't what everyone else wanted.

In the front row, growing the economy and increasing efficiency were goals most of us, whether Democrat or Republican, put first and agreed on. We believed in free trade, globalization, and deregulation. Our metrics for success became how high the stock market got, how large the profits were, how efficient the company was. If certain communities, towns, and people, suffered in this, it was all for the greater good in the name of progress.

Our obsession with economic growth empowered massive corporations that filled many communities with franchises and big-box stores, crushing the downtowns that had once had small locally owned shops and restaurants. The economy grew, but gone were the local community, the labor union, and lifetime jobs for those without a college degree.

While our front row neighborhoods filled with bespoke and artisanal stores, those left behind, literally and figuratively, were left to cope with the new landscape we had created.

If we were the front row, they were the back row. They were the people who couldn't or didn't want to leave their town or their family to get an education at an elite college. The students who didn't take to education, because it wasn't necessarily their thing or because they had far too many obligations—family, friends, problems large and small—to

focus on studying. They want to graduate from high school and get a stable job allowing them to raise a family, often in the same community they were born into.

Instead the back row is now left living in a banal world of hyper efficient fast-food franchises, strip malls, discount stores, and government buildings with flickering fluorescent lights and dreary-colored walls festooned with rules. They are left with a world where their sense of home and family and community won't get them anywhere, won't pay the bills. And with a world where their jobs are disappearing.

About a mile away from the Portsmouth McDonald's, across the railroad tracks, is an area with dope-sick women walking a loop around boarded-up warehouses, smiling and waving at some cars, hiding from others.

A short older man is riding his bike in big loops around the streets, weaving between the women. He is dressed only in sweat pants and has a fresh scar and a set of staples running along his head. He approaches, a bottle of cheap liquor jammed into his sweat pants, and insists I take his picture: "I want to be famous." I ask him about the staples in his head. "I was beaten up." I ask him why, and he spins off on his bike, yelling louder and louder, "I was beaten up, I was beaten up, I was beaten up!" As he passes by one of the women yells at him, "Get the fuck out of here, Fishhead!"

From across the street a woman calls to me from the passenger side of a parked car. "What you talking to Fishhead for? He ain't right. Tries messing with us girls and getting stuff for free." The passenger, K, is dressed in sweat pants and a windbreaker. The driver, M, thirty-two, is dressed in pajama bottoms and a flimsy, low-cut shirt. They ask if I

am a photographer. I tell them yes. The passenger smiles and says, "You found the Hoe Stroll." They both look exhausted, dirty, and sick. "We haven't had a date today and need a fix bad."

Around the corner, at the edge of the Hoe Stroll, is a home that stands out because it is so well kept. Chris, forty-one, is raking leaves in the front yard. It is his mom's house, the one he grew up in. She had worked across the street, at Mitchellace Company, which is in a large building that is now mostly empty, with the back parking lot surrounded by fencing with razor wire running along the top. It isn't completely empty; there are a few newer companies in the front that have been attracted by tax breaks. He stops raking to talk to me, saying, "I try to keep this place nice looking, keep my mother's home as we remember it. There are hookers everywhere around here. Started about ten years ago. Drugs are just everywhere around here."

I say it must be tough for him to see this.

"I try to help the women as much as I can," he says. "Give them a dollar or let them use my phone. But that isn't going to get them out of the life. I was addicted for eighteen years myself. Friends started doing it, and drugs were just everywhere. Started with OxyContin and weed, and it escalated. Ended up taking over my life. I didn't get clean till I got five years for burglary. Been clean for eight years now. Don't do nothing."

That's rough, I tell him.

He shrugs off my sympathy. "It is what it is. There is no jobs here, buddy. No jobs. Just nothing for nobody to do."

Up the hill from the Stroll, about a mile away, Jen, thirty-five, is holding her toddler. She worked the Hoe Stroll for seven years. Now she is out of rehab, off heroin, and living with her recent baby father's mother.

She is in the living room with her one-year-old daughter, who clings

tightly to her, the child's father next to her, the TV turned to a show with people yelling at each other. They live together, although they don't count themselves as being together right now, "It is complicated, as they say." she adds. This child is Jen's seventh. Two have died, one was stillborn, the other in a motorcycle accident that killed her child and Jen's father.

"My dad raised me. He worked over at the OSCO foundry. My mom? She wasn't in my life. Only thing I know about her was that she was an addict that suffered from mental illness. I ran away at fourteen because of abuse and ended up in a foster home. Then I bounced around. I even did one semester at Shawnee State, but it wasn't for me."

She dabbled in drugs early but didn't really start using heavily till she was twenty-four, when she began with Vicodin and then heroin. When asked why, she just shrugs and says, "Everyone was doing it."

When the habit became harder, sex work followed. "I had to do dope so often I couldn't maintain a regular job. Everybody knows where the girls are, and I lived in the area, so anytime I walked, guys would try to pick me up. They used to the idea any girl can be bought, and they always want a new girl. When I was pregnant with B, I was sicker than ever because my baby's dad was in jail so I had no money and I tried to taper myself off the heroin. After going to the clinic, I was walking home and some guy tried to pick me up, and I just went with it. All I thought about was getting well. I ended up doing it for seven more years."

I ask if she had regulars, and she says she had a few. Did she sell to them? "Not to my dates. I made it a point to never go with guys who are strung out on dope, or weed, or alcohol. They don't have the money to buy sex, so they try to cheat you. Or they can't get it up and then take it out on you. They get mad at you and beat you up."

The father of her child listens, and when she is finished, he gets

ready to go out and find some drugs. He still uses, dips and dabs, but is trying to quit. That starts a discussion about who is still using, who is out, who is living with who, who is in rehab or jail, and who left town to stay with relatives.

I ask them about the two children being pushed in the shopping cart, about their mom and their dad, and if they are still using, and they get confused, asking me, "Which of the couples pushing kids in the shopping cart?"

The loss of jobs for the back row is visible all across America. When you get beyond the college campuses and wealthier neighborhoods, you find empty factories, or empty lots surrounded with security wire, or just an empty field with weeds growing out of a cement foundation. The companies have closed or downsized dramatically, shuttered by automation or just "moved to Mexico or China."

These job losses were the result of policies put in place during the preceding decades, policies that focused on boosting economic growth, profits, and efficiency, policies supported by me and others in the front row. In the name of greater economic growth, more efficiency, and higher profits, we opened our borders to a flood of cheaper products coming in and a flood of factories and jobs moving away. We empowered distant shareholders at the expense of local employees. We gave my old world, Wall Street, whatever it wanted, and what it really wanted was to lower labor costs no matter how. Mostly that meant shipping US jobs requiring muscle overseas and bringing jobs requiring college here.

For me and the others surrounding me, the job losses were accepted as the cost of progress, their numbers shrugged off because they would be offset by gains elsewhere. They were a small loss compared to the

many gains that growth and our new efficiency would bring. That those gains were mostly in places we lived didn't hurt either.

Jobs are not the only thing that Portsmouth has lost over the last few decades. Those jobs were the backbone of the community. People could walk straight from their graduation onto the factory floor and build a life around it. They would get a chunk of money every two weeks, get health care and pensions, which gave them the stability to get the home with the white picket fence and build a family.

Without stable jobs to build a family around, Portsmouth began to fall apart. This happened in other back row towns, too. Whole communities started to fall apart, leaving a void in the center of town.

It was the other losses, the ones that followed the job losses—the crumbling town centers, the broken families, the isolation, the pain, the desperation, the drugs, the humiliation and anger—that we in the front row didn't fully see or understand. The devastating impact of the breakdown of community didn't show up in our spreadsheets.

The people left in these communities, who saw their factories disappear, their downtowns devastated, their neighborhoods fill with drugs and despair, they understood that the losses were more than just numbers in a spreadsheet. They have done their best to make due, to hold on to community and dignity. They have done this by creating new relationships and communities in whatever spaces are available. In the Bronx and in rural areas, in black neighborhoods and white neighborhoods, that includes the McDonald's.

While Gary, Indiana, is larger (population eighty thousand) than most communities I visited, and only forty minutes from Chicago, it has the feel and warmth of a small town. That warmth isn't

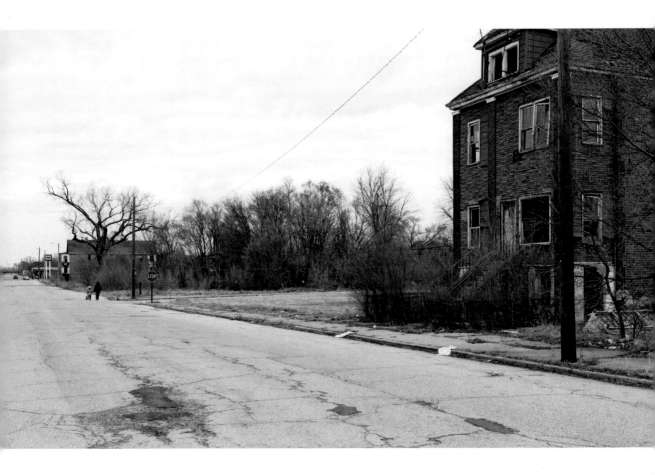

obvious at first because of the shocking visuals: while there are scattered clusters of neighborhoods with simple, well-kept homes, much of Gary is devastated, home mainly to rusted factories and overgrown lots.

Gary's downtown is a collection of crumbling buildings with doorways filled with urine and trash. Some buildings are covered by weeds and shrubs, some are burned down, and some tagged with graffiti ("Cap Bap Always Here!"); some are covered by weeds, burned, and tagged. On a Sunday when I am there, it is entirely empty, the few stores around, nonprofits and government outreach programs, are closed. In other

parts of the city, church parking lots overflow, but the churches once here are gone.

There isn't any sign of life; the empty buildings don't even look squatted in. The exception is a half-boarded-up row home with a pile of garbage around its steps. On the top of the pile is a spilled pizza box, the pizza facedown but still whole. The rats and pigeons have yet to pick at it.

The one open store is the Embassy Liquors attached to the Buzz Box Lounge. Although nobody comes or goes from either, a man stands completely still in the doorway, sheltering from the wind.

A woman holding the hand of a small child appears, coming from a Family Dollar store up the street. They walk slowly, the girl bouncing, skipping, and looking around, the woman keeping her head down and walking straight ahead. Their bright colors—the woman's red sweat pants and the child's blue-green jacket—stick out among the decay and dull colors. When they are a half block away, the girl turns to stare at me, smiling a big smile, and waves. I smile and wave back. The woman doesn't look my way, doesn't smile. She keeps talking into a red flip phone, her expression blank.

The girl calls out, "Hey, mister. Can you take my picture?" The woman shushes her. I say, "Sure, if your mother would allow me." The girl stops and breaks into a pose, with a huge smile. The woman looks up at me, shakes her head no, her face firm and unemotional, and keeps walking, pulling on the girl. "Come on. We gotta be getting."

Empty fields with concrete foundations are on the other side of the street. Most buildings have collapsed, their remains carted away, either by the city or folks scrapping. I am alone, focused on photographing the one remaining heap of rubble. A black SUV pulls up, driven by a Drug Enforcement Administration agent. He isn't working. Instead, he is back in town to visit his mother.

He grew up in Gary, left for the military, and then stayed in California. He tells me unprompted not to be worried about my safety, that the residents of Gary get a bad rap but that they are hardworking, polite, and smart, despite what the town might look like. I agree, not out of politeness but because it is my fourth day in Gary and I have seen the same.

He explains before leaving, "We used to be the murder capital of the US, but there is hardly anybody left to kill. We used to be the drug capital of the US, but for that you need money, and there aren't jobs or things to steal here."

Along with massive job loss, Gary has suffered from another big problem: racism. Gary is overwhelming African American and has been since the factories left, when most whites also left. Leaving to chase a stable job, or getting a loan to buy a better home, was an option few blacks had. Since then it has been endlessly studied, stigmatized, preached at, and finally dismissed as an example of "what was wrong with inner-city blacks."

Yet despite the one-two punch that has hit Gary, leaving it in a seemingly endless state of decline, despite the devastation, despite the initial skepticism, there was still a warm community in Gary. Much of it was happening in one of the few places always busy—two McDonald's restaurants—one downtown near the old factories, the other farther out. Both have morning groups that occupy a corner, taking over more and more tables as other regulars arrive. They are mostly older men, many arriving very early, having spent a life working the morning shifts. Many were born and raised in Gary and have known one another almost their entire lives.

Two regulars, Walter, seventy-eight, and Ruben, eighty-five, sit at

their table a little after noon in the McDonald's of a largely empty shopping center. They are the last of their morning group still lingering. They grew up just one block from each other. As a child, Walter looked up to Ruben, the cool older kid. "He pretty much raised me."

Ruben says, "I am proud of Gary because it is the only place I know. I have been to other places in the service—Japan, Europe—but I came right back to Gary. Thing is, Gary has changed. First the workforce in the steel mills went down, and then in 1967 they nominated a black mayor, and the white flight started. We once had a 'thriving downtown' back in the day, as they say. People used to come here to shop from all over. It was the second largest city in Indiana, and we were damn proud of it. Damn proud. The drugs really started in late sixties. That is when the snake started showing its head. Have you been downtown now? It is a shame. A damn shame."

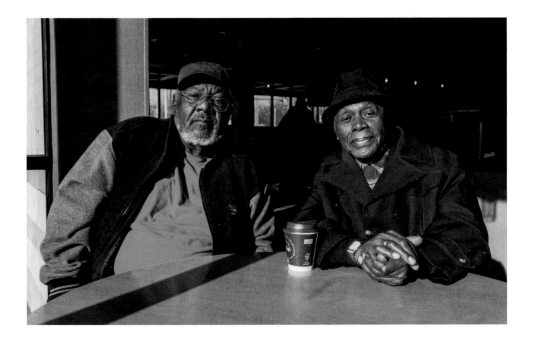

His father worked in the steel mill, and so did he. "I went right out of high school into the mill as a craneman, then took a job at the tool-works when I tired of it. You could do that then, quit one job and then go to another. There were just so many jobs. Then I went into the army in '52."

Walter busts his chops on that: "You didn't last very long in those jobs, only a few years before you hightailed out of the country."

Ruben continues. "I came back and worked as a policeman for twenty-five years." He pauses. "You got to leave Gary now for work . . . Back in my day you needed a strong back and a weak mind to get a job. Now you need a weak back and a strong mind." Walter is quiet for a bit before he says, "I am going to take this part of the inter-view serious because I care about this." He straightens up, his joking replaced by a stern look.

"I worked in the steel mill for thirty-eight years, six weeks, and three days. I don't remember the exact seconds. Was it a good job? Steelwork is a good job when you got no job. Any job that pays is a good job. When we was young, those jobs here were plentiful. I ended up an electrician but started off as labor—hot jobs, dirty jobs, greasy jobs—we blacks had to start out with those. I worked my way up to electrician. It wasn't easy because they didn't seek blacks for those better jobs. You had to want it and demand it. That was then. Now you have to leave Gary to get a job. Nobody can stay here. You have to go where the jobs are, and they require an education, and they are not here."

He pauses, then says, "You have to ask why it is like this. Segrega-tion did this to Gary. When the jobs left, the whites could move, and they did. But we blacks didn't have a choice. They wouldn't let us into their new neighborhoods with the good jobs, or if they let us, we sure as hell couldn't afford it. Then to make it worse, when we looked at the

nice houses they left behind, we couldn't buy them because the banks wouldn't lend us money. Between segregation and lack of jobs, Gary been hit with a hell of a punch."

Walter nods his head. "I been here seventy-eight years. Gary has been good to me. Now nobody can stay here, not if they want a future."

It isn't just the morning groups that fill the McDonald's. In the downtown McDonald's, there are people playing dominoes ("Been getting together for a few afternoons each week for a while"), people sitting quietly reading the Bible, younger people on their phones watching videos, or playing online video games with their headsets on, or reading Harry Potter, or just sitting for hours at a time listening to music and watching the world go by. It isn't just Gary's community center; it is Gary's town square.

Gary, like other poor communities, is dealing with serious problems, including drugs and homelessness, problems reflected in the McDonald's.

Inside the bathroom Rudy is wearing an old St. Paddy's hat, slowly and purposefully holding his clothes under the hot air from the hand dryer after washing them in the sink. His bike is out in the parking lot, with bags of cans, bottles, and clothes attached to it. He smiles and apologizes for the mess, saying he would like to talk and I should come visit him where he stays: "I don't rightfully have a home right now, but you can find me at the intersection of Fourth and Broadway. I spend my time there."

Waiting outside the bathroom is an older man, dressed in an all-blue mishmash of clothes from various eras of varying cleanliness. He is holding four stuffed plastic bags, patiently waiting for Rudy to finish up. When Rudy does leave, as he goes in, an employee walks by and

yells, "No taking a bath in there. No taking a bath in the bathroom. You hear!"

A young man wearing an unbuttoned work shirt from a fast-food franchise down the road is sitting in a booth staring out the window. He has been here for well over an hour, either looking out the window or flipping through an old newspaper. When I am done with a call, he walks over and asks if he can borrow my phone. I lend it to him, and he dials a friend to ask for a ride back home. "I need to get some sleep before my next shift," he says, explaining he just finished working a double. "I would love a phone, but I got bills to pay, so I just have to wait."

On the other side of the McDonald's a young woman, Imani, twenty-three, is watching a video on her phone, earphones in. We have been sitting across from each other for a while, and I eventually approach her, tell her I am writing about Gary, and ask if I can talk to her.

She moved to Gary with her mother a few years earlier to escape the crime and cost of Chicago. Today is her day off work, and she is waiting for her sister, using the free Wi-Fi. She says she hangs in the McDonald's because it is a safe spot. "It is still violent here in Gary. Not as bad as Chicago, but still bad . . . There are just so many abandoned buildings here. It scares me to walk by them. I don't want to end up a body lost in one of them."

We talk for a while about her hopes and dreams, and then I ask her about the rest of her family.

Her dad is in and out of jail and not much in her life, she says. I ask what he's in for.

"First time for drugs, the next few times for domestic."

"Domestic?"

"He doesn't have a problem putting his hand on females." She pauses. "Like my mom and myself."

"I am sorry. That is really hard."

"I got over it. Life goes on." As if she feels the need to reassure me, she insists again, "He really didn't affect me. I am strong."

Another man, who has been sitting in the corner for a few hours, watches us talk. After seeing me taking pictures of her, he shouts across the tables and asks me to "take my picture and get my story." He smells of cologne and drink.

He tells me he is originally from Wisconsin and is in Gary because he "caught a charge here."

> ME: What charge?
> HIM: Sexual misconduct.
> ME: What happened?
> HIM: I inappropriately touched a female.
> ME: Did you do time?
> HIM: Yes, three years.
> ME: Any other charges?
> HIM: I have a few others.
> ME: What?
> HIM: Drugs.
> ME: You going to do better now?
> HIM (repeating slowly, as if pulled from memory): I won't
> touch a female unless she touches me first.

Sylvester sits in a booth, looking out the window, sipping McDonald's coffee. Born in Belzoni, Mississippi, where his grandparents worked picking cotton, he moved to Gary when he was in his teens in the early sixties. "Why Gary? Race situation down South wasn't appropriate. Part of why we moved is because I hit a white kid in the eye with a piece of coal, when we were just playing. We had to leave."

For twenty-seven years he drove trucks, although he had wanted an office job. "I wanted to get a high-class job; I wanted to be an accountant and even started to study to be it, but white folks didn't like an educated black. I had facial hair then, and that fit the idea I was an 'uppity negro.' I made the best of my job, though, almost made three million miles before I retired."

He reminisces about the old Gary, about going to clubs to gamble and listen to blues music. "This town was alive back then. You would get your check on Friday, and you could have a proper weekend. Now, Gary was divided between black and whites then; there was neighborhoods and houses and buildings we blacks were not allowed in. We couldn't ride to this particular section of town. Then all the whites left overnight. I woke up one day and it was just us black folks. They left overnight; it was really strange. Whole neighborhoods were emptied out with empty buildings once owned by white folks who worked in the steel mills. They wouldn't let us in those buildings before they were emptied.

"They left Gary with nothing. They took everything worth keeping, like the good jobs. The whites even stole our music, like they stole everything else. The black kids today ain't much better, though. That rap music has ruined what the whites didn't steal."

At another table is an older man about Sylvester's age, dressed entirely in white except for a black Stetson. He introduces himself as Jesus Christ, without any hint of craziness. He is friendly and in the mood to chat, talking about his past, talking about his work. "I grew up here, only went away to do two years in the army, then worked for Ford Motors for eighteen-point-nine years." Like Sylvester, he talks about how Gary was when he was younger, about the bars, the clubs, the gambling. When he is done, I ask him if he is religious. He stops. "Well, I believe

in reading the Bible." I ask him why he goes by Jesus Christ, and he pulls out his wallet and shows me his driver's license and bank card— both with the name Jesus Christ. Before I leave, I ask him one last question: "I don't mean to be rude, but you ever been mixed up with drugs?" He smiles. "Not much. I quit all that. Just do cocaine now."

McDonald's

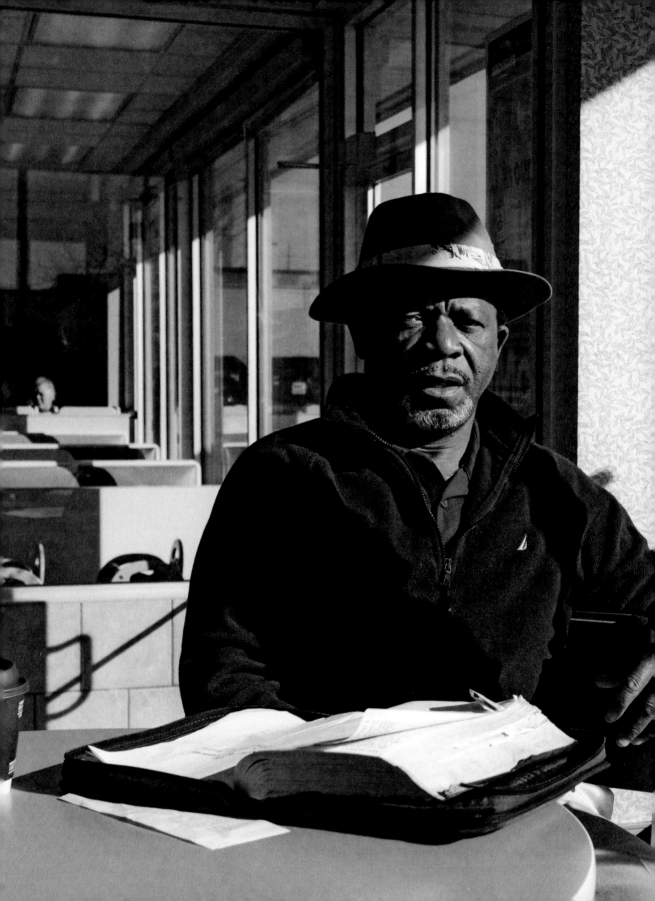

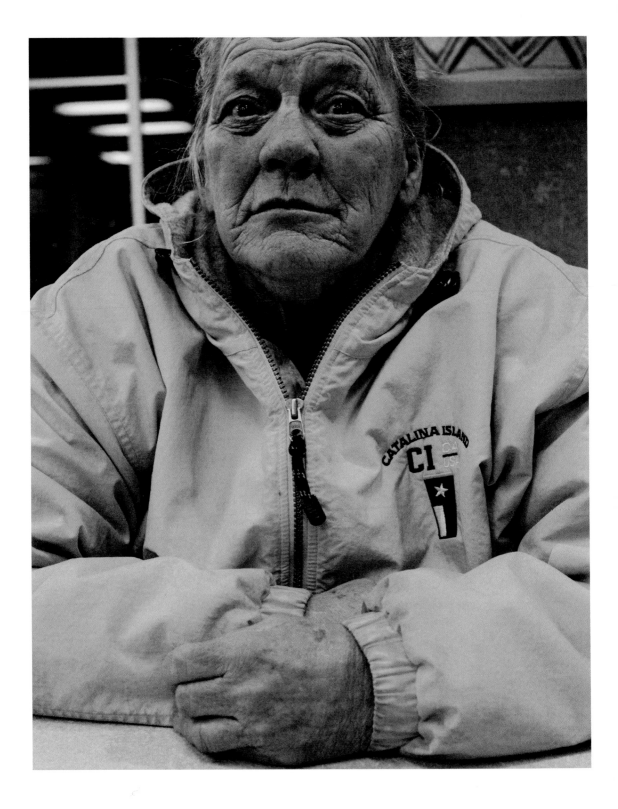

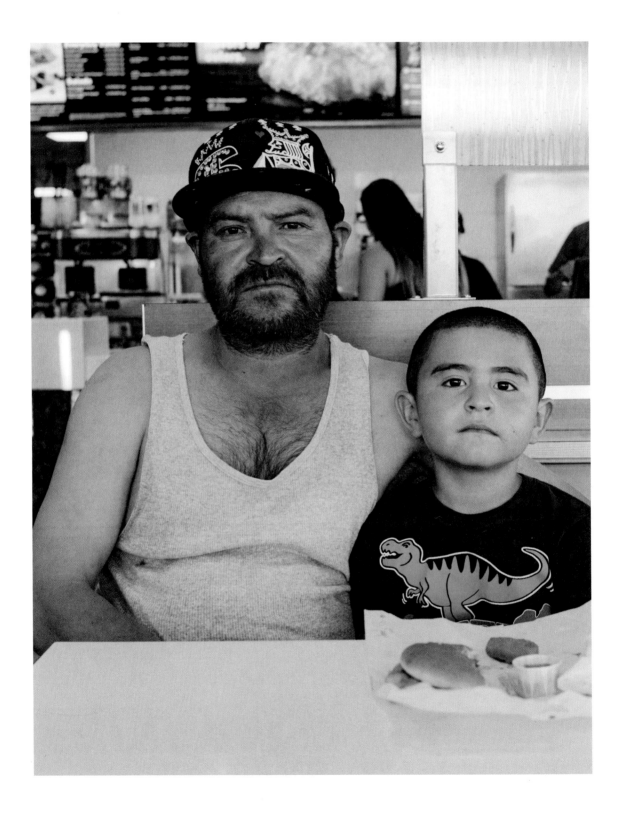

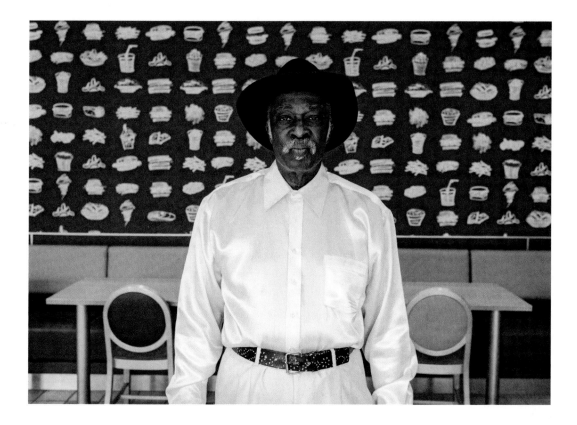
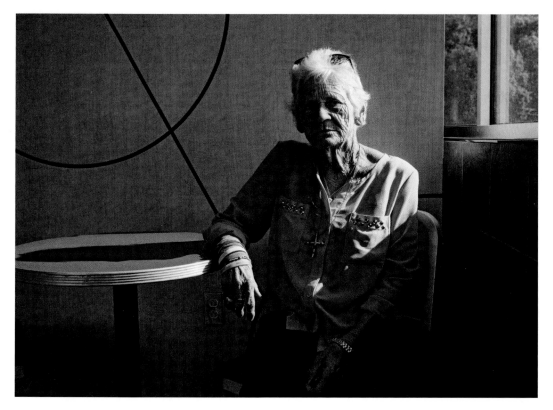

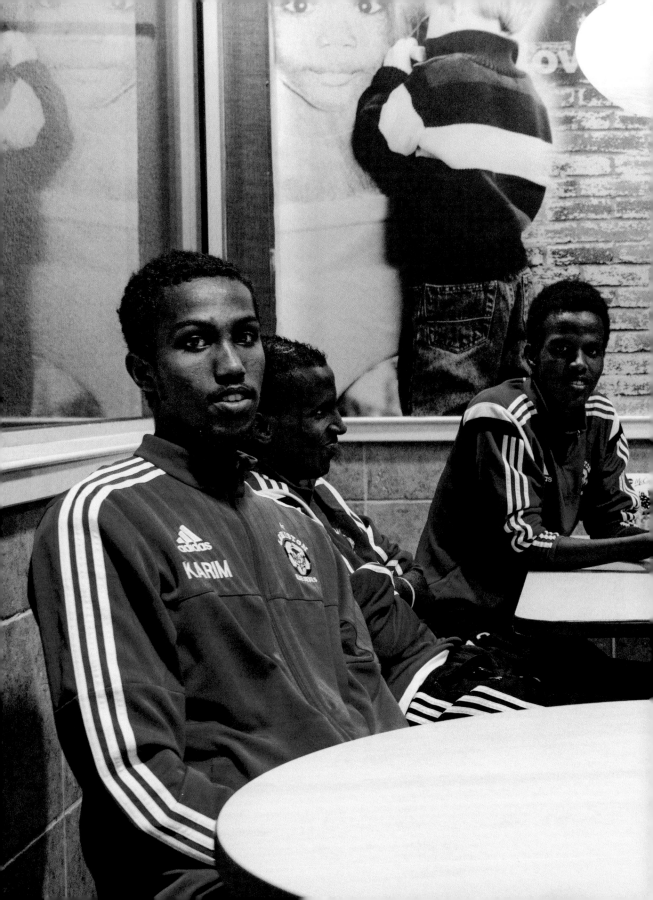

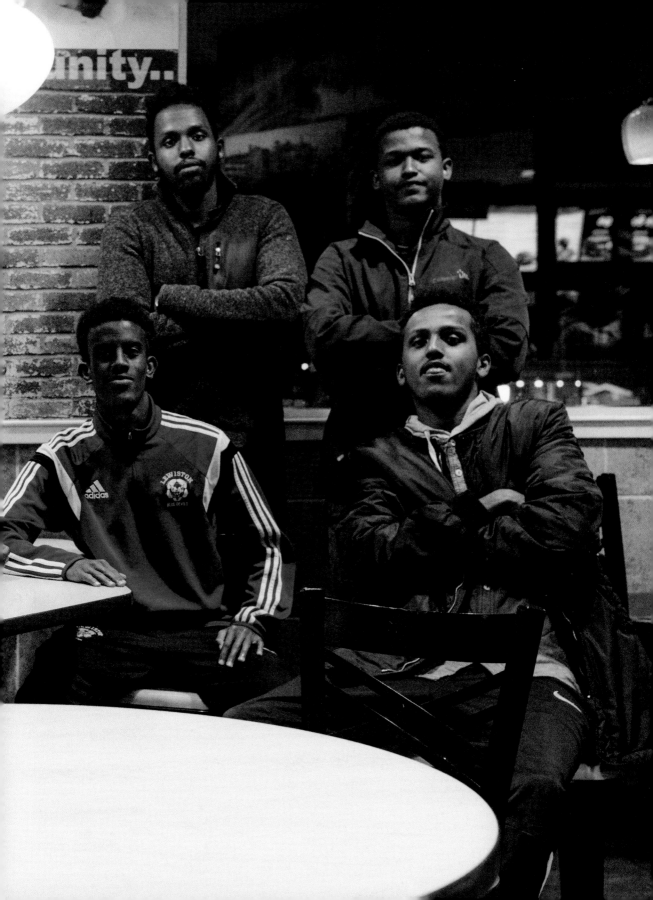

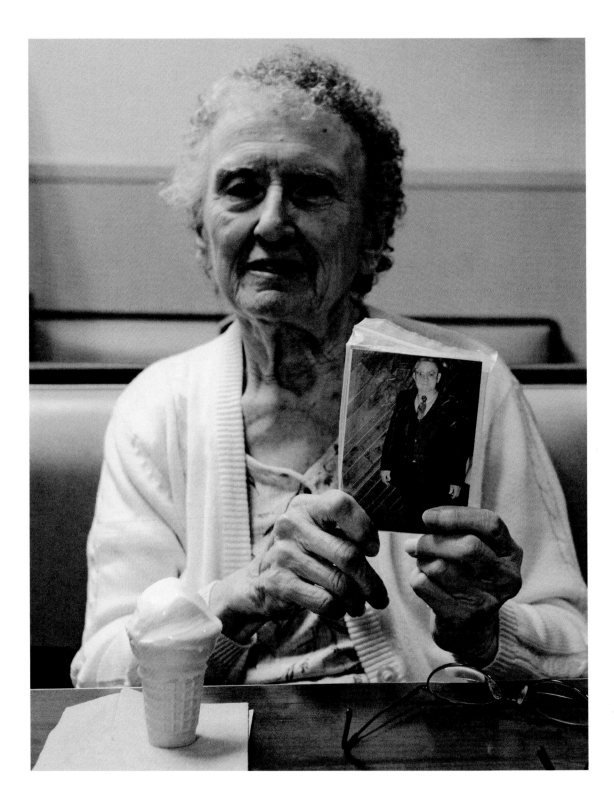

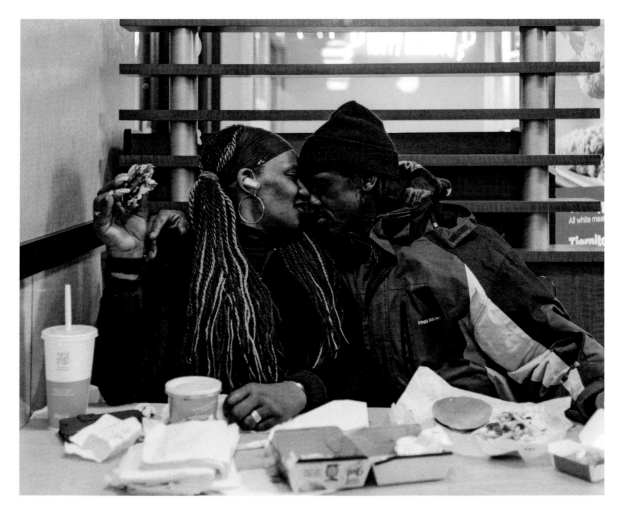

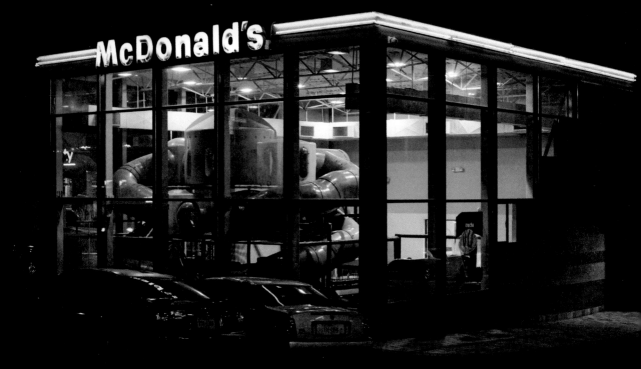

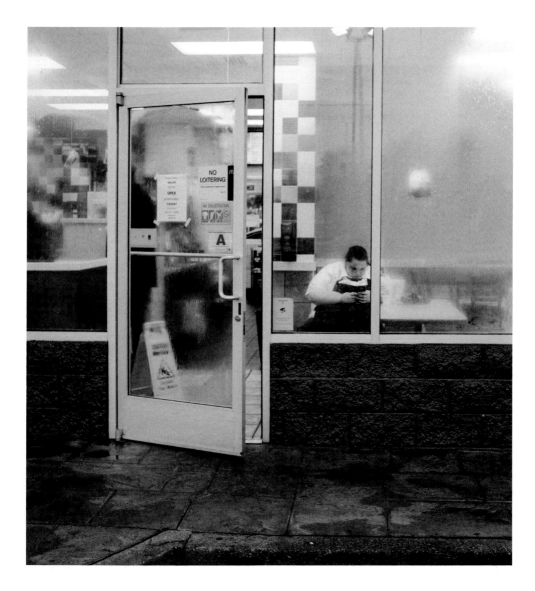

Drugs

I t is 108 degrees outside, and the McDonald's in Bakersfield, California, is filled with people escaping the streets and the heat, some for only a few minutes, others for the entire day.

While many tables are occupied by families sharing a meal, workers taking a break, and regulars who come to sip coffee and chat, for much of the day, the McDonald's is given over to people on the margins— addicts and the homeless, mentally ill, and destitute.

A large man in a greasy, full-length, zipped-up winter work suit sits at a booth. He stares down at the table, his eyes hidden beneath a wide floppy hat. He gets up now and then to refill his cup with ice, the laces of his untied work boots hitting against the floor as he goes. During his five hours inside, he doesn't say a word to anyone.

There is a man who calls himself "Black Jesus" who sits and stares straight ahead, only a cup of coffee in front of him. Every fifteen minutes, he raises his left fist in the air, holding it for fifteen seconds in a silent salute to something or other. Despite the heat, he is wearing a dirty winter jacket. Before each sip of coffee, he cleans the rim of the cup with a napkin. Almost everyone from the streets who passes comes and shakes his hand or gives him a fist bump. He doesn't say a word to them or anyone else.

Next to him is an older white woman with swept-back gray hair parted in the middle, holding a cup of ice. On her left wrist is a torn and dirtied hospital wristband. She is silent with a blank look on her face, either staring ahead out the window or at a Christmas card with the words "Joy to the World" on it laying on the table. A few times she flips the card over, looks at the back, flips it again, and then sighs. She has been doing this for almost ten hours. When I ask her if I can get her anything, she looks down at the card, then tells me, while staring straight ahead, "My wife just died, and I am trying to keep an eye on her." The card is dirty and smudged but still sparkles with glitter.

In the parking lot, a woman is wearing a sparkling pink backpack, bikini, faux-fur vest, one faux-fur knee-high boot, and one sandal. She carries an oversize white bag. She walks into the street paying no mind to oncoming traffic. She stops in the middle to adjust the contents of the bag, then grabs her breast and blows a kiss at passing cars before joining a group hanging beneath the awning of a gas station. Nobody pays her much attention.

At one of the entrances a woman in a tube top and jean shorts stands outside the door and pushes it open for everyone. She smiles each time I pass by, but I keep my head down. Eventually she calls out to me, asking for a few dollars for a meal.

"Maybe one of them fives?" she asks, as she sees cash when I look in my wallet.

I give her one and ask her if she's homeless.

"No," she says. "I live down the street in that shitbag motel they put us in."

I ask her if she takes drugs, and she says yes.

"Crystal meth?"

"Yep. This is the place. McMeth."

This McDonald's is reflective of the surrounding neighborhood, one filled with other fast-food franchises, empty lots, and a few dilapidated hotels used to house the homeless. Groups cluster under bridges or in camps along either side of a creek that cuts through the town. Women walk the streets selling themselves. Men looking to buy sex cruise slowly down the wide streets, tinted windows rolled down despite the stunning heat. The police come through now and then. Sometimes they arrive in force to arrest somebody, four patrol cars trapping a target, spilling their backpack on the ground to find packets of drugs.

The neighborhood, like all of Bakersfield, is diverse, and those living on the streets reflect that. There is an equal number of African Americans, Latinos, and whites, and nobody seems to pay attention to who is what color or who speaks what language. What they all have in common is a lack of education.

Bakersfield, which among larger US cities has the highest percentage of residents without a college degree, is, at least statistically, the most back row city in the country. Far behind the rest of the country educationally and suffering from all the economic woes hitting the back row, many in this town have taken refuge not just in McDonald's but in drugs.

Drugs really are a refuge for many in the back row (and the front,

for that matter, though for different reasons). All across America I found similar neighborhoods, where people who felt rejected and stigmatized, either by the world at large or by their neighbors in particular, found relief in drugs. Some used them to numb the pain, others as a possible way to the more permanent relief of death and others as a way to bond, since drug users have their own tight-knit communities.

In this Bakersfield neighborhood, those using drugs are very much a community, with the McDonald's one of their clubhouses. They almost all know one another, almost all help one another out, almost all swap info on housing, drugs, and the police. They bond over shared experiences of trauma, pain, and isolation.

They also bond over a belief that life is bleak. So bleak that the ultimate downside of their situation—death—isn't terrifying.

Nobody in Bakersfield comes right out and says, "I want to die," but it is the subtext behind statements like "What do I got to lose, because I have already lost so much," or "I served eighteen months for vehicular manslaughter when I killed my nine-year-old daughter driving drunk. How do you get over that?"

Their belief that life isn't worth living has turned into recklessness, their addiction into a form of suicide.

This isn't the first time I've observed this. During my years close to street addicts who lived in abandoned buildings, under bridges, and in old cars scattered around Hunts Point, I saw people who felt left behind, unable to maintain a life even in the back row, turn to drugs in the hopes that it would not only dull but end the pain.

Bernice was like that. I met her while she was standing on a Hunts Point street corner as I was heading into a bodega to get soda. She waved to me, and I went over to talk. She was dope sick, something I could tell immediately by her pale, sweating face, her desperate sadness, and the blue corrupted veins on her arms.

She was selling herself, something I could also tell immediately. It wasn't that she looked like the TV version of a sex worker—almost no sex workers do. Rather, she was dressed for comfort—a red halter top, jeans, and flip-flops—in whatever she could put together with no money, lingering on a street corner while sick.

She told me she was looking for a twenty so she could buy a hit of crack and a hit of heroin: one to get her straight, the other to lift her up.

She was thirty-six and had been doing some form of this since she was nineteen, with breaks here and there for prison, rehab, and a few longer stretches when she "got right and got clean." She counted forty-two charges in her life for sex work.

She was matter-of-fact about her childhood trauma, about a life spent hunting for a fix and running from abuse. It was a story I had heard many times before and many times since—an ugly version of an already ugly theme of poverty, dysfunction, and abuse. Before she headed off to a car waiting beyond the corner liquor store, she ended with an explanation: "I am out here trying to kill myself. I want to get a gun and do it faster, but I am too scared to blow my head off."

Bernice isn't alone. Every addict on the streets knows death isn't far away. They can tell you of someone whose life ended because of a potent bag of especially good bad shit. Everybody has a story about their own close call, waking up in an ER after forty-eight hours of bingeing, or passing out on the railroad tracks and having a train crush their hand, or getting sliced with a knife by a man who "liked to slice women," or fighting an infection that was denied and denied until the "police, yes, the police, those dirty-ass, no-good-for-nothing bastards, couldn't stand to see me sweating, breathing, and smelling like rotting flesh and called an ambulance instead of locking me up." Death is close enough that they prepare for it. Sometimes it even entices them. When someone ODs, the second question asked after who, is "On what?" What brand,

what red label was the bag stamped with? Was it "Total Control," or "Obama Care," or "Ice Cream"? Then they search for it, because it is especially good shit, potent, and they can do enough to push themselves right to the limit. Maybe they write their momma's phone number on their stomach in red marker. Or their husband's, or wife's, or sister's, because if they find you dead, you want a proper burial. You don't want to end up buried in a trench on a tiny island in the Long Island Sound with a million other unclaimed bodies.

That is where you end up buried in New York City if you die without anyone to identify or claim your body. That is what happened to Millie, a street sister to the users in Hunts Point, when her infection went to her heart and she died on the ninth floor of Lincoln Hospital as a Jane Doe, or, to be more exact, BX97—case #97 of the Bronx Medical Examiner. Cause of death: bacterial endocarditis of tricuspid valve due to intravenous drug abuse.

Or Jackie, another woman who died of an overdose, although others say she mixed pills and heroin with her asthma medicine, and while nobody should do that, she liked to do it because she said it gave her a special boost. She also died in Lincoln, tagged as BX-something, although someone said her body wasn't claimed because her man was holding on to her info to keep collecting her disability benefits. You can't get those if she is dead. "Come on. Don't you see? Nobody gives out checks to the dead."

Like suicide, addiction is often a desperate reaction to rejection, often rejection experienced in childhood trauma like Bernice's. Many of the hard-core drug users I met had been beaten, or yelled at, or

ignored, or passed from relative to relative or to whoever had their house in order or had a house at all. God forbid they got passed into a home with men who liked to do awful things to kids.

When Takeesha told me about her past abuse, her friend Carmela, sitting on a milk crate a few feet away, commented without emotion, "You lucky you only had one family to fuck you over. I was in foster care and got to be fucked over by a bunch of different families."

Being abused by the people who were supposed to rescue them was the ultimate destruction of trust, so they fled, running away either literally or mentally. Therapists call this "dissociation." On the street they call it being fucked over, and one solution to being fucked over is taking drugs, mostly heroin.

That feeling of rejection can also come from larger social forces, something minorities know all too well. Racism is multifaceted in its ugliness, and the sense of rejection by a mostly white "successful" society is one of those ugly faces. Growing up black or Latino in Hunts Point, East New York, or the Bronx; or Buffalo's East Side; or Milwaukee's North Side; or Selma, Alabama, means being confined. It means being forced to live in a certain neighborhood, one with fewer legal opportunities—fewer jobs, fewer schools, less money, less everything. It can be isolating and depressing.

It isn't just about money. These entire communities are stigmatized socially and culturally. The feeling of being excluded, of being different, is more than about what things you own; it is also about what you know, what you learn, how you approach issues. The tools you have available to solve those issues are all different, and they can be isolating.

It is about the big things and the small. It is about the type of music that surrounds you, the clothes available to you, the food your friends like, how you cut your hair, how you wear your pants. It is about how

you see yourself in the world. It is about being physically strong when everyone now values being smart. It is about caring about place and family when everyone now values caring more about career. It is about caring about faith when everyone now values science or liking McDonald's when everyone says it is bad. It can be everything and anything, and the sum of it all can be overwhelming.

It is about being on the outside while not knowing how to operate on the inside. Not knowing how to dress, talk, or walk how they say you're supposed to. Things you need to know because the insiders make the rules and you need to know the rules if you have to navigate this game of life: "If you gonna make money in this tricky world, you need to know them tricky rules."

While trauma and racism have long been sources of rejection, a lack of education is becoming a larger source as those at the bottom of our school system are falling further behind economically and socially. To get a steady job that you can be proud of and build a life around, you need more than high school; you need a college degree, and not just from any college, but from one of the better schools. This has made a lack of education all the more isolating.

It is also a stigma that is considered your fault. We claim our educational system is a meritocracy that anyone can excel in with enough dedication and smarts. We loudly celebrate those who rise above their surroundings, study hard, get a scholarship, get the big job, and move to the nice neighborhood.

See, we say, anyone can do it if they are smart and apply themselves. The moral being, if you fail, it is your fault, because you are lazy, or dumb, or slow.

Rarely mentioned is the vast difference in the quality of our schools, the vast difference in how much help students get, and the vast differences in how many personal problems students face.

It is a stigma that can lead to drugs. Go into any crack house, any detox center, any homeless camp, and you will hear story after story of someone who will say outright, "I am dumb." Or, "They said I was dumb." The drugs don't just provide a temporary mental escape from an ugly reality. They also provide a sense of belonging, a real community. The world of drugs is accepting as long as you continue to use drugs. The street corner at 2:00 a.m., the back room in a friend's house, the empty room with candles and crack pipes in an otherwise abandoned buildings, are communities. They might be filled with "fucked-up people, but they are my fucked-up people." The other users and the dealers are also running from something. A drug trap, or a drug corner, is a place to hang and fit in. A place that welcomes you regardless of your past.

If you live in one of these neighborhoods, drug dealers are not evil strangers resembling the drug lords you see on TV. They are people you know. There is a chance someone related to you has dealt drugs, a cousin or a half brother or an uncle. The dealer might be your friend or a friend from back in elementary school or a friend of your sister's. You have to interact with them, one way or another. You have to walk past them to get to school, maneuver around them inside the bodega to get milk, or joke with them in the lobby of the building you live in. They are everywhere, and you cannot ignore them, and you certainly cannot dismiss them as pure evil. Other than dealing drugs, they might be just like you. They dress like you, and they understand you.

The dealers, the kids smoking weed across the street or at the bar, those shooting up in the empty buildings, they don't question your past, your future, or your dress or hair, or how you speak. They get you, because they get your pain, which is often theirs. That others tell you

they are all bad might even add to their appeal, since almost everything you do, or think, or how you behave is said to be wrong. Why not add one more thing?

Not everyone in these neighborhoods is drawn to drugs. The vast majority stay away from them, but those who do use end up further stigmatizing the neighborhood. The in-group now has another reason to stereotype the neighborhood, turning it into a cartoonish landscape of drugs, violence, and sin—giving them another reason to ignore and diminish the residents.

The self-perpetuating cycle of rejection, isolation, and drugs increasingly wears away at the fabric of the community, isolating it further and taking over more lives. With enough time even those who try to stay away from drugs start being pulled in by expectations.

Beauty has seen this cycle both in the heartland and in a coastal city. She came to Hunts Point from Oklahoma City when she was twenty-one, brought by a pimp, although she saw him as a boyfriend she hoped to marry. Her dream was to make it in the big city, to escape her small-town, backward life, and she was coming the only way she knew how.

She was born in a prison hospital in Oklahoma to a mother doing time for drugs. Her mother stayed in prison for most of her life. "I looked forward to visiting on Sundays. She would braid my hair out in the visitors' yard," she tells me. Beauty was passed among relatives, depending on who was out and free. They all lived in the same poor section of Oklahoma City, filled with a grid of wide, flat roads holding fast-food chains, gas stations, and corner liquor stores.

Her schools were filled with kids like Beauty: poor and black. She

struggled in them, though she isn't slow or dumb. She is smart and quick, especially with words. Like many smart people, she doesn't suffer fools and pointless rules, although unlike them the only outlet she knew was rage. School was a maze of rules that didn't fully make sense, ones that you just had to follow, and she wanted to understand each of them and the rationale for them. Nobody ever explained things to her the way she felt they needed to be explained. They just told her that this is how it is and this is what you have to do. Sometimes it worked for her, and sometimes it made her mad and she said so. Then she was scolded, which set her off into even more of a rage. By the time she calmed down, she had been banished to another room, or punished, or sent home, which only made her more certain it was all unjust.

In middle school she was labeled as ADHD and put in special-education class. That worked for a while and she tried her best, tried to join in, but with everything else going on, it all got to be too much.

"In high school I was a cheerleader. For real I was. One big game my mom was supposed to come see me since she was out of prison. I was like, 'Cool, Mom is home.' She never showed. So I sat after the game on the curb figuring she was late and would eventually come. But she never came to pick me up. So I walked home along the side of the road, having to listen to all these broke-ass men shouting nasty things at me. When I got to the house it was locked. I kept banging on the door. Finally I busted through a window. The house smelled mad like crack. Nasty-ass smell. She was all out on the floor. Some weird-ass folks were also there. I cried my eyes out. When I was finished, I was like, 'Enough of this. I am out of here.'"

She dropped out at sixteen and started using a fake ID to strip at the XXX-tasy Ranch. She went home with a few customers who offered her money for sex, then turned to street sex work a few months later.

She didn't hide this from anyone; many had done something similar when an addiction flared and cash was tight.

She didn't like drugs, not the ones she saw her mother use. She didn't start using heroin (pronounced as hair-on) or crack. Didn't fool around with either and didn't respect them. "I ain't got that crack or needle habit. I saw my mom mess with that shit. I saw her picking her arms. When my mom found crack, that's when the walls started coming in on me. I can't stand that peppermint burning smell."

Instead she smoked blunts sprinkled with K2, a mix of herbs sprayed with chemicals, with names like "strawberry smack," which is marketed as synthetic marijuana and sold in almost every corner store. When she was on K2, her aggression, intensity, and rage were gone, replaced by a vacant calm.

To her, these were not drugs, although they messed her up, gave her seizures, and sometimes knocked her out. They were sold in corner stores, and they were legal, and so they weren't drugs, and many around her—customers, boyfriends, and others on the streets—were smoking them.

In Hunts Point, she joined the street family, with Takeesha as her street mother. Everyone helped her navigate their world, giving her advice on who to watch out for, which johns were "cheap ass," which wanted to buy drugs, which wanted to hurt her.

She left her first pimp, the one who brought her. He didn't treat her right, beat her badly, and started cheating on her. Over the following years she kept falling in love and kept being disappointed. All of her boyfriends did drugs, and all, like her, were homeless. They all also pimped her and some beat her, but that didn't stop her; she kept hoping and dreaming that eventually one would work out.

Beauty wanted nothing more than to be in love. She wanted her version of the white picket fence, the only version she really knew, the only version that she felt was available to her.

"Heavy and I are tight. He used to be just my friend, and now it's all intimate and he wants to get married. That shit is tempting. I mean, he got disability. I don't know if I should marry Heavy. I mean, he has been good to me. He gave me my own cell phone, he took me to Coney Island; none of my men ever took me to Coney Island. But marriage is a huge step. That is serious shit, taking a name. Maybe we should enter a domestic partnership first. I mean, every girl wants to live in a house with a decent man and have kids."

It didn't matter that the house was a homeless shelter or under a bridge. What mattered was that they were together. "My friends Livy and Will are in a shelter at 125th.... They have a tarp space under the Bruckner they willing to share. They invited me to join, but I don't want to go disrupting their situation. Livy got it good, because Will is an upright man; he ain't pimping her. That nigger gets up and hustles."

She kept getting arrested, and when she did, she ended up spending months in Rikers. She quickly took to it, falling into the structure it provided and taking pride in the work they gave her, and then falling in love with another inmate.

One charge got her locked up for five months, and she became tight with her boss in the cafeteria. She smiled over the perks of getting extra food on chicken Thursday and talked of running away with her to the boss's place in Harlem. "My boo treat me right; she keeps me calm. I can't hit anyone in here. I don't want to be orange in court." When she was finally released from jail (with all charges dropped), she went back to her street family and back to falling in love with men and back to getting hurt.

When she wasn't working, she hung out with her street family, current boyfriend, or whomever on a low wall running along a park across from a homeless shelter, sitting and gossiping and smoking K2. This was her community, her people, her world, and the minute she got out

of Rikers, or detox, or rehab, or whatever facility she had been assigned to, she walked back to that wall to sit on it and hang out.

Being out on the streets prostituting, being homeless, having boyfriends who sold drugs, this wasn't abnormal or weird for Beauty, and she didn't feel sorry for herself. It was the world she came from and the world she knew and the world she saw, and she had made it in the big city.

She wasn't embarrassed about her life, rather she was proud of what she had accomplished in the big city, although she grew more and more frustrated that she hadn't found a man who would work his ass off and build a family. She sat at my computer and checked on Facebook on her family and friends back home and thought about going back. "My momma has been clean for a minute, about to get her three-year chip. She has a room for me. I got plenty of people back there, but they all doing things, got things, have families, and kids, and people who love them. I got nothing to offer them. What am I gonna be? A social security check that everyone wants. I got nothing else. Nothing. They all got people. I got nothing. I will be a drag on all of them. I am scared. You hear? Scared."

Inside the Bakersfield McDonald's, the fear, the trauma, and the lack of education are all present—as are the drugs. But in the context of McDonald's, the fear isn't palpable, expressed instead as a resignation to being on the outside.

In the McDonald's, there is a battle over the ice and soda machine. There are always people in McDonald's who come in, maybe with an old cup, or grab a cup from the garbage, and fill it up for free. Most McDonald's employees ignore it as the cost of doing business. Now

with the heat spiking higher, with this McDonald's being a social services clinic and a restaurant, there is an open battle between the shift manager and the people trying to get free ice and soda. It also seems to be a particular concern of the afternoon manager.

There is a switch behind the counter that turns the soda fountains on and off, and the afternoon manager is quick to use it, frustrating the various people who run in, fill up a container, and then run out. As the day goes on, the game gets more involved, with people trying different strategies, different methods of deception, and the manager becoming more frustrated. Some people come in and claim they've always been there; others use it in stealth and sit quietly until a moment opens up. Others use speed. Others are blunter. One guy, shirtless and riding a stripped-down ten-speed, waits outside until he sees the machine turned on for a large family, then runs quickly inside with a massive dirty container that looks as though it is from a construction site and starts filling it, the ice loudly hitting the metal bottom. The manager comes running out from the back, waving his hand, threatening to call the police. The shirtless man just looks at him, finishes filling up the container, a process that takes about five minutes, and then walks out. While the game goes on, families sit and chat, paying no mind to any of it.

At another table a man sits quietly staring at a newspaper, sipping his soda. He is here pretty much every day, all day. He comes early, buys a soda or coffee, grabs a paper from another table, or from the garbage, and sits with it opened in front of him. We exchange glances at the battle for ice. Sometimes we both start laughing at the same time when someone pulls off a particularly audacious move that angers the manager, and eventually we start talking.

In response to my question about whether he's homeless, he says, "You could say that. I have the auto shop I work in. I also sleep in it at night, after it is closed up. So I guess so."

I ask how that happened, and he says he had some trouble, was in and out of jobs and in and out of prison for DWIs. He has three of them.

He then tells a long story about getting hit with a pole, cracking open his head, and losing his memory and his ability to read and write. "A buddy was messing around, on drugs, and swinging a pole, and whack. My head was split open and I was a different person."

I ask him why he comes to McDonald's, and he says he comes to relax. "It is amusing to watch everyone and talk to them. I like to keep up with the gossip and news and sports."

Sitting next to us is an older black man sipping coffee and reading the paper. He is always here as well, with his paper and his metal cigarette case with an engraved wolf. He introduces himself as Sage.

He goes over to Black Jesus and talks to him. When he comes back, I tell him I am surprised to see him talk, since he hasn't said a word to anyone else. "Oh. That is Black Jesus's style. He don't harm anybody, keeps to himself." We talk for a while, and after he tells me about his life (time in jail, robbery, receiving stolen property, the passing of his mother), he asks me about mine. I give him a rundown, and when I get to the working-on-Wall-Street part, he stops me and smiles. "I hope you got damn rich from that. If you gonna sell out like that, better sell out like that good."

I tell him I did OK, and he nods and gets up to smoke. Before he leaves, he starts a long speech, delivered not so much with passion but with a sense of exasperation, as if this is something he has been thinking over and over and he is sure is important but nobody else really cares about.

"White-collar crime is the biggest crime, but nobody gets thrown in jail for that. Nobody gets prosecuted. Not only don't they get any of that, they get a big check from the president. Barack Obama tells us he is one of us, says, 'Look at my skin; I am one of you,' but he doesn't help

anybody when they down except you bankers. Nobody helps us out here. We get thrown in jail. This here is a crooked society, and they wonder why we run from police. We ain't blind. People we have in office are criminals and protect their big friends who are also criminals. We out on the streets, voters, we suffer. Nobody has a heart in this country. Step into a homeless shelter and see how the system doesn't care about anybody hurting. Reality hurts. Nobody likes to face reality."

I nod my head, agreeing, and all I can think to say is, "Well, Bakersfield is a tough town."

He looks at me before going outside. "When you can't beat them, you join them. You ain't given opportunities here. You got to make them. Sometimes that means doing bad things."

A younger woman sits quietly eating her meal, ignoring everyone. I have seen her walking past a few times, down the street where others walk to "catch dates." I ask if I can join her, and she smiles. She introduces herself as Smurf, saying, "That is my street name. My real name is A, but everyone calls me Smurf. I prefer it."

She tells me that she hates Bakersfield but stays because she has no other options. That she had a good childhood but got hooked on crystal meth when she was seventeen, dropped out of high school, and is now a sex worker and deals drugs.

"I have no choice but to prostitute," she says. "To be a working girl. I sell drugs also. Sell crystal meth. Once you hooked on it, you have no choice but to be a working girl. I walk up and down Nineteenth. I get about three dates a night. That is all I need. If I do more than that, they might rob me of my cash. Sometimes I get a client I connect with and it is OK. Regulars. We go out and don't have sex. We just talk and go out. Like friends."

"You OK with me writing this?" I ask.

"Sure. Accept me or you don't. I am me."

"You religious?"

"I am very religious. Very religious."

"How much you use?"

"Smoke a dime a day, used to use eight balls, but I quit for my twins."

She begins to cry and tells me she has eight children, all taken away, though she sees them from time to time. She's been in jail once and hopes not to go back.

I ask her where she lives.

"Here and there. I don't do abandoned buildings. I stay with my boyfriend or my husband. I refuse to stay in an abandoned place. I don't need a charge like that. I stay with friends or others. I stay here and there now."

She stays in Bakersfield for her kids, who live with her sister. She gets out her phone to show me pictures of two babies—her youngest. It is an addict's phone, the front face a web of cracks and breaks. Her hands and arms are dirty from the streets, tattooed with names and dates of friends and family that have passed, her fingernails spotted with bits of purple nail polish. The largest tattoo proclaims, "100% Fabulous Puerto Rican."

She starts crying again, and an older man comes by and hands her a napkin and a religious flyer. She smiles at him and then tells me about her babies, making sure I understand she visits them often and how much she loves them.

While we talk, the controlled chaos of the McDonald's swirls around us. The fight over the ice machine continues. Black Jesus throws his hand up every ten minutes in his salute. The woman with the swept-back gray hair continues to stare at her "Joy to the World" Christmas card. Outside, a cluster of homeless—most of whom I now recognize—pester each person entering for money.

When she is composed again, I ask her another question, even though I know the answer: "Why so many kids?"

"I didn't mean to have so many, but sometimes I get pregnant."

"People gonna read that and think you need to stop having babies," I tell her.

"Them people need to walk a mile in my shoes. I got nothing but my family. That is all I got. That and my habit."

God Filled My Emptiness

I stay at Bakersfield four days, and on my last day, a stunningly hot Sunday, I attended the 9:00 a.m. service at the Full Gospel Lighthouse. The room is tiny, only twenty folding chairs facing a stage with a cross, a drum kit, a stand-up electric piano, and two large speakers. The room is otherwise bare, except for two standing fans blowing hot air around and a table with a collection plate with three one-dollar bills, plastic flowers, and a display of pamphlets titled "You Have GOD'S WORD ON IT" and "YOU can be DEBT FREE!"

I had chosen the Full Gospel Lighthouse for my Sunday service randomly, having passed by while driving from the McDonald's. Whenever I was on the road, I made it a point to attend some religious service

in each neighborhood, the denomination unimportant, so long as the church seemed integrated into the neighborhood. That meant mostly small churches in spaces originally designed for something else—a re-purposed fast-food franchise, a former shoe store in a strip mall, or an old wooden home gutted and fitted with an altar.

By the time I walked into the Full Gospel Lighthouse, I had been to enough churches that I knew where to sit (toward the back to stay out of people's way and watch), what questions I would get ("Where are you from?," "Are you saved?"), and to ask for permission to talk to the congregation, photograph the service, and write about it.

I also knew I would be warmly welcomed, despite clearly looking like an outsider. I had never not been, not when I was the only white person (often), not when I was the only one dressed in jeans (once), and not when I was the only man with long unkempt hair (a few times).

It is no different in the Full Gospel Lighthouse, where Jeanette greets me with a hug after I introduce myself. She apologizes for the heat and the sparse attendance, explaining that this is the English-only service, and the Spanish service will be in the room next door afterward and will be much bigger.

Jeanette was born and raised in Bakersfield, the daughter of a cook and a mom who worked in a cotton factory, one of four kids of parents who came from Mexico. She points to the handful in the room as mostly family members—including her children—who have come to support her, explaining, "I want them to be fully comfortable in English. My husband is over there, holding the newborn. He doesn't speak English, but he is learning."

The service is sparse and quick, with Jeanette switching between preaching and singing, accompanied by two young girls who stand in long flowing dresses while plunking at the piano.

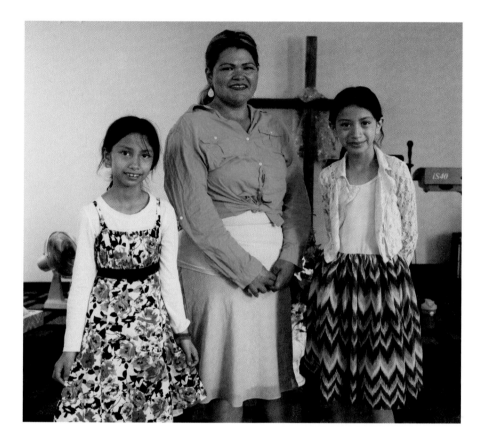

Her sister and another relative hold each other as Jeanette preaches, shouting back at her, holding their hands to the heavens, or praying with her.

"I would like everyone to pray for Heather and Peña, who are going through a difficult situation. We were able to go visit them. We are the only people they have. Their church family. We may not have a million dollars, praise God, but we have each other."

After the service, Jeannette introduces me to her husband, who spent the service taking care of a newborn and a young toddler. He smiles at

me and we shake hands, but I don't speak Spanish and he doesn't speak English, so he runs off to deal with the children.

ME: What does he do?

HER: He is a gardener. He works really, really, really hard. I don't know anyone who works harder. He has to. He doesn't have much education. He has no formal education.

ME: How many kids do you have?

HER: I have four kids. Three are from another marriage; the newborn is his. The other kids' dad left, just fled, and my new husband was in my congregation and I saw how much he loved my kids, how hard he worked, and how sweet a man he was. How dedicated to God.

ME: Why are there so many homeless in Bakersfield?

HER: They are homeless by choice. Like my ex-husband. He is on the streets now. Only place my boys see him is out there on the streets. He is an alcoholic. He drank away our money and lost jobs because of drinking.

ME: I was just in the McDonald's, and there are lots of homeless over there.

HER: Yes, he stays over there. You might have met him.

ME: What did he used to do?

HER: Welding. He always drank, but it got worse and worse, and then he just left. My current husband does not drink. That is very important to me. He may not be educated, but he works hard, doesn't drink, and he is religious.

ME: What does religion mean to you?

HER: Without God, I would be lost. I wouldn't have peace.

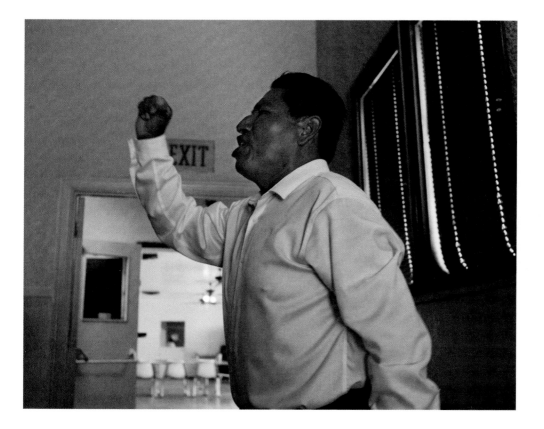

The Spanish service that follows is long, and the heat continues to grow. Nobody inside seems to mind as they sing, dance, or become lost in a rapture that sends them to the ground, shaking in joy. The intensity inside increases, and people leave the pews, walk to the front, and cluster around the preacher who is singing/preaching/shouting/yelling in an hour-plus-long, uninterrupted sermon. The preacher touches each of them on the forehead, and they fall and shake more on the ground, comforted by others, who pick them back up.

An older woman, her hands contorted by age and work, stands for the entire service, her right hand held high.

After an hour I leave, done in by the heat and noise. I also leave because I'm uncomfortable. Although I respect Jeanette and her congregation's beliefs, I don't share them. Like many other members of the front row, I see her faith as useful, but I don't think it reflects reality. I escape back to the McDonald's, which even then, on a Sunday morning, was busy with desperate people looking for an escape from the heat, danger, and boredom of the streets.

An hour later I get a text from Jeanette, who had found me and my work on addiction on the internet. "Jennifer who you took a picture of hugging me during our service was a meth addict for two years. She also lived on the streets over there near the McDonald's. She has been clean for five years since joining our church."

I had not intended to explore faith when I entered Hunts Point or even when I'd begun traveling the country. Religion wasn't a large part of my life, beyond an intellectual curiosity into how others lived.

Even though I grew up attending a Catholic church in a small town where almost everyone attended church, my parents were not religious. When I left my hometown to go to college, I also left the church and hardly ever looked back. I had gotten into science as a teenager and had stopped attending services beyond funerals and weddings. That I immersed myself in science wasn't surprising—most in the front row have embraced science, not by making it their career, but by believing science as the way to understand the world.

When I went into graduate school for physics I spent six years studying the big questions—how was the universe started, what is it made of, and what is our place in it. I embraced the belief that humans can under-

stand and figure out our world, and that there was no question too big that we couldn't solve, accepting an implicit arrogance in mankind's ability to rise above our surroundings.

During my years on Wall Street I argued for policies born out of an obsession with data. I thought we should plan to maximize things that could be quantified—like higher profits and greater economic growth. I sought to maximize efficiency and measured success by how high the stock market was or whether we had maximized profits and minimized expenses, not by whether we had done the right thing.

I was not alone. Most of us in the front row had decided that it was impossible to identify absolutes, that any moral certainties in religion were suspect, and that all that we could know or value was what science revealed to be quantifiable. Religion was often seen as an old, irrational thing that limited and repressed people—and often outright oppressed them.

Yet over the years I kept finding myself in churches, as I kept finding myself in McDonald's, going there for one reason: because the people I wanted to learn from spent their time there.

Often the only places open, welcoming, and busy in back row neighborhoods were churches or McDonald's. Often the people using the McDonald's were the same people using the churches, people who sat for hours reading or studying the Bible at a table or booth.

A few weeks before visiting Bakersfield, I met Ruby, eighty, sharing a booth with her friend in a rural Ohio McDonald's. She was well dressed, sitting next to a row of tables with other regulars, including her husband.

She was born a "coal miner's daughter in Virginia" but moved north to Ohio when she was fifteen. When she finished with school, she "walked out of high school onto the factory floor," where she worked

for thirty-five years on an auto assembly line, a job she loved and still misses. "We used to stand on the line and talk and talk to each other." She has been married sixty years to a man two years younger than she is. She points him out at a nearby table of older men behind her and says, "I still like to tell him I robbed the cradle.

"One of my sons, the oldest, had trouble with drugs and overdosed twice. He grew up in the church, but he got away from God. He spent a year in prison. Then he found God again. All his friends are dead, and he is crippled up now."

She asks me if I'm religious, and I say not especially. She asks if I read the Bible, and I say I do sometimes.

"We're very religious," she responds. "Do you mind if we pray?" I don't.

Before we can pray, a teenager comes into the McDonald's and up to her table, and Ruby hands him money for a meal. "This is my grandchild," she tells me.

She talks about her group at the McDonald's. "We meet and visit each other here. It is very important to us. There are a lot of widows and widowers in this group who are by themselves otherwise. One friend of ours, well, she and her husband, they smoked like a chimney. He died a year and a half ago. Now she comes here about three times a day." She looks around. "I am surprised she isn't here now."

I tell her I have seen the same kind of community in McDonald's locations all across America and ask her if she comes that often.

She pauses and thinks.

"Our lives used to be centered around work and church. Now it is centered around McDonald's and church."

When I walked into Hunts Point, I expected that the people there, those most impacted by the cold ruthlessness that our world can dish out, would share my atheism. Instead, I found a strong belief in the supernatural and faith manifested in almost every form, mostly as a belief in the Bible.

Often that faith appeared in unexpected places, in people I had been certain would be skeptical of the Bible. One of those was Shelly, a transgender woman who had lived on and off the streets since she was a teenager, run out of her community by an intolerance toward her lifestyle.

It was an intolerance I had assumed she would blame on the deep religious beliefs of that community. But she didn't blame religion; rather, she herself was religious.

I didn't notice her faith until I drove her from the Bronx to upstate New York to see her mother. By then I had known her for well over a year, and I should have noticed. She always carried a rosary, no matter how difficult her position was. She had once given it to me to keep before she was arrested for lifting from the dollar store. "It is my symbol of peace and tranquility. Safety and protection. Reminds me that there is something greater out there, greater than this earth and its people. Something better than this."

She wore that rosary as we sat in a McDonald's a few hours into our trip. For the first time in years, she was dressed as a man. All that was left of her work self was three-day-old cherry-red nail polish, now chipped and dirty. Gone were her breasts (toilet paper stuffed in a bra), her makeup, her heels, her blouse, her purse. Those were carefully placed in a broken rolling suitcase back in the drug trap.

Three days before, when her mom told her she could visit, she had stopped shaving, so now she had a rough stubble. Shelly's mother had laid down the rules for spending the night: "No drugs, no stealing, no girl stuff. You were born my boy, and I want to see you as my boy. Most of all, absolutely no bullshit." She had spent thirty years dealing with Shelly's bullshit, her stealing, her drugs, her car crashes, and all her lies.

Shelly was determined to follow all the rules except for the no-drugs one. She started the trip with four bags of heroin hidden away, two of which she used in the McDonald's bathroom. For close to the last thirty years, Shelly had been unable to do almost anything without shooting up. For the last thirty years, she had been in and out of jail, in and out of rehab, in and out of court, and, because of that, mostly out of her mother's life.

Now Shelly was going to show her mom that she still cared about her, still loved her, and was working on getting her life together. Her mom in return was making her favorite meal of meatballs and pasta, and everyone was going to get along for one night.

For the first few hours after we arrived, that was how it went. Shelly showed me her small town. Showed me the diner she first worked in, the police station she first got into trouble in. Then before dinner she and her mom gossiped about family, friends, and neighbors, and then the talk turned to the past.

Shelly's mother wasn't mad, and she didn't preach; she just laid it out as she saw it. For her it wasn't all about the "girl stuff"; it was about the constant lies, the constant deception. "After a certain point we couldn't even trust you to do the simplest things." After a five-minute monologue on all the disappointments, all the frustrations, she ended with "I don't like the choices you have made, the lifestyle. I will always love you. You are my baby boy. You always will be. If you get clean and

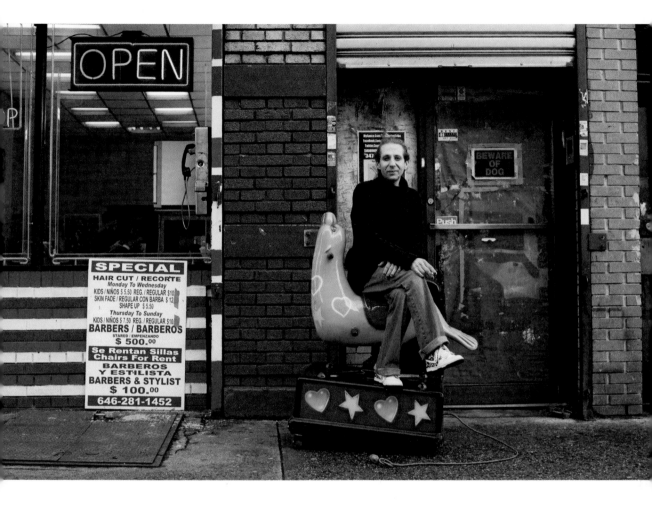

repent, there is a home for you here. You need to repent, though. The life you lead is a sin, and I hope you realize it before it's too late."

I braced myself for what I assumed was coming, preparing to drive back to the Bronx after a big fight. Instead, Shelly just sighed, kept on eating, and said, "Mom, that isn't how I see the Bible. That isn't how I see Jesus. He loves us all. Especially addicts like me. I was born a girl. Always knew it. I don't know why I was given a boy's body, but God must have a reason."

The fight over the Bible never came. How Shelly and her mom interpreted the Bible was different. How she practiced her faith was also different from the way her mother did, because without a regular home, she rarely went to church. Yet she and her mother both strongly believed in God, the power of religious symbols, and that the answers to fundamental questions could be found in the Bible.

It wasn't just Shelly. Religion and faith are essential for surviving the streets of the South Bronx. Everyone I met there who was living homeless or battling an addiction held a deep faith. Street walking is stunningly dangerous work, and everyone has stories of being cut, attacked, and threatened themselves or stories of others who were killed. Everyone has to deal with the danger. Sometimes through drugs. Sometimes through faith. Few work without a mix of heroin, Xanax, or crack. None without faith. "You know what kept me through all that? God. Whenever I got into the car, God got into the car with me."

There are dirty Bibles in crack houses, Korans in abandoned buildings. There is a picture of the Last Supper that moves with a couple living on the streets. It is the only real possession they own, beyond the Bible. It has hung in an abandoned building held in place by a syringe stuck in the wall. It has hung in a sewage-filled basement, and it has leaned against a pole under an expressway.

Rosaries, crucifixes, and religious icons are worn for protection and good luck. Pages of the Bible are torn out, folded up, and kept in pockets, to be pulled out and fingered nervously or read over in times of stress or held during prayers.

When someone goes missing and rumors fill the void, ad hoc ceremonies are held. Small shrines are made from votive candles lifted from the dollar store and old needles, with water from a leaking hydrant sprinkled around. The person almost always comes back, either from a

stay in jail, rehab, or from hiding away because of a disagreement, their death just a rumor.

Mixed with faith in God is a strong belief in the reality of evil. Crossing the bridge into Hunts Point, Takeesha looks out the window of my van. "This place is so bad and evil. It's, like, so simple to walk across the bridge, but it's like you can't go across, you understand? This place is evil. It's possessed. It's evil. I been here a long time. There are bad spirits here. I have seen good people, I have seen people that have family, jobs, and they come here and they get dug in, and two weeks later they living in a cardboard box."

Steve listens and agrees, saying, "This place is haunted. It pulls you in and chews you up. I was, like, five years in jail, and when I was released, I came back here, and the first day I was doing crack. One day back. Crack. It's a fucked-up place. Keep coming back to it. Hunts Point is for devils."

When you're up against evil, whether the mysterious efforts of demons or all-too-explainable effects of drugs, the front row's world of science, education, and smart arguments doesn't do much for you.

All that the front row offers to those living shattered lives in broken buildings is sterile institutions that chew them up and then spit them right back out. In the view of many on the streets, the Bronx Criminal Court, the NYPD's 41st Precinct, Rikers, the welfare office, Lincoln Memorial Hospital, rehab clinics and detox centers, law offices, and the nonprofits have no soul. They are just big buildings that give them nothing but heartache and problems.

They are all dreary places with harsh fluorescent lighting, checkered linoleum floors, and platitudes hung next to rules. "Hope offered here" next to a "PLEASE DO NOT TOUCH THE TV" sign.

These are institutions that they have to navigate like mice working

their way through a maze. Each hour waiting in the hospital, or the courthouse, or the intake center, is an hour that numbs them. An hour of forms to be filled and absurd rules to be followed.

Sometimes they really are mice in a maze. Sometimes scientists study them, put them in a lab, give them crack, and attach them to monitors, poking and prodding them. Takeesha did that once. "One time I did this crack study for $2,500. It was psychological. I saw the advertisement on the train and went to this building on the university. They gave me pristine Colombian, small but potent crack. Never had any shit that good in my life. They did me up and down in the head for days. Hell no they ain't doing that to me again in their hospital."

In their mind the only places on the streets that regularly treat them like humans, that offer them a seat to sit in, an ear to listen, and really understand their past are churches. They are everywhere. Small churches that have come in and taken over a space and light it up on Sundays and Wednesdays. They walk inside the church, and immediately they meet people who get them. The preachers and congregants inside may preach to them, even judge their past decisions, but they don't look down on them. They have walked the walk and know the shit they are going through, not from a book, not from a movie, not from an article, not from a study, but from their own life or the lives of their friends. They look like them, and they get them.

There are rules to follow if you join, but they don't require having your paperwork in order, having proper ID. They don't require getting grilled about this and that. They say, "Enter as you are," letting forgiveness wash away a past that many want gone. You are welcome as long as you try. The churches understand the streets, understand everyone is a sinner and everyone fails. In their mind, the rest of the world—the courts, the hospitals, the rehab clinics, the welfare office, police stations,

and even some of the nonprofits and schools (especially the universities that won't even let you on campus without the police being called)—doesn't understand that. That cold, secular world of the well-intentioned is a distant and judgmental thing. That world has given them seemingly nothing but pain.

The churches are also the way out of addiction, a way to end the cycle. The few success stories told on the streets are of relatives, friends, or spouses who found God, got with the discipline and order of a church, and moved away: "Princess met a decent man who was dedicated to the Scripture. She got straight, got God, and last we heard was on a farm upstate." "Necee went to her grandmother's and found God, and she now has her one-year chip."

This is how it is on the streets. Faith is the reality and a source of hope. Science is the distant thing that doesn't necessarily do much for you.

Faith is essential for Bruce's sobriety. He sits quietly against the back wall of a Youngstown, Ohio, mosque before Friday prayer. He sticks out, a burly white guy in a crowd of mostly darker-skinned men. His white long-sleeved shirt, his beard shaped in a style to fit in, all covering tattoos on his arms and neck. Born and raised in Youngstown, he stayed in town, working various jobs while some friends went off to college. He got dragged into drugs, because "everyone was doing it." Burglary got him three years in prison, and there he found religion. When he returned to Youngstown, he walked straight into the mosque.

"When I got released, I didn't have anything, ended up going back to a halfway house near here and then walked into this mosque, and they welcomed me despite knowing what my past is. Islam saved my life. If I

hadn't found it, I am not sure what I would have done. Lots of my friends from before I did time are dead now. The lifestyle kills you quick."

Faith is also doing something for Jerry, fifty-five, who I had met in a detox clinic in Johnson City, Tennessee, filled with people like him: poor, undereducated, white. He had driven down from Wise County, Virginia, to get his weekly supply of Suboxone, and I went to meet him.

He lives on a small plot of land in a valley far from most things, in a home held together by attachments and additions he built himself. His wife is confined to a bed off the living room, disabled from years of ill-

ness. He spends much of his time caring for her or driving her to appointments in a van with a bumper sticker that reads, "Got Christ? It's Hell without him." He is a big man and moves slowly, hobbled from injuries and pain from a lifetime of manual labor. The worst pain is from

a broken neck when he fell from a ladder that ended most of the work he could do. It was an injury that led to him being prescribed pain pills and then, when doctors cut his prescription, buying heroin.

He is shy about talking, worried that "I got nothing of worth to say, not anything anybody would want to read about." I tell him I want to hear his story; perhaps it can help others who are in a similar position. He agrees to tell me but says before starting, "I don't know my ABCs, so I can't really talk right."

He grew up "dirt poor" in a military family, the son of parents who married and divorced three times. His father was abusive and didn't provide. "When we ate, it was food we got from the mess hall or hunting. One month all we ate was cake mix, because he brought a huge mess of that home. He was too proud to ask for help," he recalls.

"I was always called dumb by everyone, my teachers, other students. Pretty soon I dropped out of school. I been working all my life, but not knowing your ABCs, you have to work harder, because that is the only work you can get. I was a big guy, and I made it the only way I knew how, with my body. But you know what they say: the harder you work, the less you make.

"I drank and smoked some weed. I did drugs to feel happiness and joy and forget all my pains and problems...I felt so dumb; nobody wanted me. They was a lifesaver. I would have killed myself without them. I tried a few times, put gun to my head, but thought of all the people I had to raise.

"I broke my neck in '93 and they started pushing pain pills on me, and soon I was hooked. I am shamed by my dealing and buying of pills. Shamed. That isn't who I am.

"Then I got saved at fifty. It changed me. I had never felt worthy before of being saved. I was too dumb. Now I understand I am worthy

of the Lord. When you are told all your life you're dumb, unworthy, you start believing it. God changed that for me."

I hear the same story in Prestonsburg, Kentucky, a coal-mining town where the inevitable decline is drawing energy away from downtown to the strip malls with McDonald's and Big Lots. The town has a population of 3,500, yet it sustains two dozen churches. There are large churches built with steeples and bells, and there are smaller churches that have taken over where a business has failed.

Billboards and signs for the churches line the roadside, with the largest proclaiming, "Jesus Loves Me," always lit, always visible. In the McDonald's and other fast-food franchises, there are the usual morning groups, with most members who count themselves as religious.

Orbin and Benny, cousins aged seventy-five and seventy-eight, respectively, are regulars in the McDonald's. Both are sons of coal miners, and both are leaders in their churches. Both were raised in strict Baptist churches, though they've moved on from that type of "controlling church."

Orbin says he's still religious because "church is about human relationships, and it is our moral foundation. You can't have none of that, but you also can have too much of it like I did growing up."

Benny was raised the same. He left to work in the auto factories in Ohio but came back often to visit and then returned for good. He worries about a decline in the church: "We used to be very religious as a community. Now fewer people are in the church because for us church was partly entertainment, and now with TV and internet, that is entertainment. Church was also about family. Parents and grandparents took their kids and grandkids; they don't do that anymore. We used to be self-sufficient here. People wouldn't take gifts. We had pride. Self-respect. Then we were flooded with gifts from the government; it took people's pride and self-respect away. The government and internet hurt

our churches, and Walmart coming to town closed every mom-and-pop business. Now people only take pride in drugs. Used to be proud of our community."

In front of the entrance to Walmart, Martha and Randy sit in matching church shirts working a bake sale. Both are the children of coal miners, and both are dedicated to the church. "Religion has always had a major role in this community. It still does, but the people have changed. They depend more on the state and less on the community. For us the religious community means everything. The Lord has made us happy."

At a large church on the edge of downtown, Pastor David, sixty-six, stands after service in a suit and tie in front of a table filled with food. In the pews a dozen people take turns getting down on their hands and knees and washing each other's feet in a yearly ritual. David was born and raised in Prestonsburg, only leaving it for a stint in Vietnam, for which he received three Bronze Stars.

"This church is everyone's home, everyone's family. We help each other out; we support each other. Sometimes it just isn't enough. I have to bury too many congregants, many who kill themselves. One woman who I knew since she was a baby shot herself in the stomach with a .38. The world is too material, and people don't think they need the community. Brother. Do they ever need it."

When I walked into the Bronx I was an atheist, something I was sure about. Standing years later outside the Gospel Lighthouse in Bakersfield I wasn't so sure. To my educated lifelong friends I might have said I was now agnostic, or still an atheist but one who appreciated religion.

To those inside the services I would say, "I appreciate the power of faith," or "I understand the power of the Bible." To the more direct and blunt questions, "Yes I read the Bible now and then, but I wouldn't call myself religious" or "I have not been saved, but I do read the Bible."

None of it was a lie, but the more direct truth was that even after I had come to see how useful religion was, I still attended services as an outsider trying to understand why faith drew so many people to it. Why it seemed to comfort those who needed it the most. In the language of the church, I wasn't yet saved. In the language of my friends, I was a scientist trying to understand religion.

I now couldn't ignore the value in faith, not as a scientist, not as a person who claimed to want to learn from others. Yet I still saw it as a utility—akin to a McDonald's or even drugs. Something popular because it worked. Yet after attending hundreds of different services I was beginning to realize there was more to it than that. My biases, my years steeped in rationality and privilege, was limiting a deeper understanding. That perhaps religion was right, or at least as right as anything could be. Getting there requires a level of intellectual humility that I am not sure I have.

Like most in the front row, I am used to thinking we have all the answers. On Wall Street there were few problems we couldn't solve with enough smarts, energy, audacity, or money. We even managed to push death into the distance; with enough research and enough resources—eating right, doing the right things, going to the correct medical specialist—the inevitable could be delayed, and mortality could feel distant.

With a great job and a great apartment in a great neighborhood, it is easy to feel we have nothing for which we need to be absolved. The

fundamental fallibility of humans seems outdated, distant, and confined to a few distant others. It's not hard to imagine that you have everything under control.

The tragedy of the streets means few can delude themselves into thinking they have it under control. You cannot ignore death there, and you cannot ignore human fallibility. It is easier to see that everyone is a sinner, everyone is fallible, and everyone is mortal. It is easier to see that there are things just too deep, too important, or too great for us to know. It is far easier to recognize that one must come to peace with the idea that "we don't and never will have this under control." It is far easier to see religion not just as useful but as true.

This isn't confined to those in poverty or on the streets; it is true for almost everyone growing up in the back row. Their communities have been shattered, their sense of place and purpose ruptured, leaving them with no confidence in "worldly" institutions and with a clearer sense of the importance, value, and necessity of faith in something beyond the material.

A few miles from town along a tiny state road is a small white wooden church in an old home. A hand-painted tin sign nailed to a light post next to the road announces, "The House of Worship / Sundays 6 P.M. / Everyone Welcome."

Soon after the start of service, Josh stands outside in the shade of the building in a T-shirt, jeans, and work boots, taking a break to smoke a cigarette while flipping through the Bible. He invites me inside, where his wife and two daughters sit along with a handful of others.

The room is simple, with a few rows of pews and a small altar up

front. A child rests laying along a back pew, her head on a fluorescent-colored unicorn pillow. It is hot in the room; the ACs are turned off to save money. Most are fanning themselves with plastic and cardboard fans decorated with a painting of Jesus on the front and the address of a funeral home and a handwritten note—"The House of Worship Church / Please leave at Church"—on the back.

There is no minister, and everyone in attendance takes a turn at the front either singing, reading, preaching, or chanting. One man, a motorcyle mechanic still dressed for work, preaches for close to an hour, shuffling up and down the aisle, around the perimeter of the church, his head bowed, singing and preaching and chanting a stream of amens, prayers, hallelujahs, all the while shaking hands and hugging others as he passes by, breaking only to wipe the sweat from his face.

A local woman who disappeared for years into a larger town up north gets up, leans against the pulpit, and softly describes her past life of meth and of what it meant to be welcomed back into the Church. Despite the heat, she is wearing a zip-up jacket, her hands gripping at the sleeves to keep them from rolling up her arm. She seems out of it, numbed either by her own story, the service, or pills to quiet her anxiety. She wipes tears away with her sleeve and says, "I have had it rough, but with you, and the Lord, I will keep my head high." When I ask her after how long she has been off drugs she tells me, "One week so far."

Josh's wife, Jenny, and another woman join her to sing a song. Jenny brings the lyrics to "Get up in Jesus's Name" handwritten on lined paper inside a plastic holder. The three of them sing in harmony, the piano left unplayed.

Get up, get up, get up in Jesus's name
The Lord is calling daily to those who would be saved

Don't go down defeated while victory's here to claim
Get up, get up, get up in Jesus's name
Oh at the gate called beautiful, they're laid out in the street
A poor and lowly beggar who was crippled in his feet
As John and Peter passed him, they saw his need was bad
Well they had no gold or silver, but they gave him what they had

The rest of the congregation stands and sways, some singing along, others shouting amens and hallelujahs, as they hold their arms open and high.

Josh takes his turn, preaching from the pew rather than from the

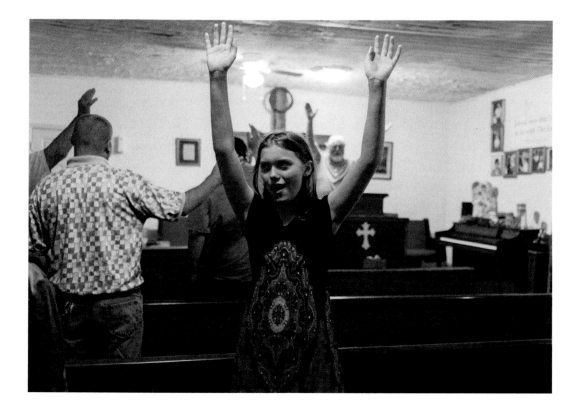

pulpit. Everyone watches as he riffs for twenty minutes, mixing Scripture with stories of his past.

"I used to drink all the time, until I discovered the Lord. Ain't never had a buzz like Jesus Christ.

"I been free from booze for fourteen years, so you can do it too.

"If you shake my hand in church, you will shake my hand outside in the world."

Josh and Jenny's children, thirteen and nine, each take a turn singing a song after reading speeches handwritten on lined paper. They thank God, their parents, and the church, after their nerves are calmed by hugs as they walk to the pulpit.

The service ends with a collection of women singing up front while an older man walks around the church calling out Scripture like an auctioneer, his last audible line being, "There is a despair that lurks within us all, that fills the world beyond the Bible."

When the song is done, everyone hugs and shakes hands, then goes outside to smoke while cars swoosh by in the late-summer twilight.

I join Josh and Jenny for a smoke, and they tell me straight up that they have nothing beyond their children and their faith in Jesus Christ. They are poor and have no shame or guilt in this. They don't have a car and needed a friend to drive them the long distance to the church.

Josh receives a disability check for seizures, and Jenny stays home to raise their two daughters. She talks about past drug use, their poverty, and her own childhood. "I was raised poor. Dirt poor. Really, really dirt poor. I did drugs and quit that a while back. The church has been essential in doing so. Why drugs? I guess it is partly because I was beaten a lot growing up by a grandmother who was a mean woman. She hit me all the time, even once with a chicken. Really. She whooped me upside the head with a chicken she had in her hand. Having been raised that way I got no patience for hittin' children. We are strict with our two, but

we love them to death. That is why we bring them to church and why church is so important to us."

She talks about how the children get teased at school for being poor and how the church has helped them deal with that.

The two girls keep asking me questions, about where I am from and why I am there. When I tell them I am from New York City, they get excited and ask question after question and say how much they want to visit New York. The older daughter says she wants to be a singer and maybe go to college there. I tell her about Juilliard and other schools that train singers. She gets more excited and pesters her mom, who reminds her, "Honey, you know we don't got money for that."

Coping

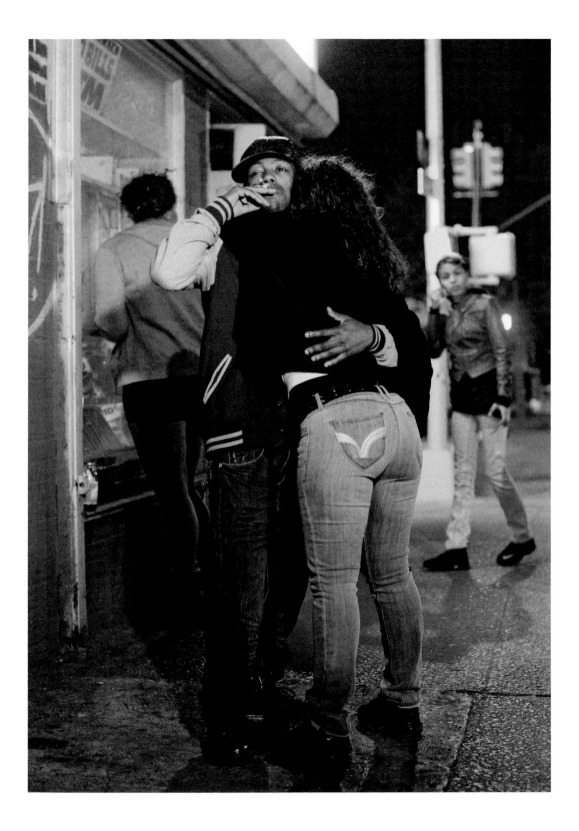

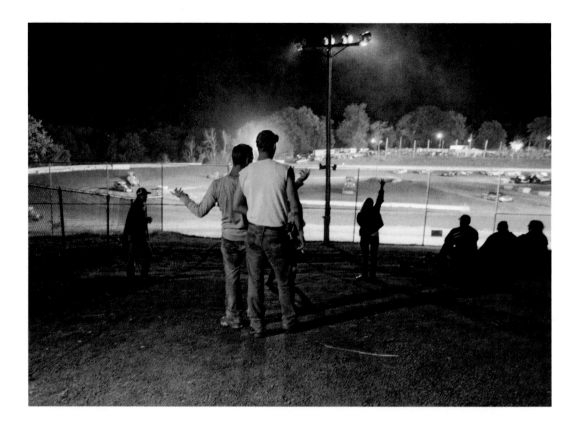

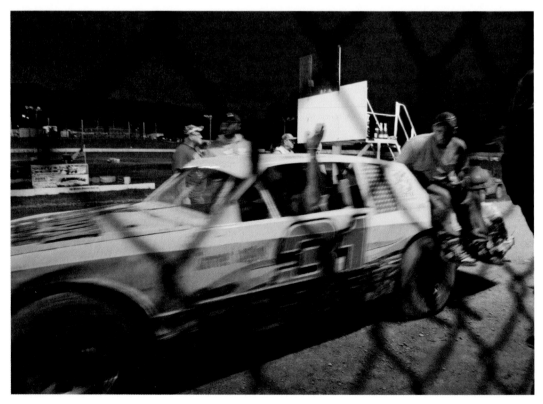

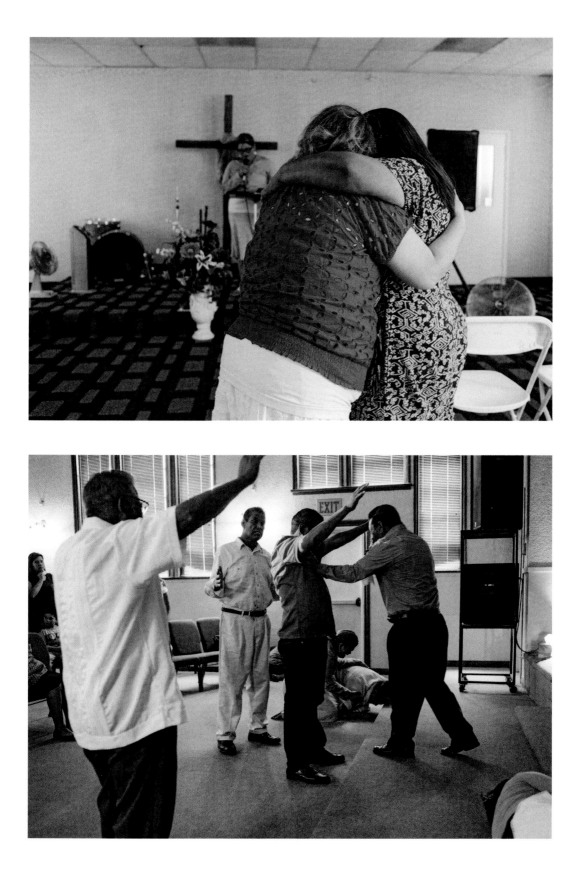

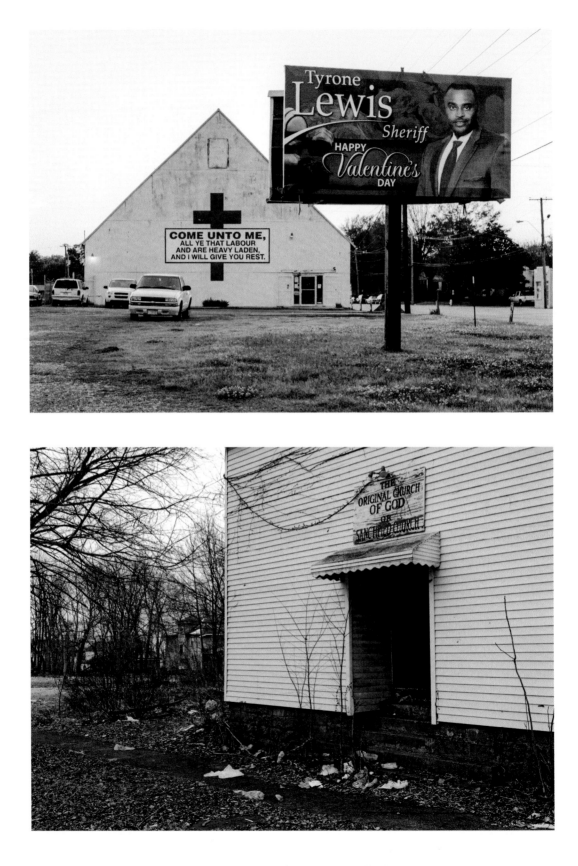

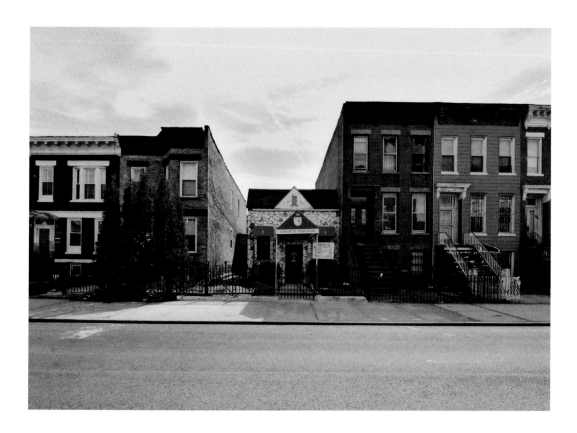

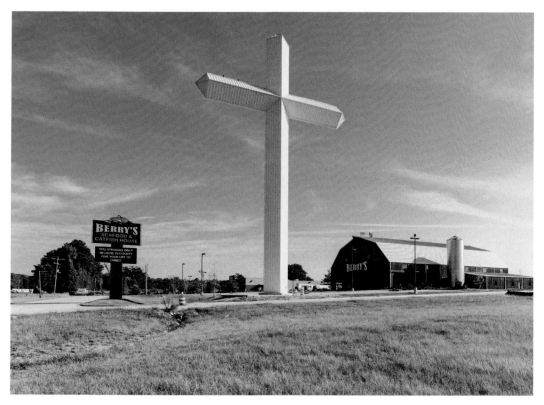

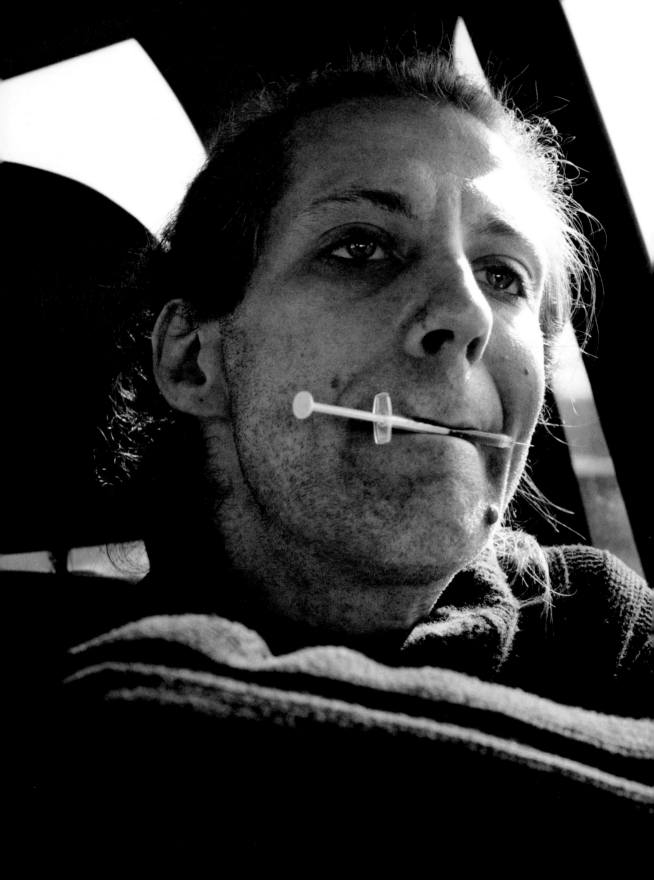

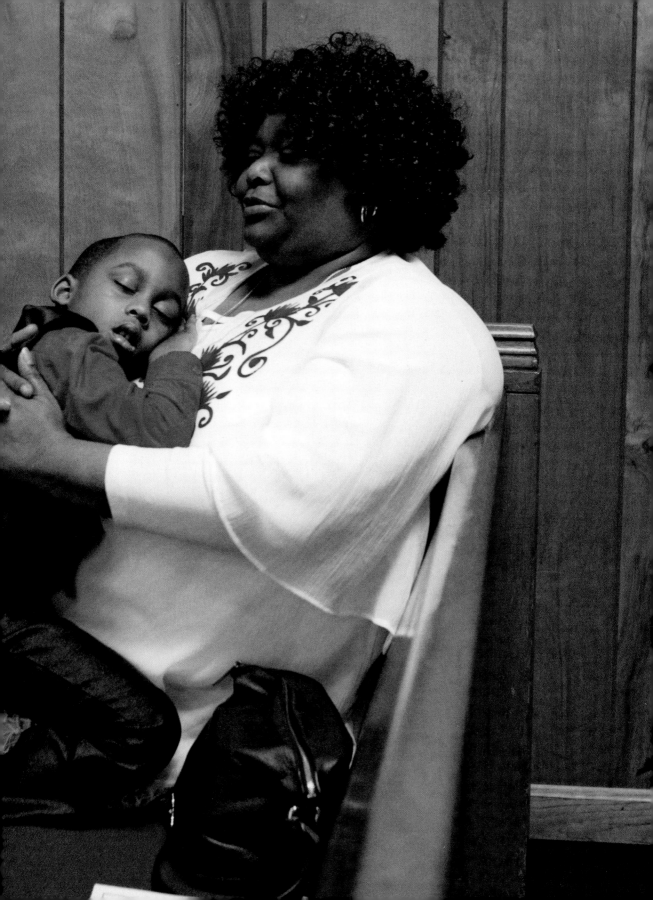

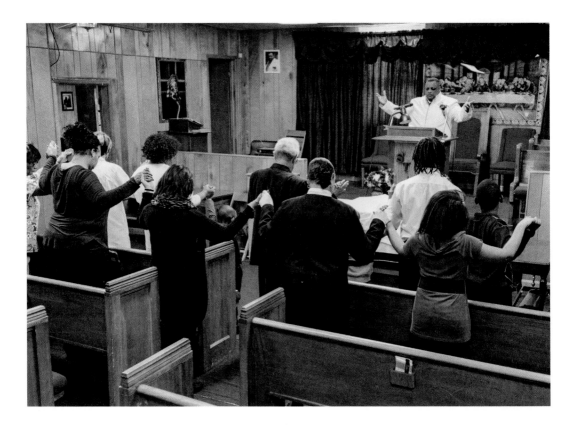

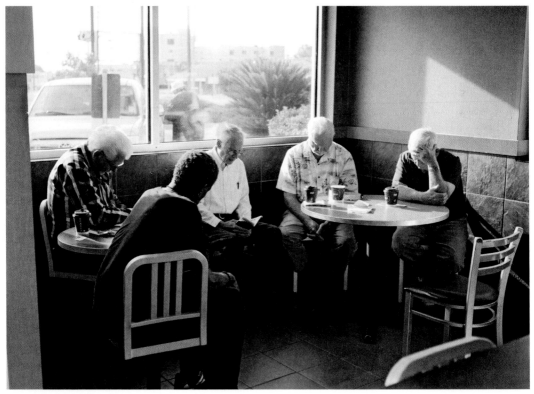

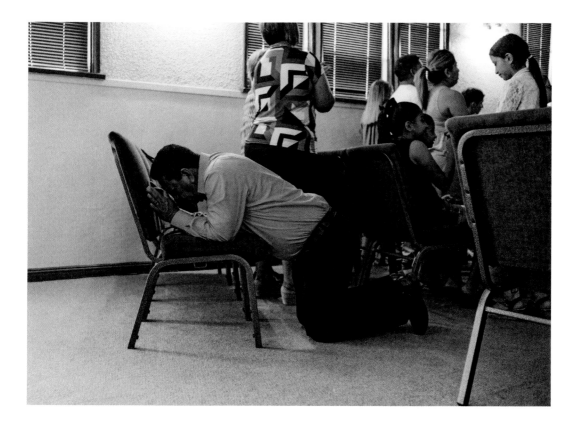

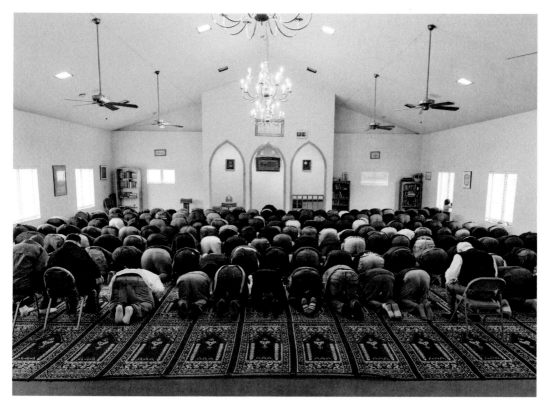

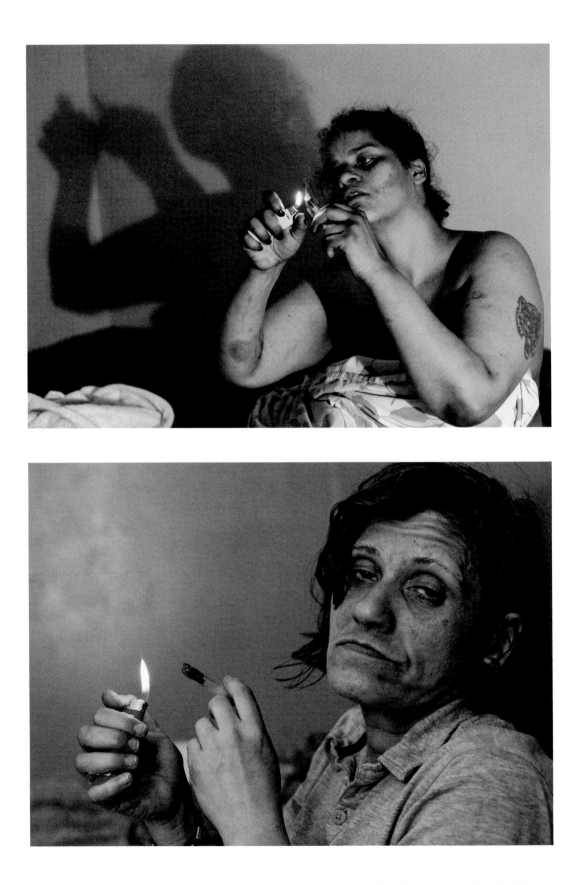

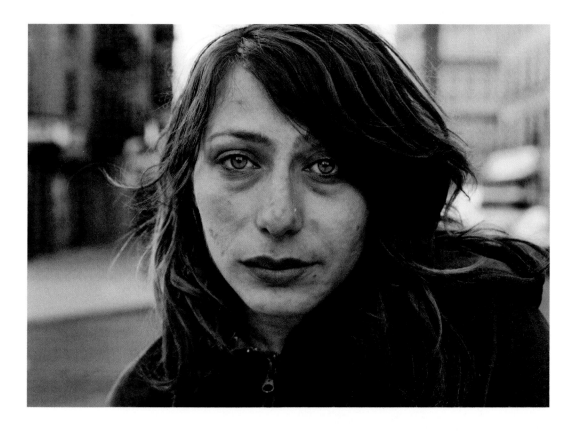

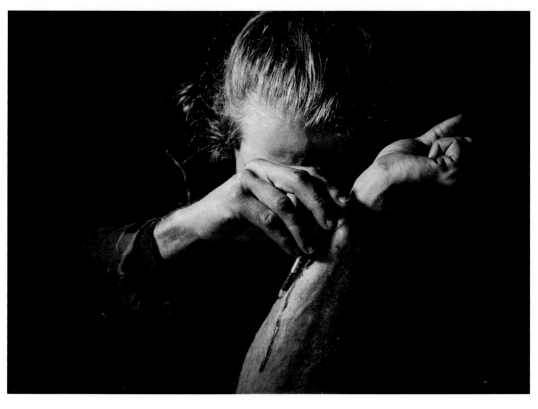

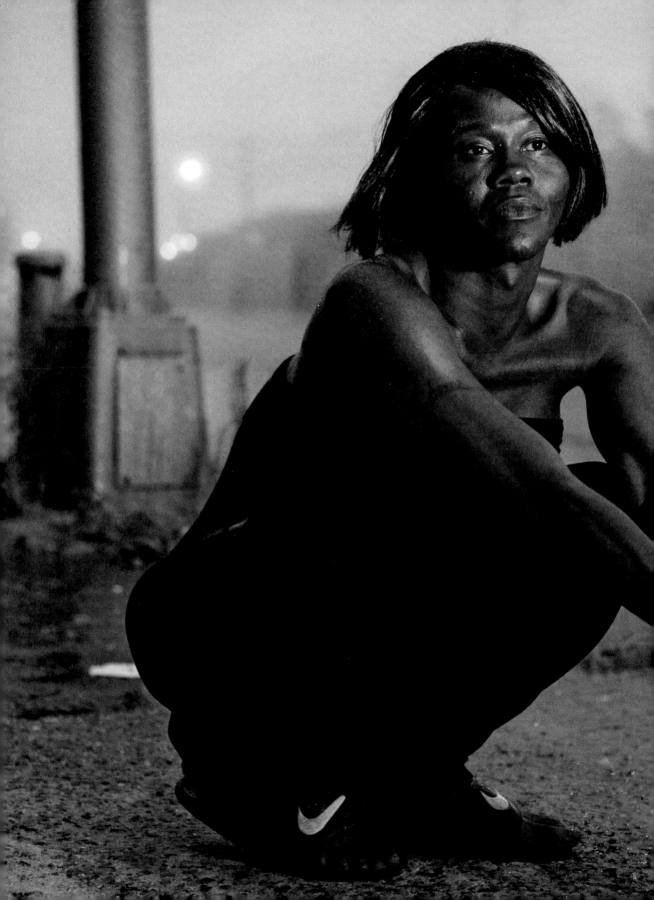

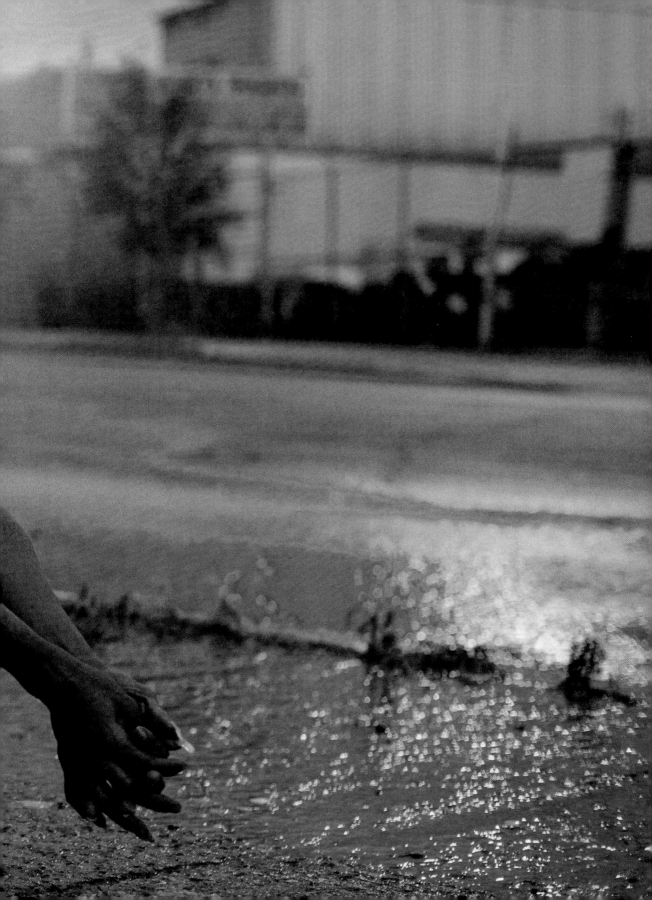

FOUR

This Is My Home

Cairo is at the southern end of Illinois, on a stretch of land between the intersecting Mississippi and Ohio Rivers. It is a small, mostly African American town on the end of a long decline.

Cairo has no hotels. The closest Walmart is more than forty miles away, something all the remaining residents will tell you. For shopping it has two Dollar Generals and two small convenience stores selling a selection of milk, snacks, lotto tickets, frozen pizza, liquor, beer, blunts, and vape supplies.

The closest McDonald's is fifteen miles away, over the Mississippi River in Charleston, Missouri, a small town that has fought the surrounding decline despite losing most of its factories. Charleston hasn't

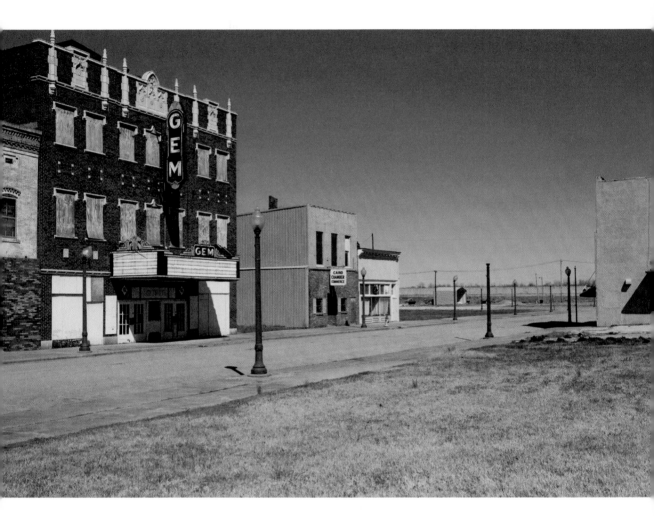

grown, but it hasn't shrunk either. It has gotten older, with many kids having left for other places. When I enter it, I meet three older regulars sitting, sipping coffee, reminiscing.

"We used to make things in this town, like shoes and rubber. Those factories—Brown Shoe, Gates Rubber, and Stark Manufacturing—all

left for Mexico in the nineties. Our national government allowed factories to leave. You used to get jobs right out of high school in them. You couldn't get rich from them, but they gave you enough to build a family.

"We used to have a Walmart here, but that closed up. Now we have to drive twenty miles to get to the one over in Sikeston. At least we got the Flying J to bring in trucks."

I went to Cairo to try to understand the long history of frustrations and wrongs endured by the blacks there that culminated in protests following the death of a young black man in police custody in '67.

I expected to hear a lot about those wrongs in Cairo from the black residents, but I don't. Those left in Cairo are focused on the present and trying to get by, to be able to live in the place where they grew up.

Getting by in Cairo is tough. Walking around feels like surveying the damage long after a natural disaster. Entire neighborhoods are just grids of boarded-up buildings being overtaken by vines and shrubs, empty lots, and empty streets, although the town is oddly orderly. The empty lots are mostly free of garbage and not overrun with growth, the streets, street signs, and stoplights are all in order and working. There isn't much trash because there is nobody left to litter.

There are plenty of reminders of what once was. An old hospital occupies an entire section of town, its decaying mass almost mocking the town that remains. A resident walking past, heading toward the assisted-living center across the street, shouts a warning: "Don't get too close to that! It is filled with poisons."

The downtown is a single street in a large field lined with boarded-

up buildings. Fake traditional-style lampposts, brick streets, and a wrought-iron archway proclaiming, "Historic Downtown Cairo," are from past attempts to revive and market it.

The single brick street ends in a floodwall along the Ohio. Behind the wall, Tom, fifty-six, is sitting next to his truck, watching the barges head down the river. He is the only white person I have seen, and he eyes me with caution. "I really shouldn't be talking to a stranger. This town isn't safe that way. Didn't used to be like it is now. People with money all left. Like a ghost town now. Like a ghost town."

Despite his concerns, he opens up and talks for close to an hour, reminiscing about Cairo and how it used to be: "Kay-ro used to be something. We had a drive-in. We had clubs. We had businesses. We had stores. We had shops. It has two rivers but can't do a thing with them, because nobody wants to invest money in this town.

"You go thirty miles in any direction from here, go to Paducah, Sikeston, or Cape Girardeau, they are thriving. All three of them have Walmarts. So to get anything you have to go thirty miles there and thirty miles back."

When I ask if he remembers the protest, he changes my wording to "riots": "Businesses all left after the riots. I remember them marching and the boycotts and then the National Guard came. Then businesses left and now there are no food stores or no gas stations."

He goes into the cab of his truck and finds a postcard he keeps in a glove compartment jammed with tools. "This picture is from 1927, when Cairo was something." When I ask him why he hasn't left, he says, "I had a good job, drove a forklift for thirty-five years, and didn't see the need to leave my home."

I walk for close to an hour without seeing anyone else. Eventually I spot a man walking down the street smoking a cigarette in a neighborhood of beautiful Victorian homes with nobody in them.

He is polite, soft spoken, and smells of drink. He was born and raised in Cairo but left town "for a woman" before coming back for his family. "Most of Kay-ro is family. I am related to most everyone here."

When I ask about his past, he mentions working odd jobs for money, and a stint in prison. "I got shot four years ago. Got robbed. Gangs did it to me; that slowed me down a bit."

> ME: You used to do drugs?
> HIM: Yes, everyone around these parts does.
> ME: What types?
> HIM: Crack.
> ME: Cairo doesn't seem like a big drug town. I don't see needles or vials.
> HIM: This ain't a vial town.
> ME: When did you start with drugs?
> HIM: When I was twenty-one.
> ME: When did you stop?
> HIM: Shit. I am still on it. Right now!

Up the street is one of the few busy parts of Cairo, a HUD-run housing complex from the fifties, a place I recognize from the protests, when shots were fired into it at the protestors. It is the only place in town where you see activity, beyond the gas station. As I get out of my car to take pictures, a man approaches me, and asks, "You from the Housing Authority?"

> ME: No. I am a photographer and writer and—
> HIM: You here to write about the problems with these buildings? We could use some attention.

ME: Not explicitly, I am here to—

HIM: Damn. These building are falling down.

ME: They look well kept.

HIM: Come live in them. They ain't well kept. They are old and their foundations are rotten.

ME: I didn't mean no disrespect—

HIM: That is OK. Just we been waiting and waiting on housing authority to show up.

He goes back into his apartment, and as I walk away, another man, backing up in an old car down the block, yells at me from the passenger seat: "WHAT ARE YOU DOING HERE! WHO ARE YOU?"

I walk toward his car, explaining that I'm a photographer, but he interrupts me.

HIM: I ASKED, WHO ARE YOU! WHAT IS YOUR FUCKING NAME?

ME: Chris Arnade.

I reach his car. He is a young teen being driven by an older woman. I offer my hand. He stares at me.

HIM: Are you Sean Michael Smith?

ME: No. Who is he?

HIM: FBI agent who been coming around these parts.

ME: No, I am not that.

HIM: You sure? You look like Sean Michael Smith.

ME: I am sure. I can show you my driver's license.

HIM: You look like Sean Michael Smith.

ME: I am not.

As the car moves away, he hangs his head out the window. "Well if you a white guy coming around the hood, you gonna draw attention. What is your name again?"

Shambrae, twenty-five, stands by. After the car rounds a bend she comes up to me. "Don't worry about him. He is on drugs."

I ask her about the buildings, and she shrugs, "I ain't from around here. I didn't grow up here. I come from the north side of town, not these here projects."

> ME: But you are from Cairo?
> HER: Yes, the north side of town, not these projects.
> ME: Do you like Cairo?
> HER: It is home, I love it. I might dislike some things, but this is the only thing I know.
> ME: What do you do now?
> HER: I go to night school. I didn't finish high school. I got pregnant at sixteen. Hard to finish school once you got a child. Now I got two, one eight and one three.

She sits quiet for a few moments, then lets loose with a poetic rant, more sung than spoken: "We are a town with a lot of hopelessness, lot of sorrow, lot of despair, lot of pain. But we are good people, smart people, who could show that if we had opportunity. We can be productive, but there is no grocery store, no gas station, no resource center. Nothing is here. We have to go out, travel to do anything. To get groceries, to get gas, to go to school, anything."

I tell her that was powerful and that she should write it down.

She smiles.

"Well, I am going to school. I am getting my welding degree at Shawnee Community College, the only girl in the program."

I congratulate her and ask if she'll leave when she graduates.

She says, "I want to stay. If there are jobs. Because Cairo is my home."

The busiest store is the corner bodega—with most of the business coming from selling Hunt Brother pizza, wings, lotto tickets, and liquor. The bodega owner, Khalid, came from Tennessee two years ago at the suggestion of a relative. "Most people here are family and related. I have never had a problem here. People said I was crazy to come here. Everyone has been nice and friendly."

Inside, Coco, twenty-nine, is holding her niece, picking up milk. She was born and raised in Cairo but moved to Detroit to stay with a grandmother after her mother died. A year ago, she moved back. She makes money "doing hair. There really are no jobs in Kay-ro. You have to go outside for work."

I ask her why she came back.

"No matter where I go, I come back to Kay-ro. It is one thing to jump up and leave, but you got to be ready to pay a lot, and I don't have a lot. You also got to be ready to miss your home and your family. I guess I am just not ready."

Marva, forty-seven, comes to pick up a pizza for her lunch break, and while waiting, she chats with those who come in. She works at the local school, which serves all grades, and knows almost everyone in the town. She was born in Cairo, and despite the decline, she has stayed, living a few miles north in a small section named Future City for growth that never came.

I ask why she stayed.

"Kay-ro is my home. It is a small community, and it is my family. You can't just abandon people you grow up with. You know what they say: 'There is no place like home.' But there is a lot to improve. But it

is my home. When you don't have anything else all you got is your home."

I never intended to stay in my hometown and rarely remember feeling, except when I was very young, like it was my home. I always knew I would leave as soon as I could, and I did so after high school to go to a state college two hours away. It wasn't far, but I never imagined a future that included my hometown beyond summer work or holidays.

I was the youngest of seven, and all my siblings left, although most stuck around longer than I did. We all had good childhoods in our town, all had close friends growing up, all joined in where best we could (sports, religion, drinking, and drugs), but it was easy for us to leave for college. My parents moved to our small town in 1961, and this, their education, and their politics made us outsiders. Most around us had local roots going back generations, few had parents with higher education, and beyond the black community, few actively supported civil rights.

It was our home, but we didn't have to like it. We also had options and expectations most didn't.

Few in my high school were expected to go to college, and few had the resources or information necessary if they had wanted to go. For them, the military was the way out. Those who went to college were expected to return to support their family or work in their business or farm.

So most people stayed in town and built a life there and when I came back each holiday, which I did until my parents moved in 2008, I rarely

saw the town change, rarely saw people leave, rarely saw new faces beyond children. Each time I was reminded it was odd that I had left so easily and early.

In my new life, in the front row of the front row, it wasn't odd at all that I had left. Here most everyone had moved multiple times and moved again for the right opportunity. Here many had grown up feeling like an outsider, stigmatized because of their political views, social views, or lifestyle. All had moved to focus on their education and find an environment less judgmental of them and their views. Here everyone was about their careers and how they saw themselves. Few rarely said where they were from, beyond what college or grad school they attended. Place was just a temporary step in a process.

I was part of a global group of lawyers, bankers, business people, and professors who are their profession first and a New Yorker, Brit, or Southerner second. They are as comfortable in New York City as they are in London or Paris or São Paulo or Hong Kong. Well, in the right neighborhoods in each.

In their minds, staying put is a mistake. If you stay, you limit your career, you limit your wealth, and you limit your intellectual growth. They also don't fully understand the value of place because like religion, it is hard to measure. What is the value of staying near the family that raised you or in the valley where you were born?

Had I asked those in my hometown when I visited why they stayed, why they were still there, I would have gotten the answer I heard from Cairo, to Amarillo, to rural Ohio. They would have looked at me like I was crazy, then said, "Because it is my home."

It is an answer that is obvious, because there is value in home, but it isn't just the value of the house or the yard. It is the connections, networks, friends, family, congregation, the Little League team, the usuals

at the hairdresser, regulars at the bar, the union hall, the crew at the vape store, the regulars at the half-price movie night, the guys for Tuesday night basketball.

The front row doesn't fully get that because they don't see that value, and like me, they moved before and they will probably move again. We have broken our connections and built new ones. If we can do it, so can anyone else, we think.

When communities and towns are destroyed, partly because of the front row's policies of globalization, the front row solution is, "Well, just move." Buffalo is dying, so just leave Buffalo. Or Appalachia or the Rust Belt or Texas or Ohio or wherever they see suffering. It doesn't matter where people work, where they live, or where they raise a family. If a factory moves and a town dies, then workers can just move.

Never mind that place, family, and friends are often the only network many people have, the only community that provides them a vital role, because what matters is growth at all cost—even if it is brutal—and that requires everyone to always be economic migrants.

The front row likes to say that the US is a country of migrants, where people have long moved for jobs. This has been done before—the dust bowl, the northern migration of African Americans. Yet those were a reaction to failure, not a sign of success.

Jim and Randy are sitting in the corner of a rural Ohio McDonald's. There isn't much of a town around, just gas stations, a dollar store, and a few franchises near an interstate exit. Unlike Cairo, there never was much of a town around, just a few villages connected by

state and county roads. The interstate brought what little growth there has been.

Both are retired (machinist and truck driver, respectively), both come each morning to have coffee and gossip, and both have spent their entire life in this county, although both correct me when I am writing down their particular details.

"So you were born and raised here," I say.

"No, I am not really from here. I was born five miles south of here, just beyond the fairgrounds. I moved up here to marry the fire chief's daughter, and this is where I been since."

"So your parents are also from here."

"No, my parents are from fifteen miles from here."

When I ask them why they stayed all their lives so close to where they were born, they answer quickly and then look at me like it is a crazy question. Neither is impolite, or rude, just confused because the answer is obvious.

"This is where I am from," says Randy.

"This is my home," Jim says.

Jim sees I don't fully get it and adds, "I didn't want to leave. I wanted this." He gestures toward the surrounding area. "Being able to see people I was born with every day and staying close to my family. I live on land where my two grown boys and their families live just nine hundred feet from me. My grandkids are only nine hundred feet away. I can see them every day, and do. What more could you ask for?"

In an Amarillo, Texas, McDonald's, Frank, eighty, sits with a group of morning regulars. The surrounding neighborhood of trailers, small brick homes, and long streets of fast-food franchises, car washes, liquor stores, and auto body shops is diverse, and the table reflects that: Frank is Mexican American and the other two regulars are an African Ameri-

can man and a white man. All three were born and raised in Amarillo, and all have spent their entire lives here.

Their conversation is focused on local events—the death in a car crash of a man they knew, city elections, and talk about friends and family. While the other two men debate politics, Frank removes himself to talk to me.

He tells me that he grew up right near this McDonald's, without a father, his mother raising seven or eight kids, including him.

> ME: Seven or eight?
>
> HIM: I am not sure of the exact number. Our home life was complicated, lots of relatives, uncles and aunts and half brothers and all that.
>
> ME: What did your mom do for money?
>
> HIM: Worked sometimes. She was on welfare at other times. We got help from relatives now and then. I had a grandfather who worked on the railroads. He helped out. I also stayed with uncles, cousins, aunts at various times.

Frank mentions a lifetime of hard work, something he is clearly proud of.

> ME: When did you start working?
>
> HIM: Shit. When I was fourteen I was working. I have always been working.
>
> ME: Did you finish high school?
>
> HIM: Hell no. I quit when I was in third grade. Didn't think I needed an education. I have learned what I needed to

learn by self-learning and I made a life of working, building things. I got this curiosity for how things work. Like grain elevators. By nineteen I was climbing up them to fix them and hanging off them by ropes and made a living working on them. Ended up with my own construction company.

Besides work, Frank focuses on raising a family of four kids, all who he made sure got the education he didn't. "If you don't have a college education now, you ain't worth a damn. That is at least what they tell you these days. I am not sure it is right that way. I think all these college people are going to outsmart themselves. They think they understand it all, but they are just making life more complicated."

I ask him the question I already know the answer to. "Why have you stayed here?"

He shoots back without any pause, "Too many ties here, and it is as good a place as you can find."

"Do you like it here?"

"Hell, I was born here. Have to like it. It is home."

Not all the young people in the towns I visited were enthusiastic about their homes. Many wanted to leave, either to get an education or relocate permanently, but leaving isn't always as simple as the front row thinks.

Moving is expensive, physically and emotionally, requiring money and information many don't have. It requires having knowledge of big things and small things. You have to know which schools to apply to, which scholarships are available, which internships to get, how to write

the proper essay, how to navigate a new city, how to dress "properly," how to speak "properly." It requires years of learning a new culture that comes with wealth and education.

It also requires leaving behind family obligations, something many kids can't or don't want to do. Especially those from the back row, who early on are burdened with the problems and obligations of an adult.

In Amarillo, Julio, twenty-one, is with his parents on a quiet and poor street outside his aunt's trailer. He had driven sixty miles from his small hometown to bring his parents to the doctor and visit his aunt. "She doesn't speak any English, and her son is in jail."

Back in his hometown Julio works on a ranch, mostly with the cattle, coming to Amarillo only a few times a month. He prefers his hometown ("Amarillo is too big") but still wants to move.

"It is too hot, and other than work and family, there isn't much for me. I have friends in Oregon and Washington. I would like to go there."

I ask him why he can't go, and he mentions his older parents' health, "They adopted me when I was a baby because I was born to a mother too young to raise me. I don't keep up with her. I hear she lives in Houston. Or maybe it is Dallas."

"What about college?" I ask.

"I thought of going, but I had to help out around the house and take care of my parents. I would like to go someday, maybe become a herbacologist. Study plants. There is another word for it. I don't know what it is."

"Biologist?"

"Yes. That is the word. Me and plants go hand and hand. I am happiest when I am working with them and getting my hands in the dirt."

I ask if he has considered night school, and he points out the closest one is forty miles away, then adds, "I also spend lots of the night helping out my parents with chores and making sure they are OK. I am gonna be here until my parents are gone. Then I will do my own thing."

In Reno, Nevada, Andrew, nineteen, is sitting in the otherwise empty rec center of the local community college, studying for a summer midterm. He has "one full brother and six half siblings." Both he and his brother are the first in his family to go to college.

Andrew's mom, a waitress at one of the casinos, raised them by herself, and she is the reason he is staying, "She worked her whole life for me and my brother. For me to provide for her is the biggest thing in my life. That means I have to be here."

Being close by is especially important for Andrew because his mom is sober after years of addiction. "There were times when we wouldn't see my mom for weeks. She would be on a bender, messed up in the lifestyle, and me and my brother had to raise ourselves and do things for ourselves. I was just never tempted. I could see how bad it was."

"How bad was your mom?" I ask.

"She was real bad. She has been sober for seven years. She cleaned it up."

He pauses then talks about the past. "There was this one time when my father was with his friends, messed up on the couch, and my mom was in jail and my grandma came over to the house to check on us, and her and my father got into a fight. He threw her down the stairs, and they were yelling, and he was hitting her, and me and my brother ran outside to hide. We were, like, ten. I will never forget that."

I ask if police got involved, and he shoots back without pause, "No. You can't call the police on your family. It never crossed my mind. People who don't live through this won't understand that. They just won't."

"What about people who left for bigger colleges who never went through this. Do they frustrate you?"

"I need to choose my words carefully," he says. "I don't get frustrated much, but people shouldn't be able to judge you if they have never been through experiences like that."

I ask him again if he's staying in Reno.

"I wouldn't go out of state. Only reason my mother is clean now is me and my brother's support. We are here for her. If I could leave here I would, but I can't. When I get to a point where I can move and bring her, then maybe I will move."

Crystal, thirty-six, goes to the same community college as Andrew and is also the first in her extended family to go to college. "Just me, nobody else, not even cousins."

This is her second year in college, a choice she made after years working in retail and warehouses. "There was a period of time, starting about 2009, that I just couldn't get a job. For nothing. Not McDonald's, not Walmart. I just had to get an education."

Like Andrew, she is staying in Reno for family, though in her case for her father, who raised her alone, "My dad is my hero. Best person I ever met. I got three brothers and sisters and he did everything for us." She has been in Reno all her life, except for one attempt to move to Idaho.

"As soon as I got there I had to come back. I got homesick. My dad wasn't there, and I need him. Not that I was reliant on his support to pay the bills, I am not, but I just wasn't around him. I couldn't talk to him. I couldn't just drive over and get a hug. I also worried about him."

Viewed from a distance, Crystal's and Andrew's decisions to stay and attend a small community college don't make much sense. Everyone is supposed to want the best education to make the best career. That is the message everyone hears, and it is how we reward people. We repeat over and over, "Get the best education you can, go to the best school you can." Yet do we really want to be a society that stigmatizes a daughter or son who stays to help their parents?

It is more than just the emotional and physical obligations of family that make it harder for children from back row towns to move. It is also about their sense of identity. Leaving for college or to live in another town means giving up a part of who you are. Going to college means becoming a different person, and many kids understand that and want that. Like I did, and like so many people I met at college and grad school and in my career did. We didn't necessarily fit in with the community we were born into, and the community didn't value our choices and our identity. For us, leaving, if we could do it, made sense.

For others, who feel at home where they are born, it is harder. Moving for college or work means becoming detached from their old identity. It is an especially hard choice for those living in towns struggling and labeled failures. Part of their identity has become intertwined with failure, adding another level of stigma for staying. Even though corrupted and stigmatized, that identity is all some have.

Moving would mean destroying their identity and breaking their support system of family and friends. Their happiness would be reduced. The few good things they have going for them, things that don't cost money, would disappear.

Mountain Grove, in the Ozarks, is big enough to have a Walmart and a McDonald's but too small to have a college, although there are courses offered at the Missouri State extended campus—a ranch-style trailer offering mostly online classes.

The town is off US Highway 60, and what energy and buzz is in the town is at the cluster of strip malls, gas stations, and franchises near the exits. That is where the McDonald's and Walmart are, and both are almost always filled.

Unlike many smaller back row communities, the downtown doesn't feel defeated and deserted, although it isn't busy. A well-kept square park with a bandstand, historical markers, and a few statues is at the center. Local businesses surround the park, including an independent grocery store, a diner, and a health food store.

Inside the park toward evening a group of locals pulls out chairs and sits talking, drinking, and gossiping. They are there each night I am, and after the government buildings close, beyond them, there is hardly anyone downtown except the cars passing through or stopping at the grocery.

They flip between discussing who is currently doing what for work, or what type of drugs they are on, or who is going with who. A vehicle passing is almost always identified, bringing an "Oh that is X," and begins a conversation about their recent heart surgery, or their daughter's marriage, or the wonderful cookies they made at that bake sale, or their house that was put up for sale despite their having plenty of money already, or about "their brother who was gonna jump me but they didn't jump me," or about their "dirty truck and what dirty stupid music they are playing and what dirty stupid nasty people they are."

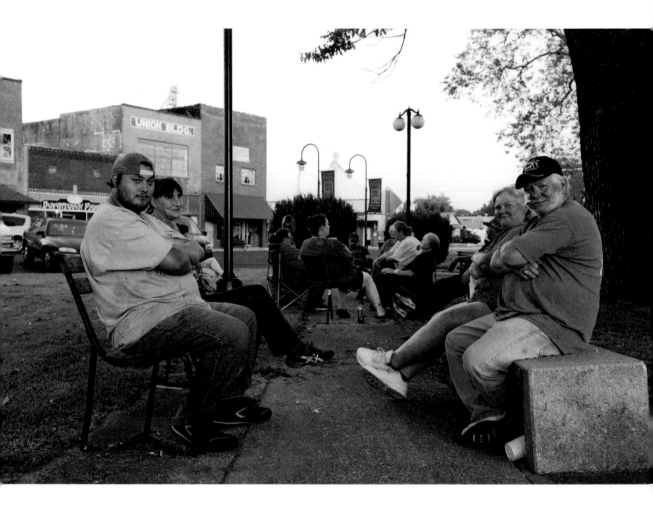

When I first come into the park and approach them, they eye me with suspicion, and when I tell them I am a writer from New York, they say, "Oh, you must be here to write about meth" or "You here for the drug stories?" or "You here about the killings?"

I explain that I am there to write about more than just drugs, although I have spent a great deal of time writing about addiction in the

Bronx. A man in a trucker cap with a bandage on his face tells me he used to drive to the Bronx for work, back in the day. "I drove trucks up to New York City. It is dangerous there. All sorts of crime. I saw a kid get beat up all over three dollars. Now I work at the chicken factory. That has a different type of danger."

When I ask if they all were born here, everyone says yes, although Ruth, fifty-six, makes sure I know she is from Freemont, an hour away, and has only been right here since 2004. "Most of my family comes from around here. I thought of joining the navy, but I didn't. People from around here pretty much stay here. I stayed mostly to take care of my parents. I never did finish high school."

She starts talking about drug use, including her own son's, who sits next to her. "I don't use drugs. Other than cigarettes. Never really even drink much. When I was young, we had things to do, like work. Didn't have time for drugs."

Her son, Curtis, smiles. He didn't finish high school either and is evasive about work or what he has done for work, if anything.

When I ask about his father, both get a sour look on their faces, and Curtis adds, "He was abusive and a drunk and a drug addict and was crazy. He spent some time in jail and eventually was committed. He hasn't been in my life since I was eight."

Curtis is currently clean, and like most currently clean, he is excited to talk about his past addiction, telling stories bordering on boasting. "I started early, at fifteen. People I was hanging out with was doing it. K2, drinkin', meth, heroin. Then I just got tired of it all. Saw what happened to my father and I quit."

I ask how long he's been clean, and he says three years. Then, after a pause, he amends his statement: "Well, I was clean for a year, then I started drinking again. Hard drinking. A cousin came to live with us,

and her daddy was all into drinking, and he got me into drinking, and I started with a beer, and then I started day drinking, and then I was drunk all the time. I quit that a year ago. Or six months."

I ask if there are jobs around, and he says no. I ask why he stayed.

"No other place feels like home."

Next to him, Tammy, fifty-five, holds a *Shrek the Third* DVD from the library, a bottle of Dr Thunder soda, and jumps in to say she wants to tell her story.

I ask if she is from around here, and she shoots back, "Of course."

ME: What did your parents do?

HER: They did a little bit of everything. Daddy died, Momma still alive. There are fourteen of us, just two of us kids are gone. One of us is in Wichita, the rest are around here.

ME: What did dad do for work?

HER: Jack of all trades. Raised pigs for money.

ME: What did you do for schooling?

HER: Finished high school. Didn't go to college. With that many kids couldn't afford no college. Then stayed around this stinking town. This town sucks.

ME: Why?

HER: I was raised here. It just sucks.

ME: Why stay?

HER: Haven't left because my family is here and my mom is in bad shape. I got to be by her to help.

A woman crosses the street, and everyone gets up and cheers as she approaches. She is jittery and tweaking and proudly yells, "I just got released from jail, motherfuckers!"

Off the park is a barbershop run by Dwain, seventy-four. He keeps the door open and spends much of the day sitting in his chair looking out toward the park. His shop is filled with pictures of family and customers, outdoor magazines, and a collection of antique Coke bottles and Coke signs. There is no phone or TV in it, because, Dwain explains, "when I had a phone here all the callers wanted to know if there is a wait, and I always tell them, just come down."

He does have a radio, which he uses to listen to local high school games, preferring them to the pros. "I prefer the high school teams because I know all them kids. I cut their hair as they grew up."

He was born not far from Mountain Grove, and beyond two years in Kansas City for barber school ("Didn't like it, too many people in KC."), he has spent his entire life here, most of it in his shop.

ME: Has this town changed?

HIM: Most shops went to the shopping centers. Used to be busier down here. When towns get a certain size, it moves to shopping centers.

ME: Are there jobs here?

HIM: You see any factories? There ain't no factories so there ain't no jobs.

ME: What about drugs?

HIM: Everyone knows someone who has suffered from drugs. I have some relatives who have. Some good friends who have. Ain't nobody exempt from the bullshit.

ME: You like it here?

HIM: I am the happiest man alive. I have three boys and four grandchildren. Just tickled to death. Rural living is

a different lifestyle. Who is happier? You have a family and a belly full and you are all set, that and Jesus in your life. Everything else is complications.

At the county fair at night I pass Dwain, who waves at me with a big smile. Next to the midway is a small rodeo, mostly for teenagers and FFA members from the local high schools. Around the arena is a small grandstand and a line of trucks filled with spectators.

In one of the trucks is a group of regulars from the park. I go up to say hi, and we talk about what I think of Mountain Grove. In the bed of the truck are two younger women, who when they hear I am a photog-

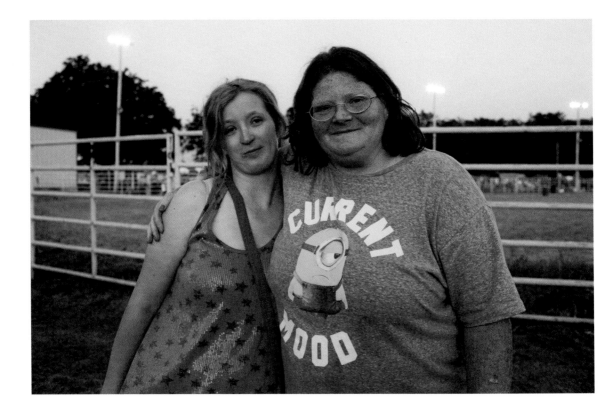

rapher from New York City writing a book, ask me to take their pic-
tures.

"We want to be in your book. We gonna be famous."

I ask if they'll leave the town if they get famous.

"No. Just build a big house here."

Desolation

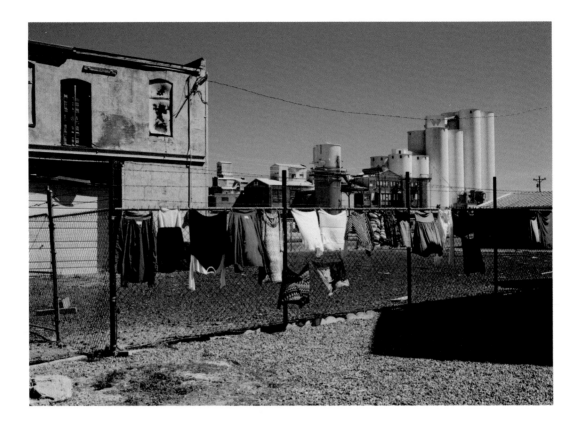

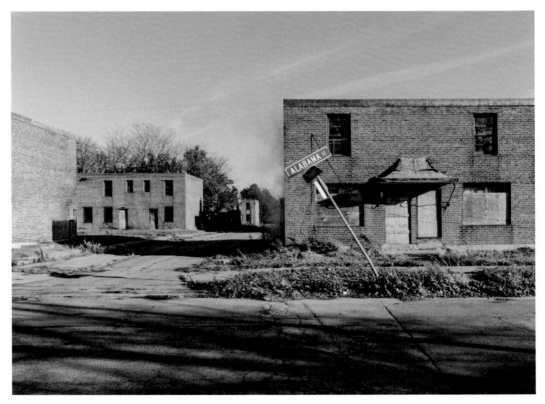

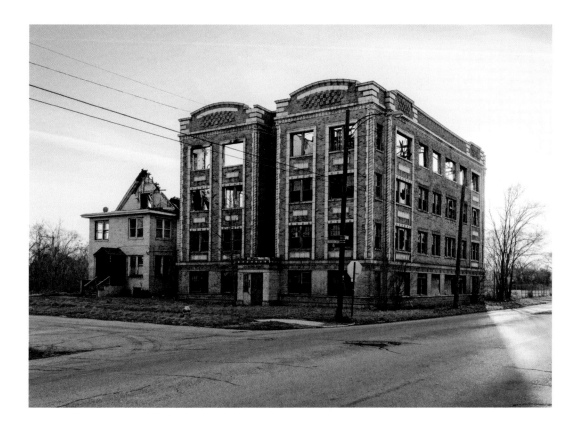

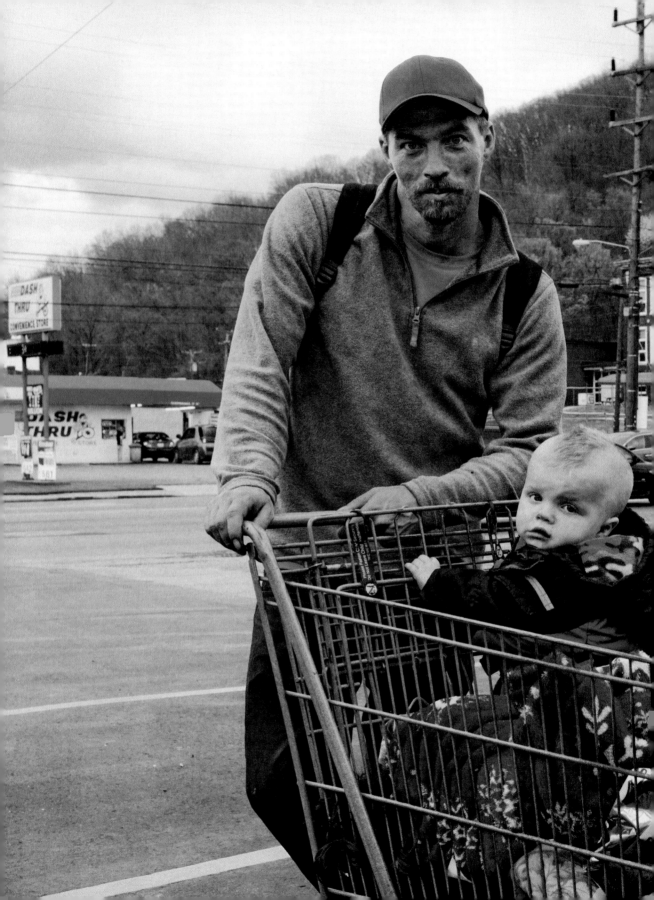

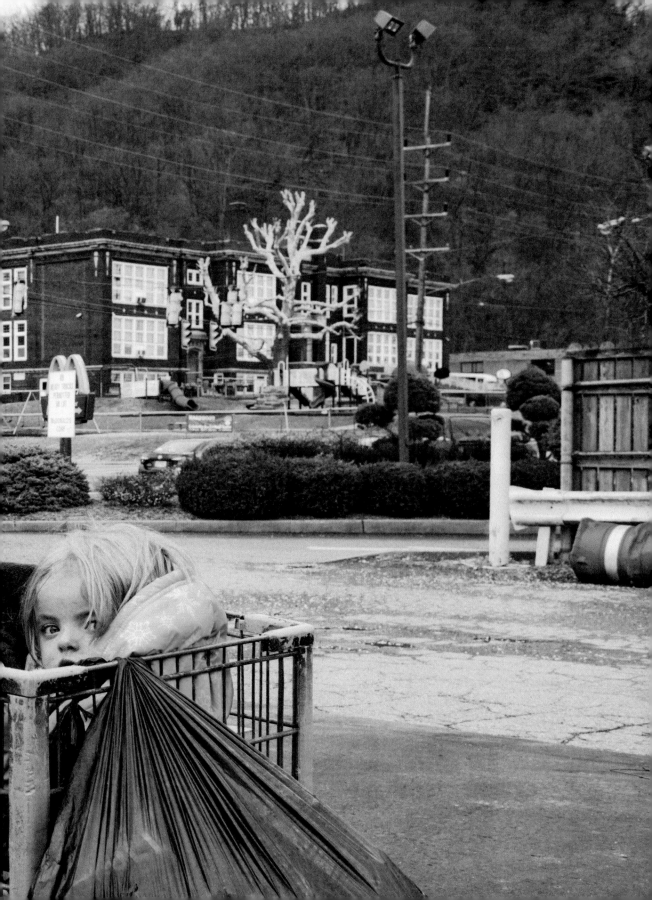

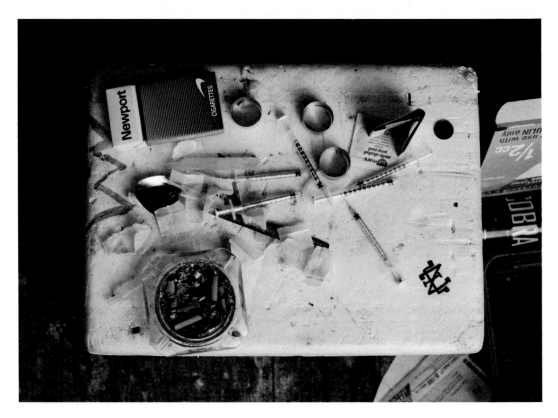

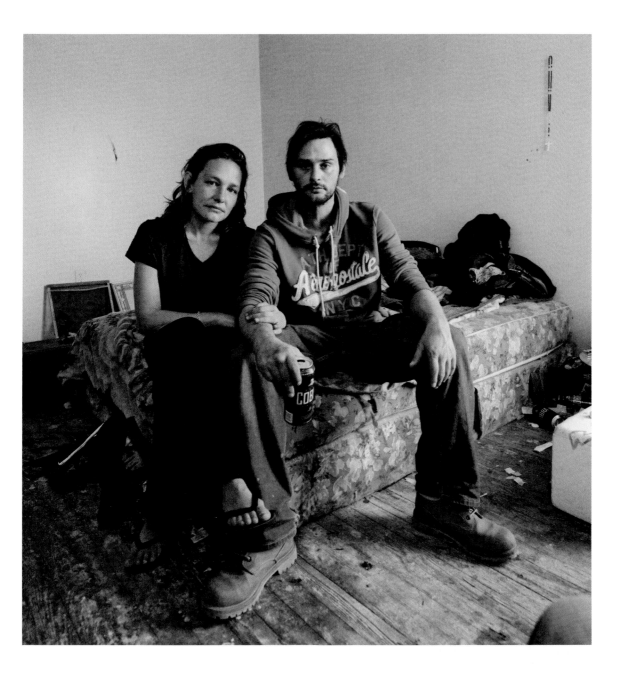

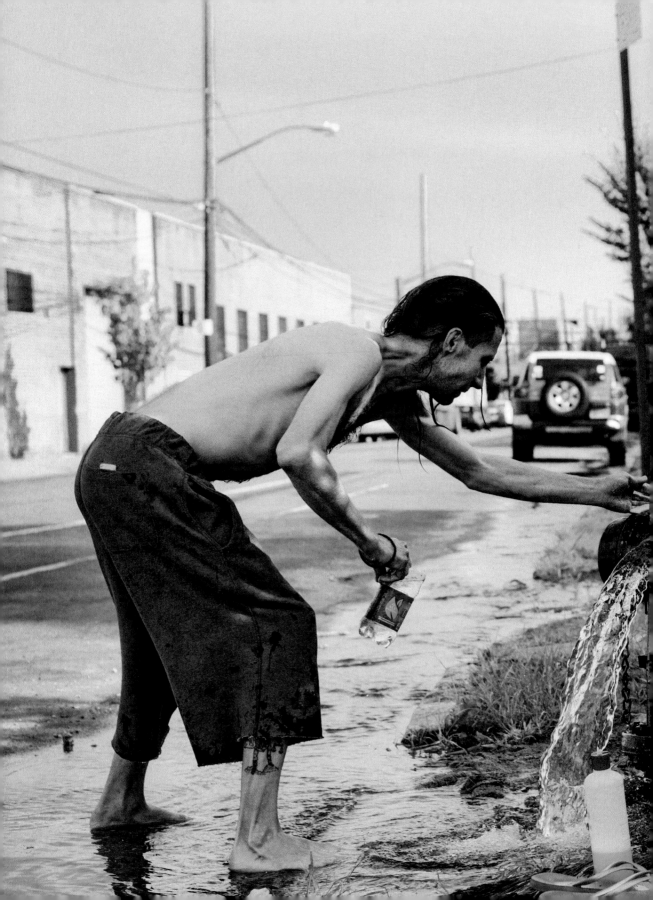

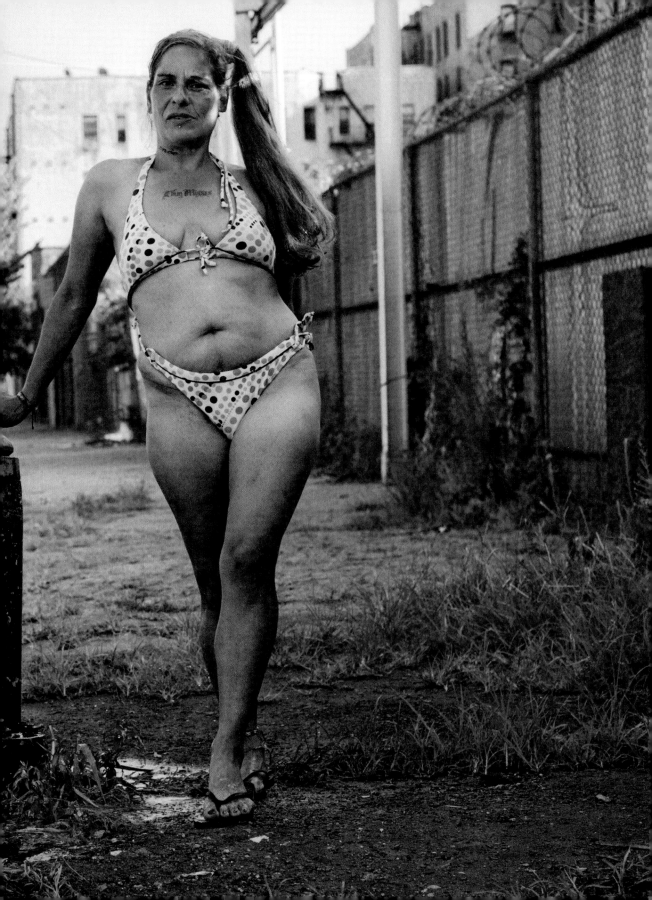

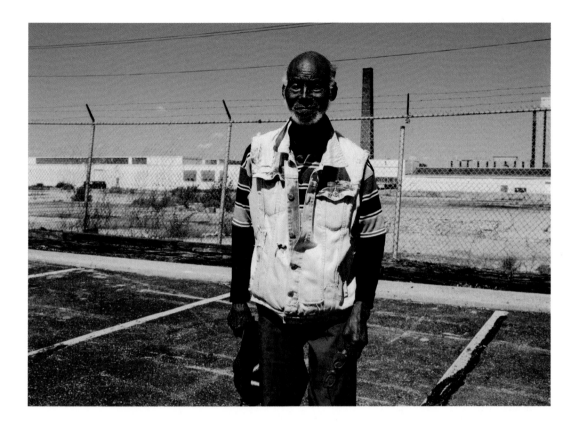

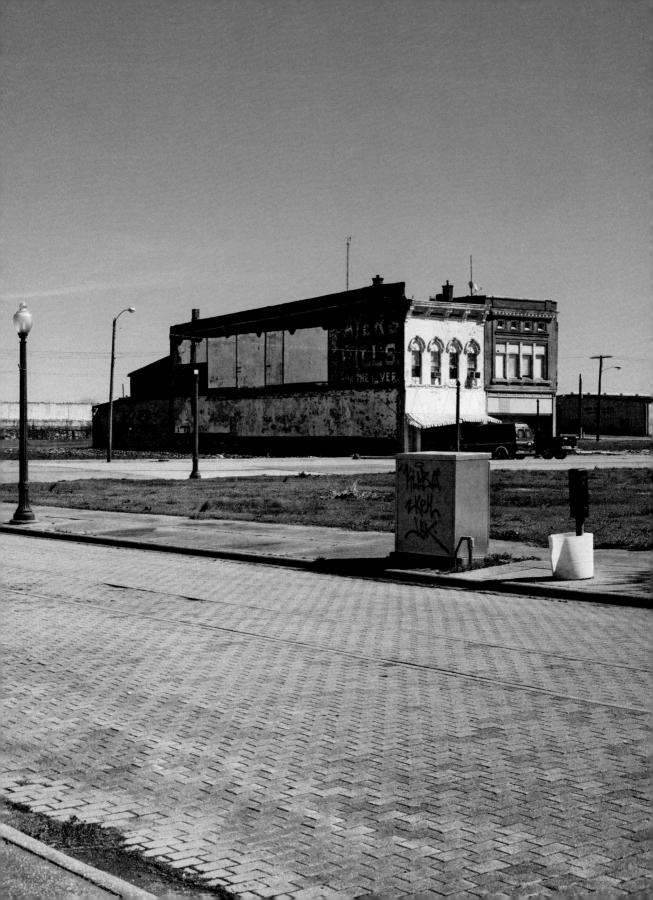

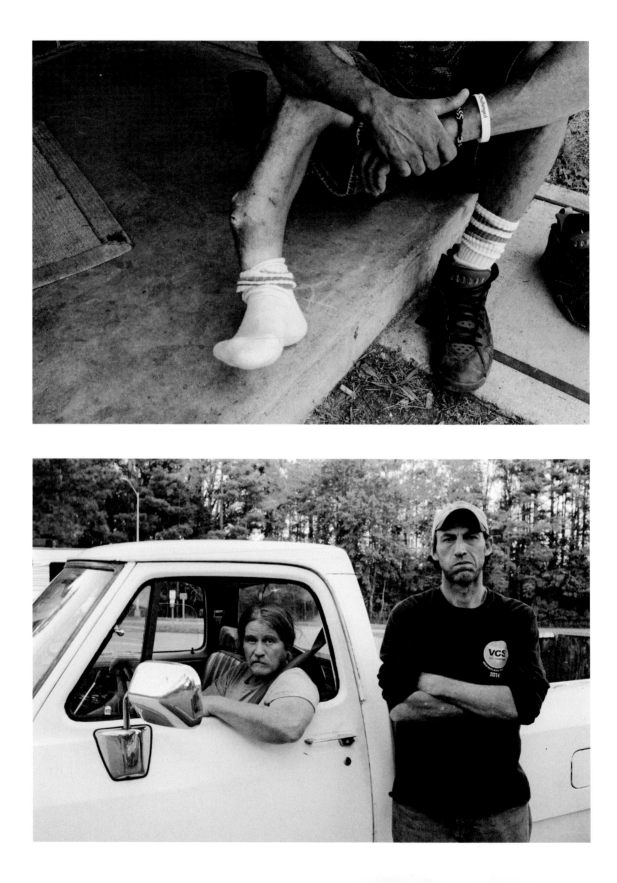

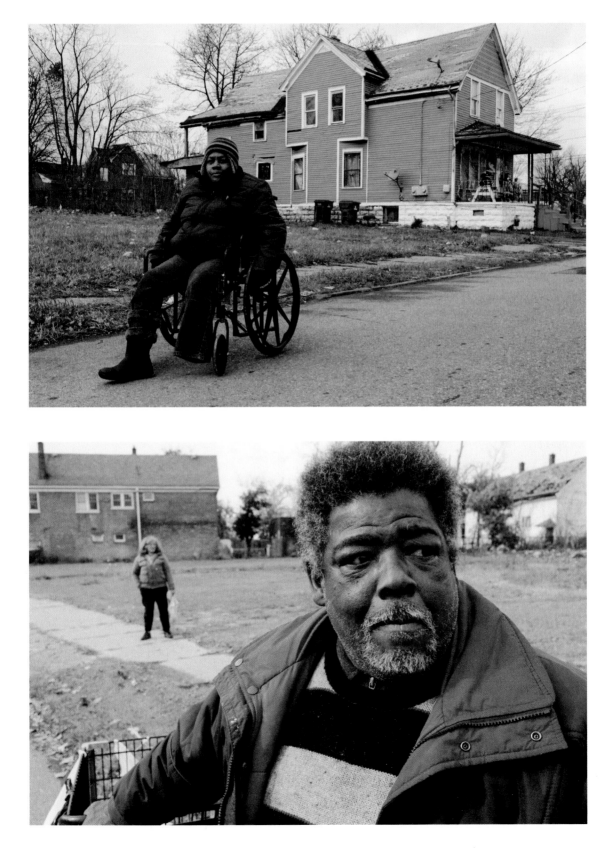

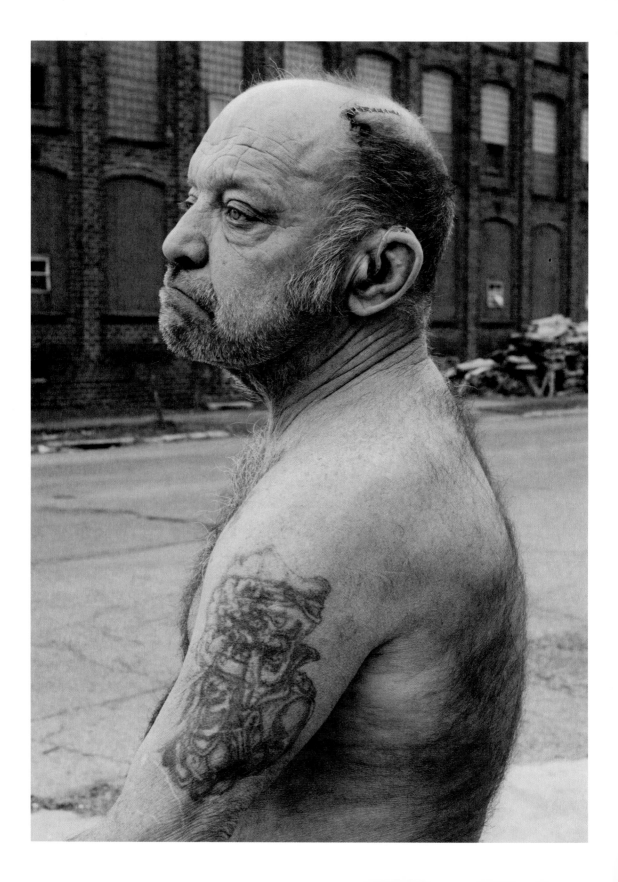

Racism

There are two McDonald's locations in Milwaukee's North Side, and both are filled morning to night with people socializing and hanging out. Entering either means being approached by people desperate for money and drugs. Inside there are others looking for a respite from the streets, filling booths with their bags and their drama. Next to them are groups of retirees who come in the morning and often stay till evening. All are black, and almost all are originally from the South, having moved to Milwaukee when they were young. They all look back at that move with a mix of nostalgia, regret, and frustration.

Winston, eighty-four, gets to the McDonald's early and always wears the same outfit: bright blue sneakers, bright blue pants, and a

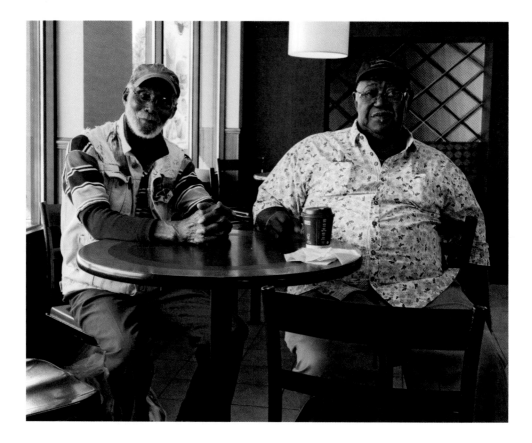

faded blue denim vest. "I let my daughter chose my shoes. I tell her find me shoes that will be appealing to women." His story, coming to Milwaukee in 1948, is a familiar one in the neighborhood. He was born in a small town in the Mississippi Delta and put to work picking cotton at eight years old. It was hard work for little pay, but he started saving, and by age sixteen, he had enough to leave.

"I remember that day perfectly," he tells me. "I could tell the time by the shadows the cotton cast, and when it got time for the morning bus north, I waved bye-bye to my family and walked right out of the fields.

Walked to the bus stop. All the other workers, when they saw me walk right out of the fields, yelled at me. 'Where you going, boy?' I just waved bye-bye. I heard my momma tell them, 'He has always been a strange boy. Determined to do things different.' I just wanted a job that paid and wanted work that respected the work you did.

"I spent three days on that bus. Rode it all the way to Milwaukee, sitting in back with a huge grin on my face. I came here because there was talk of good jobs available. And there were. Everywhere you looked there was factories, and they were hiring. They hired you if you were black or if you were white. They didn't care; they just wanted hard workers. But you only could live in this one here neighborhood."

He gestured out the window. "If you went south of North Avenue, no way. You just were not allowed."

Telling members of the back row that they should solve their own problems by moving is insulting no matter who you're talking to. But it is particularly insulting to African Americans; their entire history in the United States is of forced and coerced movement. They were forced to come here as slaves, and when legally freed, they were confined to the worst land, worst jobs, worst education, in places they had no connections to. It was freedom in name only, and yet many formed strong communities despite the oppressive environment.

When black populations migrated north in the hopes of finding a better racial climate and better work, it was a migration driven by desperation. Their move changed many northern cities, filling them with large black populations, but the relief they hoped for was often not found. The newcomers did find work and a better legal situation, but

they didn't find less racism, just the same problems dressed up differently.

Milwaukee was one of the destination towns. Prior to the 1940s, it had few black residents. An industrial boom magnified by World War II changed that, as did a drop in available white workers due to restrictions on immigration that started in the twenties. The black population swelled beginning in early 1940, filling with mostly young men and women coming for jobs that didn't require more than a high school degree, if even that.

The move north didn't end the racism they faced, although it was said to be better.

Blacks in Milwaukee were confined to living in one poor neighborhood, the North Side, which had little going for it beyond being close to the factories. Despite the racism, despite being limited to second-rate schools, second-rate homes, and second-rate jobs in the factories, they built their own community, a working-class neighborhood filled with families in well-kept smaller homes. It was a community that mixed Milwaukee traditions with their rural Southern culture. They built corner taverns that opened as early as 6:00 a.m. for the third-shift workers, decorating with hunting trophies and Packers posters and jukeboxes of blues, soul, and funk. They built churches dedicated to the evangelical faiths of the South rather than to the restrained Lutheranism and Catholicism that dominated Milwaukee. They built a neighborhood that worked.

Seventy years later, most of the factories are gone and the North Side has large parts given over to abandoned buildings, boarded-up homes, and empty lots littered with beer bottles, needles, and dirt trails snaking across them. It is a neighborhood emptied of jobs and filled with street memorials dedicated to young men killed by gunfire, some

from police. It is a neighborhood where hope left, replaced by vast frustrations. It is a neighborhood that still has some of its soul and community left but is deep into a cycle of a rejection by racism, isolation, and drugs.

Henry, seventy-nine, sits listening to Winston, nodding along. He gets it because he is also from the Delta. "I come from on the Mississippi side; Winston comes from the Arkansas side." He also came to Milwaukee as a teen in the early fifties. When asked why, he simply says, "Jobs." When pressed, he explains, "There was jobs everywhere here then, factories across the street from other factories. You could pick which one you wanted to work in. It was hard work, but I was used to hard work, because I grew up damn poor. Cotton-picking poor. But we worked hard. We didn't rob or steal; we worked."

I ask him if racism factored into his decision.

"Not particularly," he says. "It was just as bad here as there. I don't miss those times. If you black in Mississippi, you are gonna be poor. But can't say it was better here, though. There are no more racists in Mississippi than there was here in Milwaukee. Just under the table here. But just as bad. Here they lie to you about the racism. Down south they didn't bother with the lying."

I ask if it's better now.

"Racism is the same as it was then. Awful. But then they needed us for jobs. Now they don't. So black kids now got nothing to do. Nothing. So people call them lazy. You ain't lazy if nobody will hire you. You just frustrated. Kids need work. It keeps the mind occupied."

At the McDonald's across the neighborhood, the scene is largely the

same. A group of older men and women socializing, mixed with a collection of desperate people taking a break from the streets.

Here the older regulars come around noon and take over the front half of the dining area. An old boom box is brought in, set up on a table, and turned to high, replacing the overhead pop music with traditional blues music. Everyone here is black, all are originally from the South, and all share the same frustrations voiced by Winston and Henry. It doesn't matter much who you pick among them—male or female, very old or old—to tell their story; they are all variations on a theme: leaving the South in hopes of a better work and racial environment and finding better work but just as much racism.

Dudley, eighty-two, from Crystal Springs, Mississippi, came to Milwaukee in 1956. "I hated picking cotton," he says. "My parents were sharecroppers who got their own plot. I didn't mind the hard work but minded only getting $3 a day." In Milwaukee, he worked as a union longshoreman, AFL-CIO local 1815, and was pleased to have the job but disappointed by the "behind-your-back racism." Now he says Milwaukee has become much worse. "We used to have killings and crime then, but not all this street violence and drugs, this random gang stuff. You got to ask why that is. The jobs are gone. You don't see people getting off from the second shift like when I was younger. Kids just got no work to occupy them, so they get involved in all this nonsense."

Scooter, seventy, is from Tennessee and feels the same. "I grew up in Memphis, and well, I didn't experience much racism there. Didn't know about it. White family who owned the corner store knew my entire family. I knew them. We were friends. Then I came to Milwaukee in 1966 and found streets I couldn't go to. If I did, police would harass you. They still do. Kids are harassed by the police, less than when we were young, but they still disrespect them."

Not far from the McDonald's is Caspar's Lounge, one of the corner bars for third-shift workers. Caspar's occupies the ground floor of a home painted Packers green and yellow. It opens at 6:00 a.m., and by 9:00 a.m. it is busy with regulars, some who got there when it opened, some who come in following their coffee. Neighbors come and go all day, each welcomed with a shout. They use Caspar's as a neighborhood living room, playing slots, watching TV, gossiping, and listening to gospel, soul, funk, and country on the jukebox.

The slot machines sit beneath a wall filled with taxidermy trophies from fishing and hunting trips by the owner, Luther. An older woman sits playing the slots, sipping her drink, punctuating each loss with a cry of "Right church, wrong pew!"

Luther bartends mornings, starting at 6:00 a.m. He is calm but firm, keeping everyone and the bar in line. "I don't put up with any funny business in here." He still has a trace of a Southern accent from his days in Tennessee. He was born there, grew up working his parents' land and running machinery. At eighteen he moved to Milwaukee. "Why?" He scans the bar. "Same reason we all came here. To better myself." When asked if racism factored into his decision to move, he looks a bit confused. "Milwaukee was no different from Tennessee; still isn't. It all depends on who you are. Depends on the individual. Don't stereotype me, and I don't stereotype others. Some people are fair no matter where they are; some people are not."

At night Luther is replaced by Gloria, who is also originally from the South. She was born in Texas and moved when she was twenty. "They kept saying that the jobs and things are better in Milwaukee. So I moved up here, and the jobs were better, but the racism was just as bad. And people were not polite, black or white. Not in the least. I remember

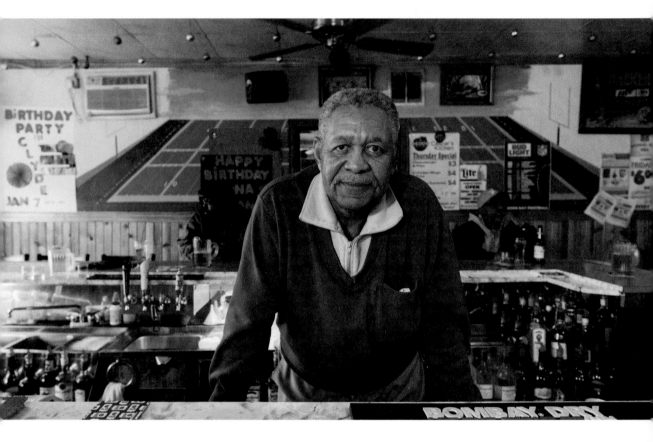

walking to school when I first got here, and nobody waved to me. Nobody said hi. I, of course, did. It hurt. When I go back south—I still got people there—everybody, white or black, says hello and is polite to you. Cares about you. Here they just pretend to care about you. When you go in a store here, they watch you out of the corner of their eye. Nobody just comes up to you and tells you what they worried about. Back south, as a child we had separate water fountains. I knew how things stood. Here it is all under the covers. Everyone says it is all good—but it isn't."

On an otherwise dreary block, Chuck's Barber Shop is lit bright, its windows painted with Christmas decorations and biblical sayings. Inside a bold printout announces, "Absolutely No Pants Below Boodie (No Exceptions)," and a second printout in smaller type reads, "PUBLIC SERVICE ANNOUNCEMENT For all those that think it's nice to walk around with your pants below your butt . . . read the following explanation: This trend was born in the united states' jails, where prisoners who were willing to have sex with other prisoners needed to invent a signal that would go unnoticed by the guards. . . ."

Chuck, sixty-one, is welcoming and opinionated. Once asked about his past, he talks nonstop for close to an hour, weaving together his story, his politics, and his concerns. He is open about a past that includes drugs, drug dealing, homelessness, a son murdered for "doing the shit I had once done," and prison. He has been sober now for seventeen years, after three prior failed attempts. "God is the reason that I am here." He was born in Reynolds, Georgia, the son of a sharecropper. "We had it rough, had to go out in the fields from age five. We didn't have a choice. We lived in a shotgun house, one where you saw chickens roosting beneath the house through the floors. There was a white man, Mr. B, who owned our land. We worked for him, and we had to call him sir. He did all right by us in the end, taking care of my granddad when he couldn't work the fields no more.

"I came to Milwaukee for the jobs. There were plenty back then, until the eighties. But thing is, you go to the jobs, jobs don't go to you. Racism? It is everywhere, but it is only bad if you accept it. You got to work harder because of it, but so, work harder, then. It's people's minds that cause the problem. Man cannot enslave man; man enslaves himself.

"In the South you knew where you stood. Here they are smarter

about their racism. They never show you their hand, like a snake in the grass. They talk one way and act another. They told me it was integrated here. Hell it is. Wasn't no such thing as integrated. You couldn't go north of Center Street if you were black. If you did, you weren't coming back. We knew our position then and could do something about it, unlike the young people today.

"There are just no jobs and young men want status, want to be seen. So they do this gangster stuff. That is straight-up silly shit. What do they get out of it? They get nothing but more problems. They get more burned-out buildings and less jobs. No factory gonna move to a place where the people burn down buildings. You got to have jobs or else all this silliness will continue. As my daddy always said, 'What is going to happen if you only give nine bones to ten dogs?'"

While many African Americans left for Milwaukee and other cities in the North, plenty stayed in the South and fought for, died for, and won dramatic changes. Today those victories can feel very distant.

Driving toward Selma, Alabama, you are constantly reminded by historical markers that although once a city of slavery, the city now symbolizes those civil rights battles and victories. Crossing over the river is another reminder; the Edmund Pettus Bridge is recognizable from newsreels and current TV news shows whenever presidents and politicians come to mark an anniversary.

Just after the bridge are three short blocks filled with museums, historical markers, and shops catering to tourists. Beyond those blocks, where most of Selma lives, is an ugliness that comes from racism and the poverty and frustrations that come with it. This, not the museums or the

politicians posing for the cameras, is the reality for many residents of Selma today. Selma may be emblematic of civil rights victories, but if you look closer, it is a reminder of the destructive power of racism and the failure of the current status quo to deliver tangible results to most black Americans.

There are a few nicer neighborhoods filled with simple, well-kept homes fighting against a decline, but they are the minority. Those homes often have small American flags, or crosses, or the "Stop the Violence" signs. Those homes are often adjacent to an empty field or a boarded-up home.

Next to those neighborhoods are blocks given almost entirely over to decline. There are dilapidated and boarded-up homes tagged with gang symbols, empty lots littered with vodka bottles and fast-food wrappers, and sterile low-income projects. There are no working factories to be seen, only ones being torn down for scrap.

Council, fifty-two, lives on one of those broken-down blocks. He has spent his life in Selma and wishes he could leave. He blames the city's problems on a lack of jobs, which he sees as a result of racism, "All the factories that used to be here are closed. The candy factory, the furniture company, they all picked up and moved when we elected a black mayor."

His house is one of only two on the long block that isn't abandoned and boarded up. The one next to his is half burned down. The others sit empty, although a few people squat in them. "Selma ain't like that movie. There everyone is shown working together and putting the past behind them. But the reality is Selma has been left behind, and folks are certainly not working together."

There is little that shines in Selma beyond the historical markers. Those are well-kept and feel anachronistic, their immaculate and preserved presence mocking the town.

The historic Brown Chapel is one of those monuments. It is surrounded by a housing project filled with poverty, drugs, and crime. It looks almost exactly the same as in the photos and films from the sixties, when it was the backdrop for celebrated civil rights battles.

The projects occupy four huge blocks comprised of long brick apartment buildings that feel like prisoner-of-war camps. T-shaped metal clothesline posts fill the gaps between the buildings, most without any line or clothes. The only activity I see is a group of children playing outside. They all come up to me and ask me to take their picture. Forgetting they are children, I start to interview them, asking them, "Do you like Selma?" They look at me blankly, except for one child of about nine, who shouts, "No!" When I ask her why, she tells me, "Too much shooting and my momma can't find a job. That is why we are moving to Florida."

The rest of the residents stay inside, only rushing to their car or walking to the corner store to buy milk, bread, cigarettes, or liquor. The few who are out have little good to say about their neighborhood or about Selma.

They share a frustration you hear across so much of the city, one of resignation and cynicism but little anger. They know their anger will bring only more ugly stereotyping and more problems. They are also cautious of me and my camera, pointing out, "No picture in Alabama ever did a black man a favor."

They all point to the same issue—"no jobs"—and if pushed further, they say why: "Racism." Some elaborate, including Jay: "Everyone always saying we don't have jobs because of things we lack, but it ain't what we lack; it's what we have: black skin. When I was a boy, we had to cross through the white neighborhood to get to school, and they used to sic the dogs on me and my younger sister. I left Selma and joined the military. When I came back, nothing much changed. They don't sic dogs on you anymore, but they stack so much against you that it might as well just be dogs."

Some don't need to elaborate because to them it is obvious: "Alabama the most racist state, and Selma the most black city. So you get it." Or, "When we got a black mayor all the factories moved away. Ain't no secret why."

With little legal work available, the illegal has filled the vacuum. The one person always visible in the projects is Tonyo. He runs and sells drugs, mostly crack, pills, and weed, and isn't shy about doing so. He sells out in the open, only yards from the church. "You in the real hood now. Forget New York. Selma is straight-up the baddest place."

He was born in New York, one of five children, the son of a crack addict. He came to Selma when he was a teenager, brought by his

mother, who was escaping when child protective services came for them. "She took us here when they came to take us children away. She ran down here with us, to be with some kin."

He makes only "pocket change" from selling drugs; his real money is made running guns to New York City. He pulls out a Glock from the waistband of his sweat pants to show me. "If you don't carry here, you gonna die. Selma is a hundred times more dangerous than New York City. Folks here got nothing to do but shoot each other. Guns flying around here like mad."

The week before his cousin had been killed half a block away. He spends a few minutes honoring him with details of his life, how he will be missed, before pivoting into a lesson: "He wasn't carrying at the time, so I hear. I been there when folks shot who didn't have a gun, and they get killed. I won't be that person. If you don't carry, you gonna die."

Tonyo has been shot six times, showing me his various wounds. He doesn't do so out of pride or out of a want of sympathy but to illustrate the injuries that come with his work. These are his paper cuts.

They are also signs of him "messing up," each wound another reminder that nothing but bad comes from not shooting first or fast enough. "I learned quickly you got to escalate, or guys will see you as weak and shoot you dead."

He says he has shot four others, or hit four others, that he knows. "Hell, I probably shot ten, but can't rightly say all my shots hit. Four did, that I know."

Tonyo isn't ashamed of any of this. He doesn't try to hide, doesn't try to explain away his actions as a result of a bad family, racism, or any other reason. He doesn't think what he does is wrong. This life is all he knows, and to the degree he has any concerns, it is a worry that he will end up shot before he can shoot.

That worry comes and goes, but in his mind, he is trapped in a life of running guns, selling drugs, and shooting whoever he thinks will try to shoot him first. "I want to get out of this life, but to do what? Ain't no jobs here. I got no skills and four felonies; who is gonna hire me? And the minute I drop my gun and put on a McDonald's outfit, someone gonna pop me for being weak."

He doesn't worry about the police because he thinks they are all corrupt or just outgunned. "The police here are corrupt as anything. One offered me to sell for him, but second you do that, then they own you, and you are their bitch."

Not far from the projects is a section of Selma that is worse. At the end of a narrow street lined with beat-up wooden homes and empty fields are two long brick apartment buildings. They seem abandoned but are fully occupied—some of the windows are missing glass, with just shards lining the frame, some are boarded-up, others have AC units and fans in them. In other windows sheets keep the light out and plastic wrap the cold. In front of each door is a single chair next to a pile of liquor and beer bottles.

This is the current home of the Jasper family, and getting close requires getting out of the car, being patted down, and being accompanied by someone (a friend of Tonyo) who can attest that I am good: "He is white, but not a cop." Another man approaches the car and demands a $3 entrance fee. I give him $5 and don't ask for change.

The buildings are being squatted in, taken over, and lived in. So says one person. Another claims they are paying rent to a landlord. Some call those living and hanging there a family, some a gang. It is unclear their exact relation, but they all know one another, all trust one another,

all have connections, making it feel like an open-air clubhouse. One with guns and booze. People sit around playing dominoes, some drinking, some working on a small garden of tomatoes and potatoes. Others come and go with guns jammed into their pants.

The area is currently being monitored by an older woman who someone calls Momma D. She gets close to me, her eyes only a few feet from mine, and asks me a series of quick questions, hoping to get me flustered, to reveal that my intent is bad. She grills me about who, why, and where, before letting out a loud laugh when I tell where her I am from. "Brooklyn? Selma is far badder than Brooklyn. Brooklyn is child's play." She then turns away and shouts, "He good!"

Nobody pays me much mind after that, spending time instead gossiping with my chaperone. They are all polite, and when I ask them to give me quick rundowns of their pasts, I discover that many have criminal records. Guns, assault, drug charges, and robbery dominate.

In the back, next to some cars on blocks, Kojak cuts up a deer he recently shot. He keeps working when talking to me, dividing each hunk of meat into a small enough size to give out, offering me one. He is direct that although he has a rap sheet ("Who in Selma hasn't?"), that isn't who he is anymore. "Me? I got an old felony for gunplay, but now I am just trying to get by."

Another man who has moved on from this life drives in after work and starts chatting. He is long done with his past, done after a felony for gun possession and is now an electrician who "just comes here to have a beer and relax."

When I ask if anyone is worried about the police, a man sitting off to the corner laughs and says, "They are corrupt."

This part of Selma is particularly bad, but it isn't an anomaly. Boarded-up or falling-down houses make up about a quarter of the city.

Many other buildings that in other places would be considered derelict, with broken windows and porches filled with holes, are occupied by desperate people charged by distant landlords.

There is legal work in Selma; it just comes with a lot of pain and little money.

Across town, old cotton warehouses, built back in the era of slavery, have been torn down. A foreman is hiring people to sort through the rubble. He sits at a beat-up metal desk in the middle of a concrete slab, writing in a spiral notebook who has collected what and who has been paid. The particular job he is hiring for is to remove bricks from sprawling tangles of the fallen buildings, chip them clean of mortar, and stack them. Everyone on the streets has heard of the work, but most won't or can't do it because it's painful and pays just $10 or $20 for a pile of hundreds.

The site spans two large blocks on either side of railroad tracks—fields of rubble, foundations, and weeds. The silhouettes of people working through the rubble catch the eyes of those walking by. They usually stop and watch, taking the opportunity to chat with one another or with those taking a break from the job.

A well-dressed older man who moved back to Selma after a military career stands rigid, looking over the scene, and then shakes his head. "Everyone heard about this job, but few want to do it, because it pays nothing, and lots of people been hurt doing it. But there are no jobs here in Selma. Especially if you got a record, and almost everyone in Selma has a record." Nobody knew who owned the old warehouse, although most reckoned it was a white man: "They own everything around here."

Chubb, fifty-five, walks up with the help of a cane and watches. He can't speak much but manages to ask for $5, for milk. The older man reaches into his pocket and gives him some spare change. Chubb walks away, and the older man whispers, "Crack addict, already had three strokes, but he still going at it. Lives off disability. Sometimes they act like getting disabled is hitting the jackpot."

I stand on the street with the gathered group, who watch, chat, and laugh (because what else can you do) at the insanity of it all. Someone notes, "Twenty dollars to break your back, bust your hands, and hurt up your back. When you hurt up, nobody gonna help you. They might give you a bandage or a wrap, maybe drop you off at the infirmary, but that is the extent of it."

A brick buyer from a construction firm, a white man in a large truck, comes to look at the finished piles. He explains, "Handmade bricks, especially historical ones like this, are in demand. They often sell for over a dollar per brick." He sells to companies specializing in reclaimed materials that advertise to those wanting "historical charm." Most of the buyers are fancy restaurants in fancy neighborhoods, places that seem so far away from Selma.

Sem joins the group, watching, taking a break from the pile of rubble she's been sorting through, to smoke. She spent the day working and wasn't complaining: "I am a single mother with five kids. I will do any work, and this is the only work in town."

Another worker joins her, his hands bleeding beneath a cloth wrap. He also isn't complaining, although when I ask him directly what he thinks, he smiles tight. "This is slave work, that's what it is, but the only work around. Kind of funny when you think about it, because them bricks were probably made by slaves. That is Selma for you, though: still a city of slaves."

W hen pressed about why the United States is as segregated and unfair to minorities as it is, most of us blame the racism of others. In my case, I blamed the people I'd grown up with in Florida, where my small town was white, and each town around us was split in half, with blacks on one side of the tracks and whites on the other. Everyone

was poor there, but the black side was poorer, damningly so. They had lesser roads (often dirt), lesser homes (often shotgun shacks), and lesser everything else. They weren't allowed to move to the better side.

I spent time on both sides of the tracks, since my parents were actively involved in the civil rights movement, hosting the first county meeting of the NAACP at our home. A neighbor, a declared white supremacist, wouldn't allow me in his yard because of my parents' views, and his kids were not allowed to play with me, though they did anyway. My father's car window was shot out, and there were rumors that the volunteer fire department wouldn't be all that quick to put out a fire in our old wooden house. What we experienced was far, far less than what the black members of our community faced, yet we had a sense of what was at stake—and who was responsible.

Our middle school had been the black high school before integration and suffered from neglect for fifty years. By the time I arrived in the mid-seventies, it was falling apart and was also the first taste of integration for kids from my town, since it was on the other side of the tracks and 30 percent of the students were black.

Kids responded by self-segregating. The cafeteria was split in two, with white kids clustered at ten of the tables and black kids sitting at the rest. In PE, the teams ended up being white versus black, often with games turning into real fights. I was one of the few white kids put in the black group, since the principal, a black man, was close to my father and wanted me to be an example: a white kid with black friends.

A minority of white kids, but a minority large enough to have an effect, responded with anger, hate, and unabashed racism. It was what they had learned from their parents. My shop partner, assigned to me, made a wooden club he labeled his NN, for Nigger Nocker. He wasn't alone. Nobody reprimanded or questioned him or his friends. It was just what it was.

Others taunted the black kids whenever they had the chance, throwing spitballs or whatever they could find. If the black kids fought back, which they did, the fights would escalate until the teachers had to stop it.

As I got older, the racism dissipated a bit, but that core visceral hatred never disappeared, only simmering and boiling beneath the surface. Then I exercised an option very few of the black kids (or even the white kids) in that town had: I left.

As I moved through a series of schools, institutions, and neighborhoods that were almost all white, slowly making my way to the front row and New York City, I began to forget what I had seen as a child. With each step, I put more of the awfulness behind me, eventually looking around to say, "It's getting better."

On the surface it was getting better. When I was home to visit my parents and went across the tracks, the roads were paved, the shotgun shacks replaced by housing projects of brick homes with running water, the trash-filled gullies by sewer systems hooked up to the rest of the town. By the time I reached Wall Street, I could believe that the country had gotten much better, that we had moved beyond the worst of the ugliness. My office was diverse, my neighborhood was kinda diverse, and my children's elite school wasn't just white kids.

It was easy to live in successful New York and believe the United States was slowly moving beyond racism, or at least that you yourself, your friends, and your city had. Those subway or car trips through the Bronx, or East New York, or Harlem, were reminders that we hadn't done everything we wanted to do, that there was still a lot to solve, but we were better and moving in the right direction.

If we still hadn't done enough, it wasn't my fault, I figured. I could point to my childhood and say I was different from the rest of the whites in the front row, a more nuanced version of "I have black friends." And

I could tell myself I was doing everything I could for minorities. I voted for and argued for policies I saw as fighting the remaining problems—I supported criminal justice reform, I supported affirmative action, I supported expanding the social safety net, and I supported increasing my own taxes for all of this.

Then I did more than drive through the Bronx or East New York. I spent time in each, and I listened, and I saw it wasn't any better. It was just the same ol' thing, dressed up differently.

Then I got in my car, and I went to the other side of the tracks in Buffalo, in Boston, in New Haven, in Selma, in Milwaukee, in Washington, DC. I saw that poor neighborhoods are still overwhelmingly black and Hispanic and are still places one can't leave without a hell of a lot of luck. There aren't explicit legal barriers around them, but there might as well be.

You can ignore data, but you can't ignore when friends are thrown against the wall by police for nothing but their skin color, while the police don't bother you. You can't ignore seeing kids your own children's age crushed and fall into drugs and homelessness while yours rise higher, all because of their neighborhood. You can't ignore seeing kids your own children's age given lesser everything, all because of the color of their skin. Someone can tell you the reasons why minorities are confined to secondary everything are different from the reasons of my childhood, but the outcome doesn't look much different.

I realized to my horror that I had shielded myself from the visceral racism that still permeates most of the US. And that I couldn't pin this continued racism entirely on my Southern white neighbors, who had supported the explicitly racist system we had moved beyond.

When I went home, I saw that some of those angry white kids had grown up to be tolerant, and almost all were living lives closer to the

minorities I claimed to want justice for than I was. Those white kids and those black kids I had left behind now had more in common with each other—shopping in the same shops, working the same types of jobs—than I had with either.

I still tried to say, "Well, I don't support the old explicitly racist system, so I can't be racist." Yet the system that replaced it, the one we supported and thrived in, was racist. It is a system that ranks people by how much you learn and much you earn, and it is rigged against the back row, and minorities disproportionally start and are confined there. As educator Vivian Wilson Henderson said, "Racism put blacks in their economic place, but changes in the modern economy make the place in which they find themselves more and more precarious."

That system isn't just legally rigged against them; it is rigged against their entire worldview. It is rigged against people who find meaning from place and from faith. It is a system that says you cannot reject anyone based on the color of their skin, but you can and should reject those without the proper credentials, and minorities rarely start with the proper credentials.

It is a system that offers only an extraordinarily narrow path to success, requiring one to be uprooted from family and home, and then buy into the front row worldview. It is a system especially hard on minorities who suffer from the least access to credentials.

The front row when it views the problems faced by minorities doesn't bend, redefine, or adjust their definition of success. They rarely reevaluate their own values, their own worldview, their own priorities. They rarely look inward at the status quo they have constructed and its narrow and rigid definition of success. They rarely ask if maybe their narrow definition of success, narrow definition of value, is itself exclusionary.

Instead they tell minorities, like they tell the entire back row, that they need to readjust their values, readjust their worldview, and try to join the front row. They do this by offering a few of them help via an accelerated pathway to the credentials they have.

Like anyone from the back row, many minorities don't necessarily want to buy into the front row world. They don't want to leave their family and change where they live, who they are, what they believe, what they like, how they act, what they care for, what they value.

In the black community the term "acting white" captures some of this, but it is larger than just how you behave; it is changing what you believe. It requires not just "acting front row" but becoming front row. Given the absurdly narrow path available, given the overwhelming amount stacked against them, that is something most can't do. It is also something many don't care to do anyway—and for good reason.

The direct solution we offer for minorities is affirmative action, an accelerated boost to the front row for a lucky few, and although justifiable in the short term, it is a Band-Aid for a system needing surgery. For one thing, it still presumes that the main problem is a lack of education or credentialed achievement, implying that people who value less measurable forms of meaning get what's coming to them. For another, affirmative action inflames racial tensions as it drives another wedge between the white and black members of the back row.

This is especially dangerous because the back row has been left with little to take pride in that doesn't need credentials. For those who don't have the resources, personality, or desire to get an education, there is little left that values them. There are fewer and fewer jobs to take pride in, the religious life is viewed as illogical, and local pride is said to be provincial. There is another option: racial identity. That option is the most dangerous.

The Acme Snowshoe Club in Lewiston, Maine, has plenty of members, but few of them snowshoe race, or even own snowshoes. It used to be much different, a few decades ago. They were French Canadians who worked in the adjacent mills and lived in tenement buildings, many without showers. They used the Snowshoe Club like their living room. They would come after work, shower in the basement, then spend afternoons and nights watching TV. A few times a year they held snowshoe races against other members-only clubs.

The mills have mostly closed down or moved in the seventies. When they left, most of the member clubs closed down, although a few besides the Snowshoe Club still hang on. The 20 M Club across the river is built around darts, not snowshoes. It is still going strong.

The Snowshoe Club still has members, but they come not to shower or talk snowshoes but to drink, eat, watch TV, play pool, and chat. Many are retired. A few used to work the mills, although most work at the L.L.Bean factory not far away, or the navy shipyard down on the coast, or construction, or for the school system or some other city job.

The club is on the edge of the downtown, a part of town that sat mostly vacant for two decades before the Somalis came. Lewiston, Maine, was close to all white before a refugee agency moved an African family into Lewiston in 1999. Now, eighteen years later, after an influx of Somalis, it is roughly 15 percent black. Outside the Snowshoe Club, the neighborhood is largely Somali; inside, there are none, although I am told they are welcome.

Anyone can come in and drink, although they need to register their name and pay a membership fee of $5. The club can turn anyone away, something they rarely do. The regulars are all white, all mostly French Canadians, although few openly identify as that.

Sam sits at the bar drinking and chain-smoking from a pack of generic cigarettes. He is close to fifty and after eight years in the military makes his money driving trucks or logging upstate, although he is now between things. He isn't happy, although he exhibits a sense of resignation more than anger: "I am scared to death for the kids in this country. My parents struggled; I struggled just the same. The government is corrupt as hell, and we all been left behind."

An older widow sitting next to Sam nods her head and then tells a long story about a friend who faced eviction from Section 8 housing and who couldn't get a lawyer. "The Somalis get free lawyers to help them, but she can't. This world is screwed up, and I fear for my kids. World changing so much so fast I wish I could go back."

Sam listens to this, and then adds, "We are all immigrants here. I get along with some, but others act like they own the place and we owe them. I seen friends, good vets who fought for this country, moved out of their Section 8 home because a refugee came. My friend lost his place to a Somali. He was injured serving this country and now he gets less than someone who just came over? I am one-third Native American, so everyone to me is an immigrant. But let's shut this open border down because we becoming a minority in our own town. I get food stamps, and my line is now twice as long. I go to DHS and the Somalis are cutting in line. What was once a forty-five-minute wait is now two hours! I don't got much. I am at poverty level because I don't fuck over people. I do honest work, and this is what I get? I mean, I even stitch myself up when cut rather than go to the doctor."

The bartender listens and then adds, "Oh come on. I am fine with them. They don't do nothing to me. They are cool, and I am cool. They don't bother us. Let them be."

Another bartender is more direct: "We are the problem, us adults.

The kids all get along fine. White and Somalis. You see it in the schools. You see it when you chaperone school trips. They all get along. Hell, the Somali kids are more respectful to teachers than the white kids. They respect their elders. The problem, if it exists, is with the adults."

A mile away from the Snowshoe Club is the McDonald's, which has a large group of regulars, all white, all older, and almost all male. They have all been here all of their lives, although some went away for a few decades to work. Most have known one another since growing up. When asked about the changes in Lewiston, they almost all twist up their faces and tell of the wrongs brought by the Somalis. They talk about "the freeloaders," and "the lazy," and those that are "just different," and "not like us." A few defend the changes, reminding the rest what the downtown was like before the Somalis came, how it was empty and filled with boarded-up buildings and drugs. "They rebuilt that downtown, and we should respect that."

Bill, seventy-six, is quiet for most of the conversation. He listens to the cross talk, and when most everyone leaves, he just shakes his head, and then opens up. He was born here and moved away for a bit, to teach French, before returning. He talks about how Lewiston was a town of mills and churches and social clubs, of the parades they used to have, and of local newspapers that were in French, not English. "I am OK with Somalis. The ones you hear who are anti-Somali, it is consistent with how they were raised. They didn't like blacks back when we were young. They are working-class French Canadians, and they worked in mills, and they have forgotten that their parents' generation, who moved here in the 1910s and '20s, and got beat up by the Irish in town! We were the ones who didn't speak English, who everyone said was taking jobs, who were getting stuff for free. We were called the white niggers of Maine. How soon they forget. It is sad."

Only a few blocks from the Acme Snowshoe Club, the once-vacant downtown is now filled with stores run by and for the Somali community. Each offers a variety of services. The Mogadishu Business Center lists "Money Transmitter, Seamstress, Tax Preparer, Halaal Meat, Cleaning Services" on its storefront. The Bakaaraha Halal Market offers "Halal Meats: Goats, Camel, Chicken, Beef," "Fast Money Transfer You Can Trust," and "Safari Travel Agent."

Inside one of the smaller stores is a local hangout. It is owned by a couple with the husband running the front of the store, selling clothes, packaged food, and financial services. In the back is a single stove behind a counter, run by the wife, serving food and drinks. Two small folding tables in the back are always filled by people sipping tea and chatting. When it gets busy, women get up and help cook while the men help clear the tables. The talk is mostly about sports or shared friends.

Fowisa sits and talks to me, sipping coffee and telling her story. She is thirty-eight and came to the States in 1996, first settling in Atlanta. When I ask her why she moved to Lewiston in 2003, she smiles and says, "I wanted a community that was small and safe after growing up in a war zone and refugee camp."

Her experience in Atlanta didn't offer that. She also couldn't relate to American blacks, despite being the same color. "In Atlanta was the first time anyone ever told me I am not African. I came here to Lewiston because it was safer and I found less racism here. But I am friendly and positive and take time to say hi and smile to everyone. That helps a lot. My kids also fit in here. They are doing well in school, on the honor roll. One of my daughters didn't know she was different until seventh

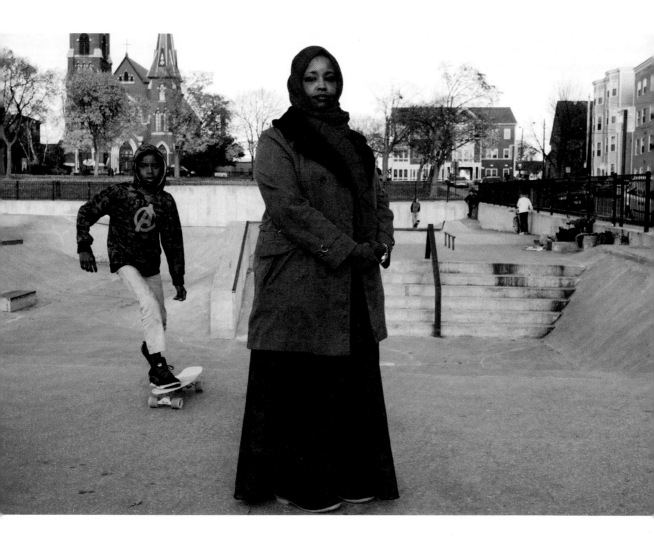

grade! We want to assimilate and integrate. My kids only speak English, and I love that."

Sitting with her is Hawo, twenty-six, who came in 2000 from Columbus, Ohio. "I love Lewiston. It is a small community, and I have en-

countered only nice people. In all my life here I have never felt unsafe. As a woman walking at night even. We came from war, and we came here and found peace. So for us America is great!"

She pivots to the negative stereotypes I mention hearing from some whites in town: "Everyone says we are all on welfare? I worked hard for what I got. I got help, and then I moved on. You only get special benefits the first six months, then you are like everyone else. You have to work in L.L.Bean or Walmart if you want money."

I ask why she moved to Lewiston.

"To be blunt," she says, "I wanted to be in a white town. Black Americans have treated us worse than white Americans. I feel safer around a white community than in a black community. When I came to America and was put in a black neighborhood, it was the first time I was told I was not black or African."

I ask her if she has had any bad experiences in Lewiston.

"A few, but I look at the positive. Like Bob. Bob lived in my building. He lived alone. He was a vet on some form of disability and had some issues. But he was so nice and always made a point of saying hi to me and welcoming me, and whenever it snowed he would shovel my car out and clean it. He did this without me ever asking. I would thank him and he would just smile and say, 'It is my pleasure to help.' Well he got sick about a year ago and fell behind on bills so we organized a rent fund. That is what we Somalis do for each other. We get together and help out. I am not sure anyone else helped him other than us. Well, Bob died last week."

"I am sorry"

"Well, I went to his funeral. I was the only black person there. Just me in a church that was all white. Now I felt a little out of place but during his brother's sermon he thanked our Somali community for helping Bob and when he did that everyone in the church turned and looked at

me. I have to say I felt a little strange. Then afterward when the service was done everyone came up and hugged and thanked me. It is this that I will remember and think about."

A few blocks away is a nonprofit run by Abdikadir, a middle-aged man who came here a decade ago from Atlanta.

"Why Lewiston?" I ask.

"Because it was white," he replies.

"Really?" I want to be sure that I heard right.

Yes, he says. He says he came to Lewiston for safety, education, and community. He mentions what I had heard from others—that he was first settled in Atlanta where he and others were verbally attacked. "People would play tricks on us. There was gunshots all around. This was new to me. We have the same assumptions, sadly, that it is safer and better to live in white neighborhoods and cities."

Lewiston is better, he says. "Many of us come from rural society. We are not used to big cities. We survived a war-torn region, refugee camps, by helping each other, so the sense of community is essential. That was here in Lewiston. Remember, we want what anyone else wants. We value education for our kids. The schools here are much better than Atlanta."

I ask about racism in Lewiston.

"I have had some bad experiences. Every refugee has. But the US has offered a lot to myself and my family and my community. So when I get angry, or someone calls me names, or taunts me, I do my best to try and offer them a chance to talk over tea or coffee and talk about what we have in common."

Outside the office, adjacent to downtown, is Kennedy Park. It is one of the few parts of town always busy and used by both the whites and the Somalis.

Youseff is feeding pigeons on a park bench. "It was hard when I got

here young. I was torn. My parents wanted me to be one way, the kids in the school another. I am embarrassed to admit it now, but I wanted to be liked by the kids in school more than my parents. But school was tough at times. Fights. People calling us 'sand niggers.' I had people come up to me, right to my face, and say, 'We don't want you around here. Go back to Africa.' But that has changed. Things just kind of got better. Now our town's soccer team, it is all Somali kids, won the state champion and we are celebrated. Now they see that the boarded-up downtown is filled with shops. Our shops."

The park is mostly self-segregated, with the white adults staying in one part and the Somalis the other. The exception is the playground, basketball courts, and skate park. Each are filled with an equal number of Somali and white kids. In the skate park they are riding skateboards, bikes, and scooters, all zooming past one another. There is a small cluster of young boys, all white, who are the most experienced, each showing off advanced tricks: loops, spins, and falls. A group of Somali kids stand watching them, each shyly holding a skateboard. They try to match the tricks but mostly fail.

I sit and chat with the boys and take their pictures. The Somali boys step away from the camera but still stand close to watch. When I ask the cluster of boys how everyone in the skate park gets along, two of the white kids answer, "We get along OK, but sometimes we have problems. Mostly with the girls who come in here and ride their bikes and call us names when we get in their way." When I asked the Somali boys if they want to join in the picture, they give me a blank look. I ask again, and they just smile. One of the young white boys rolls his eyes. "That is them for you. A little weird and hard to talk to."

Next to the skate park in the toddlers' playground, a young white girl in a white summer dress is playing mother to two younger Somali

girls. She is holding their hands, taking them around the playground. She lifts each up and puts them on the swings, then pushes them for fifteen minutes. The two smaller girls are dressed in traditional clothing, their red and pink colors standing out. On a bench I find the mother of the older white girl, and I ask her if I can take a picture of her daughter pushing the younger children. I explain how I love how they are getting along so well and the clash of dress colors.

It is a picture I desperately want to take, one to leave me with a sense of hope after hearing and seeing so much misunderstanding, ignorance, and racism.

She says no and explains that she doesn't know who the other kids are and that her daughter always plays mother to younger children. I ask her if she is from around here, and she says, no, she had to move here from another town because of money troubles and what with no man in her life, at least no decent man, she is doing what she can to get by, and if that includes being in Lewiston, then Lewiston it is.

Then she adds, "Lewiston is a dump."

While we are talking, her daughter runs up and hears me say how much I like the bright-colored dresses the Somali women wear.

Her daughter agrees. "I want to wear those colors. I like them. They are so beautiful." When she runs off to play, the mother looks at me and says, "Over my dead body will she wear anything like that."

I tell her again I think the dresses and colors are beautiful and her daughter would look great in them. She takes a pull on her cigarette, gets up, and turns to me before walking away to get her daughter. "I don't want my daughter to stink like them niggers."

A year later I find myself in another small town with a growing Somali population—and a growing racial problem. I had stopped at Lexington, Nebraska, to stay the night on a longer trip, knowing nothing about it. I found a small town built around a railroad, one filled with grain silos, warehouses, and a massive cattle market that is a network of pens, gates, and auction houses.

I also found a town smelling of rotting flesh and sewage. The smell hits you from different angles at different times, depending if the wind brings the smell from a large meatpacking plant on the edge of town.

The plant is what brought in Mexicans and Somalis to work, changing the downtown, where the only activity is in stores catering to the newcomers: restaurants, small nonprofits, and a bank turned into a mosque.

The plant is near the highway, a Walmart plaza, and a line of fast-food franchises. This part of town is busy, especially the Walmart, which is open twenty-four hours. It is one of the few places that the entire population of Lexington—the Mexicans, the Somalis, and the whites—all use and intermingle in.

Across the street the McDonald's is awash in the smell drifting from the packing plant.

Inside is a mix of morning groups—almost all white retirees, beyond a few Mexican Americans. Mary and Tom are alone, the last members of a particular group. They explain that there are four different groups and that most have been coming here for twenty-five years: "One group meets at five thirty, before work, others meet at six thirty, eight thirty, then nine."

Mary was born on a farm but she went to technical school to become a draftsman.

"You didn't want to farm?" I ask.

"No! Farming is hard work, often from dawn till midnight. Some days we didn't see our father unless we took food or water out to him. I told my mother, 'I am never gonna farm or marry a farmer.' We sold the farm, and I was sorry to see it go but wasn't going to work it myself."

I ask if the town has changed, and she says yes. The Sperry New Holland factory, which made farm machinery, left, and it became a meatpacking plant now run by Tyson. "Type of people living here changed."

I wait for her to clarify.

"First the Mexicans came, then the Somalis came. Really changed the town. Mexicans assimilated pretty quickly; the Somalis have not."

She points to a local McDonald's regular, Al, who is Mexican American and was hanging with the group earlier. "He is our friend." He waves back.

I sit quietly, letting her and Tom talk, letting them explain the changes as they see them.

"They are always in the way, don't seem to understand how long they take," Tom says. They are at the bank lines, or at the Walmart lines, sticking quarter after quarter into machines, taking their time. "I was in Walmart the other day, in the eight-items-or-less line, and Somalis were in the line with full grocery carts. One guy gets out food stamps to pay. Why come over here and live on welfare? We have a friend who can't get food stamps because they own their own house. I know that sounds bad, but that is how I see it."

"They came here for the meatpacking jobs, right?" I point out.

"Yes. Not enough locals would work in the factories. It is hard, nasty, and dangerous work. A few locals do it, but we didn't have enough of those workers here."

Mary jumps in. "There is one little Somali girl who worked at the hospital. She was the nicest thing. She wore the nurse's outfit—not the Muslim outfit—and the head scarf. I got no problem with the head scarf. I don't know what became of her, but she was the nicest girl. I believe she went away to study. So sweet and so smart."

Tom shakes his head. "I don't know why they need to dress like that. If they looked like us, dressed like us, it would be easier to include them."

I ask them if their children have stayed in town, and they both respond, each adding to and finishing the other's thoughts, "Oh no, we encouraged them to leave. Didn't want grandchildren living here."

"Why?" I ask.

"It wasn't safe then. There were gangs here in the midnineties."

"Gangs?"

"Yes. When the packing plant first opened they brought in a lot of single young Mexican men to work there. Now most of the Mexicans are here with their families, and it is much better."

"Would you have wanted your kids or grandkids to work in the Sperry New Holland plant?"

"Yes!" They both say.

"What about Tyson?"

"No. It is awful, awful work. Just awful. And so dangerous!"

I go downtown to try to talk to the Somali community, but everyone turns away, or tells me they are busy, or waves and shows they don't speak English. I stop when I realize I am making them nervous. As I get ready to leave, making one last walk along the main street, a man who speaks broken English approaches me from inside a nonprofit I had been in. He explains there is fear in the community and mentions Kansas. I am not sure what exactly he is saying until I sit and read about a

white supremacist group recently arrested for plotting to bomb Somali apartments in a meatpacking town in Kansas.

Beyond the Somali businesses, the only busy downtown store is a small gas station near the railroad. Inside, a young Mexican American woman is holding her daughter's hand, chatting with the cashier. Everyone who comes into the store stops to say hi to her and hugs her. An older white man smiles when he sees her—"I hope you being back here means lower prices for gas and cigarettes!"—then hugs her and thanks her for the picture she took of him a while back.

ME: You are so popular here!

HER: Well, I used to work the cash register for years.

ME: Were you born and raised here?

HER: I wasn't born here, but I was raised here. I was born in Mexico and came here at eight.

ME: What did your dad do?

HER: Don't know him.

ME: Mom?

HER: Tyson worker.

ME: What do you do for work now?

HER: I work in a factory that makes valves. It is a good job, better than Tyson.

ME: Do you like it here?

HER: Don't like it. Nothing to do.

ME: Why don't you move?

HER: I have nowhere to go. I don't have family members that live somewhere else and can help me out.

ME: What about college?

HER: I went to Central Community College. I tried for two

semesters, but I had two jobs and two kids and didn't
have the time to put fully 100 percent into it.

ME: Why did your mom stay here?

HER: This is the only thing she knows.

ME: She has a good job, though.

HER: It pays well, but it deteriorates the body.

A Somali man comes in and smiles at her, and they talk and gossip,
and she waves to him, the only person she doesn't hug.

ME: How has the community responded to Mexican Amer-
icans here?

HER: They have mostly been good. I myself have never
experienced racism.

ME: What about the Somalis?

HER: I have seen a few ugly moments. One time when I
was working the counter here a very drunk man came in
and saw a Somali in here and shouted they should go
home. I threw the drunk man out.

ME: What else?

HER: Well, some of the Somalis don't try to fit it. Some
smell good, shower, and learn English; others don't
shower often or eat with utensils and take advantage of
the opportunities we offer them, and instead look for
free help. It makes it harder.

I wait for her to continue.

HER: I have been a US citizen for a long time, my mom for
eighteen years. I been working and paying taxes since I

was fourteen. I don't feel any insecurity or fear about being here.

ME: It is July Fourth!

HER: Yes. I love America. It is about opportunity. I don't think people would risk their lives in a desert or swimming across a river if they didn't feel this country provided opportunity for them.

Respect, Recklessness, and Rebellion

I n August 2016, Sylville Smith, a twenty-three-year-old black man, was shot dead by a Milwaukee police officer while running from a traffic stop. His death was followed by marches in the almost entirely black neighborhood of North Side. They began peacefully and stayed that way until midnight, when a small group turned violent. They set fire to three buildings, one a gas station many blacks had a long history of frustration with.

Months later, the exact spot of Sylville's death is marked by deflated Mylar balloons, Hennessy bottles, and candles clustered around a tree. Each morning the adjacent street fills with his friends and their friends, who park cars across the entrance to the block and hang on the street.

They come daily, standing around, talking, laughing, listening to music, with the intent to stand guard to honor Sylville's memory.

When I try to photograph the memorial, the crowd rushes toward me, a tall, slender man leading the way. He splits off from the group, holding them back with one hand, the other hand pointing toward me: "No way you doing that. Nobody gave you any rights to come around here. Get out of here."

I tell him I want to write about the challenges faced by the neighborhood, and he laughs, putting a finger gently on my chest. "You going to just turn us into young thugs. They already have turned Sylville into a hoodlum, a gangster. Now move on."

I come back every day, each time looking for the tall, slender man to try to convince him I am well intentioned, that I got it, that I understand his and

his friends' frustration. On occasional visits, someone around the memorial would let me in, and neighbors would apologize for their skepticism of outsiders, but most of the time the crowd puts up a wall of silence and aggression, telling me to leave Sylville's memory alone that and this is neither my story nor my story to tell. On my last visit, the tall, slender man approaches me, once again gets in my face, and tells me, "This is not your hood; this is our hood, and the police with their bullets have made this our street."

Venice Williams, a minister and local community activist, lives blocks away. Her house is a one-floor ranch similar to the houses on the block where Sylville was shot. Her yard is filled with vegetable gardens, whatever space she has available given over to squash, corn, greens, and beans. A small handwritten sign facing the sidewalk welcomes anyone who wants to learn to garden.

She has spent the last few decades helping her neighborhood. Her latest project is a community garden, a massive green space fashioned from an empty lot that was once filled with garbage.

When I ask her about Sylville's memorial, she says she wishes those standing guard would reopen the street, cut the music, cut the posturing, but she also understands why they are there: "Our young people are tired of being humiliated by police. Tired of being researched and overanalyzed by journalists and nonprofits. This behavior, the clothing, the music, and sometimes the drugs and violence, this is the only toolbox these kids have. It is one filled with a need for pride and protection."

P aul sits in his truck in the Prestonsburg, Kentucky, Walmart parking lot waiting for his wife, who is shopping in the Goodwill. The parking lot is filled, but it is always filled. No other part of the small

town is as constantly busy, as central to the town, as the Walmart plaza. It is so busy that a city police officer is assigned to patrol it on a bicycle.

Prestonsburg is a small, almost entirely white town surrounded by hills mined for coal. Those hills ring the plaza, which lies in a flat space carved out of the hills.

Paul's left leg is missing, lost to cancer when he was young. He pivots from the cab of the truck to the back edge, swinging his body on the doorframe with his arms. He dropped out of school after freshman year. Most of his time in school had been in special education. "I hated school. I was teased all the time. The other kids called me retard or cripple. I learned to fight them. I had to."

Now he is on disability benefits, supplementing that on the down-low with lawn care work for a few friends. "The government doesn't want me working since I get benefits, but I got to work. Nobody can't work."

Flying from the back of his truck is a large Confederate flag. It is attached to a rusted pole held in place by a cement block, just behind the cab of his truck. I ask him about it. "I love the flag, because I love fishing and hunting. That is what it means to be from the South, and I am proud of being from the South."

When I mention that people see the flag as offensive and racist, he replies, "No, sir, that isn't how I see it. For me, it is about Southern pride."

Much of the back row of America, both white and black, is humiliated. The good jobs they could get straight out of high school and gave the stability of a lifelong career have left. The churches providing them a place in the world have been cast as irrational, back-

ward, and lacking. The communities that provided pride are dying, and into this vacuum have come drugs. Their entire worldview is collapsing, and then they are told this is their own fault: they suck at school and are dumb, not focused enough, not disciplined enough.

It is a wholesale rejection that cuts to the core. It isn't just about them; it is about their friends, family, congregation, union, and all they know. Whole towns and neighborhoods have been forgotten and destroyed, and when they point this out, they are told they should just get up and move (as if anyone can do that) and if they don't, then they are clearly lazy, weak, and unmotivated.

Everyone wants to feel like a valued member of something larger than themselves. The current status quo doesn't do that for most of America, because it only understands value in economic forms of meaning. In that world it is all about getting credentials, primarily those gained by education.

The current status quo supports a system that is said to be a meritocracy that allows anyone to rise to the top. To get there you just have to follow a path that weaves through a series of select educational institutions, internships, jobs, and communities.

It is a path that is supposed to be available to everyone regardless of class, race, gender, and sexuality. Yet the path is tightly rationed, with only a few allowed access each year. It is a path requiring information (how to apply, where to apply) and resources (economic and cultural) that few beyond those with the right families born into the right communities have.

For those born into well-connected communities, there is plenty of support and a long history to draw from to navigate the path. For those born outside these communities, there is little guidance. It's about not just money but having the time and access to needed information. Many children have no idea about the rules, language, and expectations of edu-

cation (something needed to navigate the path) because they don't know anyone who went to college. Other children are overwhelmed early with caring for older family members or dealing with the problems of adults. Some children are tasked with parenting the parent—a responsibility that denies them the time to dedicate to their own education.

The educational meritocracy is a well-intentioned system designed to correct massive injustices that enslaved, demeaned, constricted, and ranked people based on the color of their skin, sexuality, and gender. Yet in attempting to correct a nasty and explicit exclusion, we have replaced it with an exclusion that narrowly defines success as all about how much you can learn and then earn.

It is a system that applauds itself for being a meritocracy, allowing anyone to succeed. Implying that those who don't choose this path, who can't or don't pick up and move constantly, who can't overcome the long odds, are failures and it is their own fault. They are not smart enough. You didn't make it out because you suck. That is humiliating.

It is all the more frustrating because the new system is still unjust and slanted against minorities, relegating them to second-class citizens, rejecting them at birth. Few minorities are born into communities or families with the right connections and enough resources to navigate the path.

For them, the rejection, frustration, and humiliation aren't new. They have long been subjected to the cruel trope that they are lesser. Long subjected to demeaning and amoral conditions—legal and illegal, large and small—simply based on their race and place of birth. It has made getting an education and a decent job and building a meaningful life a long shot overcome only with immense focus or immense luck. Then, if they fail at the long odds, they are told it is their fault. Their fault for being lazy, dumb, or whatever the speaker feels they need to be. When

they play the long odds because the short odds aren't available, they are told they are morally weak, prone to illegal behavior, or just dumb.

This has made growing up in places like Selma, Milwaukee's North Side, East New York, or the Bronx frustrating and humiliating.

People respond to humiliation in different ways, but the most common response is to find a source of pride wherever possible, even if that means in places the status quo doesn't approve of. It means trying to find a community or activity that values them. For those in the back row, that means a place that doesn't demand credentials.

Drugs are one of them. Bars, drug traps, and crack houses offer communities that don't care about your past, your failures, or the color of your skin. As long as you join in, shooting up or taking a hit or swallowing the pills, it is all OK. They also offer a numbing salve from the pain of humiliation. It is a reckless choice, but when your choices are limited, recklessness might be all you have.

Many churches offer that, especially Pentecostal and evangelical faiths. They offer a community with few barriers of entry, regardless of someone's past. The only requirement is a desire to reform, to live a different way, to accept a set of rules on how you live your life and how you expect others to live. They also provide a place in the larger world. You may not be valued here and now, but you are valued by God, and you will be valued in the afterlife.

Living in the place you grew up doesn't require credentials. It's a form of meaning that cannot be measured. Family doesn't require credentials. Having a child is an action that provides meaning, immediate pride, and a role, especially for the mother, who can find value in raising a family.

There are other non-credentialed forms of community that come with far greater stigmas but can appeal to anyone frustrated enough.

Racial identity is one, providing a community that doesn't require

any credentials beyond being born. Like drugs, it is rightly stigmatized, but also like drugs, it can appeal to the desperate.

Finding pride in racial identity is dangerously easy because it doesn't demand anything beyond pride in your own group and the capacity to hate. For frustrated whites, it is especially easy because it offers a community with a long (and ugly) historical legacy, boosting its sense of importance. It also offers plenty of scapegoats to punch down at.

In the back row, it can feel as though everyone is sinking, making it the perfect environment for the politics of blame. That all anyone does is throw out a few lifesavers, providing an escape to a small group, makes it even more appealing. That the lifesavers are seen to unfairly go to minorities via affirmative action makes it even easier.

Affirmative action is the right short-term way to try to deal with the long history of structural racism, yet if everyone—black, white, Hispanic—is sinking, it can feel unfair. If it is more about getting a larger share of a shrinking pie than a larger share of a growing pie, then it can inflame hate.

Donald Trump, in 2016, exploited the dangerous and easy appeal of racial identity. He offered frustrated and angry whites a community wrapped in a political movement that didn't require credentials and claimed to value and, most of all, respect them.

Trump talked their language—rough, crude, and blunt. He addressed their concerns, built around frustration, humiliation, and anger. He acknowledged their pain, offering up easy-sounding solutions. He took their anger and leveraged it by blaming minorities and mocking the front row. He built a community steeped in racism that celebrated being uneducated and white, twisting the need for respect into a demand for revenge.

All of the back row is stagnating, is humiliated, and wants respect. Yet only minorities, African Americans in particular, have suffered from

an unending history of racial oppression. Consequently, how they respond is different. They can and do form political movements built around racial injustice and vote for politicians simply because they will support blacks. Racial pride and finding an identity in it is one of the few unique freedoms afforded to minorities.

For whites, given their responsibility and complicity in our country's history of racism, of segregation, of slavery, finding respect through race is extremely dangerous. Yet with other forms of non-credentialed meaning gone, with other outlets for respect eroded, it has left many with few options other than surging into the ugly, unacceptable territory of outright racism.

Rick, fifty-three, is sitting in his usual corner seat in a Central, Cleveland, McDonald's, reading newspapers, writing poetry, and drinking coffee. A mile away, in a convention center surrounded by police and protestors, the Republican Party is nominating Donald Trump for president. In this neighborhood, in this McDonald's, the only sign of the convention is the distant sound of helicopters.

The surrounding neighborhood shows no sign or awareness of the convention. There are no posters, no protests, no increase in police presence, no journalists. The neighborhood is very poor, almost all black, and filled with complex after complex of public housing. Rick has spent almost all of his life here. He grew up in the oldest projects, the Outhwaite Homes, a cluster of three-story redbrick barracks built in the thirties, after his mother moved him and his four siblings from Mississippi. "My mom was what they now label a welfare mom."

He knew within a year of moving to the projects that he needed to focus on a hobby or a passion or develop a skill, anything, in order to

not succumb to the drugs, violence, and despair that he was surrounded by. "I wanted to be good at something to get a scholarship, and chose running."

He earned a full track scholarship to an elite school but discovered getting out of the projects was harder than he had thought and the impact of racism deeper than he had understood. "I went to college and studied hard, but I didn't make contacts, because I was so different and was so far behind in education. These white kids came in and made contacts. That was the smart thing to do. When you grow up in the projects you don't have that. That is the real impact of racism. It is more about who you know, not what you know."

After college he returned to Cleveland and dedicated himself to fighting the racism and injustice he saw. He turned to education, then writing, and then politics. He built a life in the neighborhood he grew up in, determined to find some small way to make it better for those there. Now he lives in a small apartment with his wife and two children not far from where he was raised.

The maze of projects is his world. It is where he is most comfortable and what he understands. It is also where he is known. When he walks around, he knows most everyone, stopping to talk to them, catching up on their family or his family. His easy way with people is a skill that fits his interest in politics. He once ran for mayor of Cleveland, even though he knew he was a political nobody and his candidacy would be dismissed as a novelty. He did it nonetheless, determined to make a statement: "I wanted to give a voice to the people who the big politicians ignore or take for granted."

While walking he talks politics, focusing on the small examples of what he sees as massive structural injustices. He points to the lack of transportation, the lack of quality produce, the lack of good sports pro-

grams. He also reminisces, detailing the obstacles he faced as a teenager, the dealers and gang members he had to navigate around—or choose not to go around. At Paul's Serv-Rite Food Market, he tells of an older man who "owned" the corner near the store, forcing him to make a daily decision to walk through his space and face confrontation or cross the street. "I had these type of choices almost every day. One day I didn't cross the street and I walked past him and he pulled a gun and put it to my head."

The grocery store is still run by the same older black couple, something that makes him proud. "I wanted you to see there are black-run businesses." Its entrance is pasted with handwritten signs stapled and taped to the door and outside wall:

Black Owned Store!!!!
Black on Black
Crime Doesn't
Serve Your Own
Community
Think Before
Acting

Loitering Here
After 100's of
Request Not to
Is Stupid As A
. ???

He stands on the exact corner where the gun was put to his head, remembering without any anger or frustration. Those feelings have long given way to an understanding of the realities of living here. If he shows any emotion, it is for the man who threatened him with a gun. That man is long gone, either shot dead, in jail, or moved on. His exact corner is no longer "owned" by anyone, although other corners around the projects are, and kids face the same decisions Rick faced.

I ask Rick why he isn't angry. He just smiles a tight smile and says, "You got to understand the projects. You got to understand what motivates people. Take drugs. Addiction is people who don't have anything, looking for something, looking for a little happiness. Take the man who pulled a gun on me; take the others who engage in that behavior. You got to understand, when you don't have anything, respect is all you have."

Near the corner, leaning against a stop sign, is a homemade lawn sign announcing in bright red, "WE BUY DIABETIC TEST STRIPS 216-333-9022."

The nearest telephone pole has an orange-and-yellow poster for the Revolutionary Communist Party, loudly announcing:

America Was NEVER Great!
We Need to OVERTHROW This System!

The posters are a constant in the neighborhood, taped or stapled to light poles, their bright colors standing out against the dull red brick of the projects. Nobody pays them attention; nobody reads the attached six points call for action. Nobody is sure who put them up or when they went up. "They always seem to be here."

At the busiest corner is another small convenience/grocery store attached to a gas station adjacent to an empty lot. Worn paths weave through the lot filled with empty liquor bottles and Swisher Sweet cigar wrappers toward the parking lot. In the corner of the parking lot, next to a busy intersection, two older white men are hawking T-shirts from beneath an assembled white tent. "FUCK TRUMP" shirts hang next to "Black Lives Matter in America" and "Hands Up Don't Shoot" shirts. Both men walk along the sidewalk, both wearing "Black Lives Matter" shirts, trying to sell them to stopped traffic. They are the only white men in the neighborhood beyond the police passing by now and then.

Everyone ignores them, too busy with kids, or getting groceries, or lost in their own thoughts. One man, still dirty from work, soda in hand, walking past on the way to his apartment, gives them a nasty look. "Look at that. Just trying to make a buck off of us. Hell. We at a low point right now, nothing is going to fix this. Like we are in a third-world country. It is 2016, and we still discussing race? Black Lives Matter, but it shouldn't be that. It should be All Lives Matter. We in the hood have suffered enough. Why we going to get everyone all riled up against the police?"

Another man, sitting on the stoop of his apartment, getting ready to grill, is smoking. He sees me and asks why I am here. I explain, and he smiles. "You know what I think about Trump? He is so racist he is past racism, into something we can't even comprehend. He is dividing, by wealth, and by race. He doesn't have any idea what it is like to be black, what it is like to grow up in the projects. Racism will always be there, but to be really dangerous it needs a leader. Trump is that leader."

A few blocks away, six police cars and ambulances are parked in a haphazard semicircle, their doors flung open, the officers either standing around or attending to a man stabbed in the arm. One of the officers, hands cased in plastic gloves, places a tourniquet on the man's arm while he sits up, blood covering his upper body. While the police work on his left arm, the man searches his phone with his right. Everyone walks by, cars pass by, nobody stops to take a cell phone picture, nobody stops to stare, nobody stops to gawk. Twenty feet from the cluster of police is another poster yelling

America Was NEVER Great!
We Need to OVERTHROW This System!

Ten blocks away, a McDonald's is jammed against a large Baptist church. The front entrance is closed, its window a spiderweb of cracks, broken by a punch. It is mid-July, and the air conditioner is broken and a wall of heat hits you inside. Without music, the only sounds are customers complaining about the broken ice cream and McCafé machines. On Sunday mornings, the muffled sound of the preacher from the adjacent church drowns out the complaints.

In a back corner, sprawled along a wall of tables, is a collection of older men, regulars from the neighborhood. They come almost every

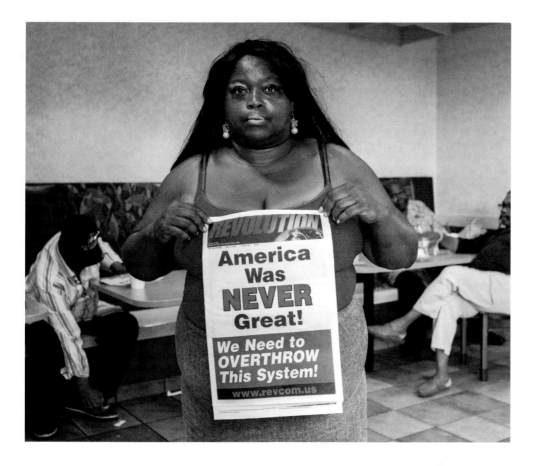

day, from morning till closing, to chat about sports and crime. Recent shootings are the big topic, with who might be involved and why debated and discussed. Late one afternoon a young woman comes in carrying newspapers for the Revolutionary Communist Party, the front page matching the posters: "America Was NEVER Great! We Need to OVERTHROW This System!"

She approaches the men, who talk to her about everything but politics. Eventually she asks them if they want a paper, explaining, "We need a revolution to change the system. I am for the Million Women march. We need to end violence against women. Stop police brutality." The men politely decline. One shakes his head no, and then mentions, "Revolution? Revolution comes with violence and with guns and with killing. We got the violence but without the revolution." She smiles, talks about the heat, and goes to buy an ice-cream cone. The cashier gives her a cup of ice instead.

Fifteen miles away from Central is the almost all-white neighborhood of Parma. It is a neighborhood of street after street of simple one-floor tract homes, each just a slight variation of the other, each with a small, well-kept yard, many flying American flags. Between the vast neighborhoods of homes sit mostly empty auto factories: massive edifices to another era. Next to the factories are union halls with large, empty parking lots.

The factories and unions shaped the neighborhood, providing it with stability. Racism also shaped the neighborhood. Although plenty of blacks worked in the factories and were in the unions, none were welcomed to live in Parma. The racism was both loud, the "you can't live here safely" type, and quiet, the "we won't show you that house and you won't get a loan" type.

There are still union members in Parma, but most of them are re-

tired. George, seventy-nine, is one of those, a lifelong member of UAW local 91. He and his buddies meet each afternoon at the local McDonald's, "remembering good times." He is still proud: "I am a union man, through and through. They made this country; they gave us our standard of living." He and his friends still define their politics by the unions. He catches a glimpse at a TV showing scenes from the convention and grimaces. "I am Hillary all the way. I am Democrat all the way. I am union all the way."

In another McDonald's not far away, another collection of retired factory workers gathers each morning. Some worked in the steel mill, some in the auto factories, some in trucking. All were union members, and all are quick to list the benefits that came from their union. "I was part of the longest strike in US history. Lasted twenty years. Union kept me afloat during that time." Unlike George and his friends, they support Trump, and their language is rough, blunt, and filled with racial slurs and jokes:

> A: What is the longest bridge in Cleveland?
> ME: I don't know.
> A: The [unintelligible] Bridge, it goes from Poland to Africa.
> ME: Huh.
> A: It goes from a Polack neighborhood to a black neighborhood. I can say Polack because I am a Polack. I can't say the N word, though, because you would tell me I am a racist Polack.

A union job in a factory is the past for Parma. The present can be found in an Irish pub across the street from a deli with a neon sign flashing the daily special and then "Blue Lives Matter."

It is a small, narrow, dark bar with the feel of a clubhouse. It opens early to serve retirees. The early regulars reflect the past, a mix of third-generation Polish, German, Italian, Irish, and other Europeans. In the afternoon, as guys get off their shifts, the bar changes. It is still all white, but the customers are mostly younger guys, all who have made or make their living working with their hands, few who are union.

The conversation in the bar is dominated by small talk, by local dramas, by gossip. The Republican convention, only fifteen miles

away, plays out on the TV. The only sign it is in town is the occasional sound of helicopters or bitching about traffic: "Don't even go downtown. Don't. I had a job there and I spent hour just trying to get a few blocks."

When the conversation switches to politics, it is driven by the TV, which silently flashes news from the convention. Joe, forty-one, sitting next to me and quietly drinking a beer after work, owns his own security company. He is vocal about politics, cheering when Trump flashes up on the TV. "The country is falling apart, from the bottom up. We got these lazy people freeloading off the government. Meanwhile the rich just keep getting richer, and working guys are getting screwed. We just got to break the system."

He is quick to add, "My ex-wife is black. I have hired plenty of blacks to work for me. I am not a racist. Trump is not the racist. Hillary is the racist, only standing up for women and blacks."

The bar starts filling with more and more guys getting off their shifts, finishing their jobs. Two guys, just off work, come in from the back of the bar after jumping out of their work van, and yell to their friends, "Fuck yeah, dicks! The Polacks for Trump are here!"

Others are more cautious, aware of the sensitivity of race and politics. One of the pub's owners is a retired union firefighter and army veteran and is unsure of how he will vote. He voted for McCain in 2008 and Obama in 2012. He sits quietly and thinks. "I am just disgusted with everything."

I ask him if Trump is a racist, and he turns pained. "I want to choose my words carefully. He isn't a racist but a realist. It is easy for folks who live in wealthy neighborhoods to say they will accept any neighbor of any color. Who wouldn't want to have a doctor or lawyer move next door, regardless of if they are black or white? But that isn't who is moving into our neighborhood. It is mostly people without jobs, on assis-

tance, and mostly African Americans from the projects, and it is sending our crime higher and our house prices lower. I think folks in rich neighborhoods wouldn't want that either."

As the bar fills up, others are unabashed in their views, celebratory, giddy to have Trump addressing their concerns and talking their language. That everyone else hates Trump makes them more confident, further cementing the feeling they are members of an exclusive club, one built on race. When the TV shows a controversy over something Trump said, a man yells, "You get them, Donald! They been getting us forever."

The day of Trump's acceptance speech, except for a ten-block area around the convention center, Cleveland is oddly quiet, feeling almost drained. In a mixed working-class neighborhood adjacent to Central, a group of younger men sit on the stoop of a home falling apart, drinking beers, smoking blunts. They are covered in dirt and grease, just off work at dismantling cars at a junkyard.

Jo-Jo, drinking a Bud tall boy, notices me walking past and shouts out to me:

> HIM: Yo! You a reporter?
> ME: Yes, kind of, I am just walking around talking to people.
> HIM: About Trump?
> ME: Yes.
> HIM: That dude is crazy. He talks crazy, says shit that nobody else says.

ME: Like?

HIM: Just shit that gets him in trouble. Shit that if I said would get me in trouble. But the man is rich, so he can say what he wants.

ME: You like him?

HIM: I guess you can call me a Trump man. I like him because he is gonna make America great again, like he says. Right now, guys like me who work for minimum wage are getting screwed.

His friends, mostly "relations distant and not so distant" of his, nod and agree. A few shout out, "Trump is the man!" or "Damn right!" or "Make America Great, motherfucker. . . . Make motherfuckers great!"

One friend, the only black man in the group, lowers his head and shakes it and walks away from the group over to his car. The others yell at him, "Yo! Jay, you disagree? Come on, man. You like Trump, too." He smiles and laughs and shakes his head again. "I can't, man. I just can't. Trump? That man is a racist. That man doesn't like me. That man doesn't like any black person."

Jo-Jo looks at him, "Come on, man, how can you know that? You tight with us, you part of our family. You know we wouldn't go supporting no racist."

Jay shakes his head again, still smiling. "It is just different if you are black. It just is. You know when someone has it out for you. And that man has it out for blacks."

Not far away is a park with basketball courts and a rec center. In the park is a gazebo turned into a memorial for Tamir Rice, the twelve-year-old black boy shot and killed here two years earlier by police. He

had been playing with a plastic toy gun the police said they mistook for a real gun. The memorial is filled with balloons, candles, posters, flowers, stuffed animals—all in various states of decay and rot. There are political flyers taped up from a variety of groups, some stating simply "Stop the violence" or "Black lives matter," others filled with long essays in tiny print.

I had visited the memorial every day, and although the park and rec center were always busy, the memorial was always empty. Now a black man in a shirt proclaiming "Tamir Rice" is standing in the gazebo, holding flyers, lecturing loudly. He continues for twenty minutes, uninterrupted and with no audience. Two smaller children wearing the same shirt stand playing with a plastic radio-controlled helicopter, flying it around the gazebo. I ask them if they come often and what Tamir Rice means to them, and they explain they just came from a march near the convention center, and one adds, "I don't know nothing about this. My uncle asked us to come with him for the day, but he is kinda crazy. Always talking about this or that." The uncle keeps talking, and they keep playing, and their plastic helicopter keeps flying around the gazebo, and police helicopters keep flying far overhead.

That evening the McDonald's in Parma is quiet, filled with families, nobody looking at the TV broadcasting Trump's acceptance speech. Michael, forty-three, is cleaning up, wiping tables and mopping the floors, now and then glancing up at the TV. He is the only black person in the McDonald's, the only black person I have seen in Parma. He smiles at me each time he passes, asking me if there is anything he can do for me.

ME: No, I am good.
MICHAEL: Just let me know.
ME: How long you been working here?

MICHAEL: Oh. I just got here about six months ago. I moved here from the projects. I got this job after getting out of prison.

ME: What for?

MICHAEL: Drugs. I got messed up with drugs for a while.

ME: How you doing now?

MICHAEL: Oh. I am just so happy to be clean, working, and living here. Happy to be away from the violence.

ME: You live near here?

MICHAEL: Yes, they found me a group home not far from here.

ME [pointing to the TV]: What do you think of all this politics?

MICHAEL: Oh, I don't really pay it much attention. I am just happy to be clean and have a home and a job. That is all I focus on. That is all. I can't start thinking of anything more than that.

A few miles away on an industrial road across from massive auto factories is a strip club. There are only a few customers, and they are all outside smoking with a few dancers and the owner. The dancers are playing Pokémon Go on their phones while the owner listens to Trump's acceptance speech on hers, broadcasting it loudly to everyone. The owner is in her sixties and is blunt and bitter. When I ask why she seems so upset, she points around her.

HER: No customers. Biz has been shit, just shit.

ME: Why? The factories closing?

HER: Sure, some of it is that. People used to come here after their shift and spend and party with the girls. Look

at the parking lot? You see any UAW stickers? You see any cars at all?

I don't say anything.

> HER: Not just that. World has changed. Nobody wants strip clubs anymore. People say they are bad for neighborhoods, so the police don't want us. They want us gone and are hassling. They park a patrol car right over there and pull anyone coming out of this lot and give them a ticket for DUI or possession. You can't have a strip club without drinking.

I let her continue talking.

> HER: Come inside and be our first paying customer of the night.
> ME: Thanks, but no thanks. I don't drink anymore.
> HER: You give up drinking?
> ME: Yes, I had to a few years ago.
> HER: See, everyone is going soft.
> ME: You like Trump's speech?
> HER: Hell yes I do. Something has to change. This country is broken. No decent jobs, and you can't party anymore. Guys used to come in here after a long day working and let loose a little. Now nobody is allowed to have any fun.

Another pause.

HER [pointing to a woman playing Pokémon Go on her phone]: These kids spend all their time playing kids' games on their phone.

She pauses, drags on her cigarette, while Trump speaks in the background. "This world is just going to the shitter."

Dignity

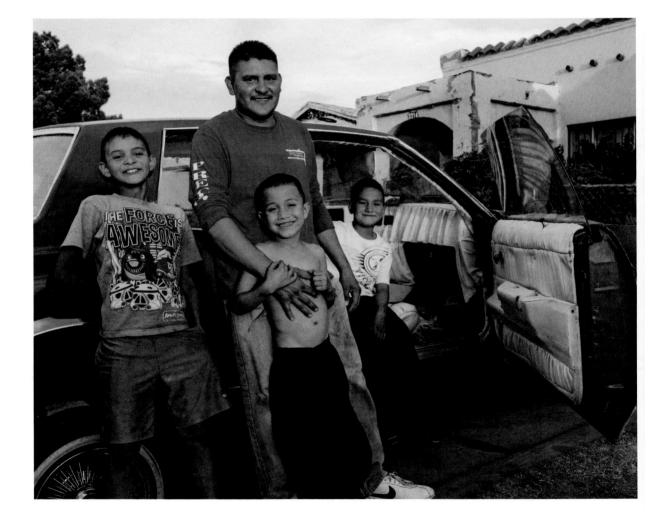

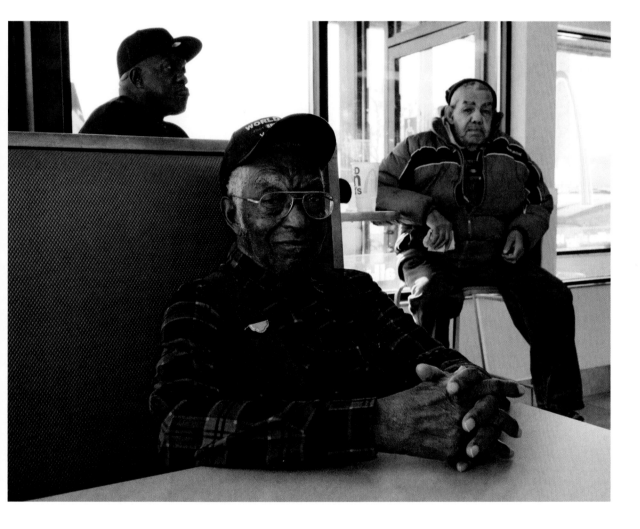

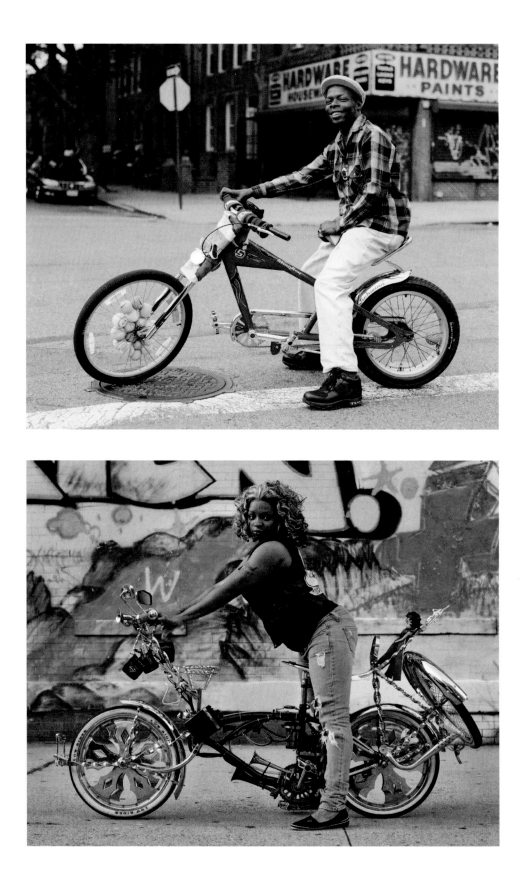

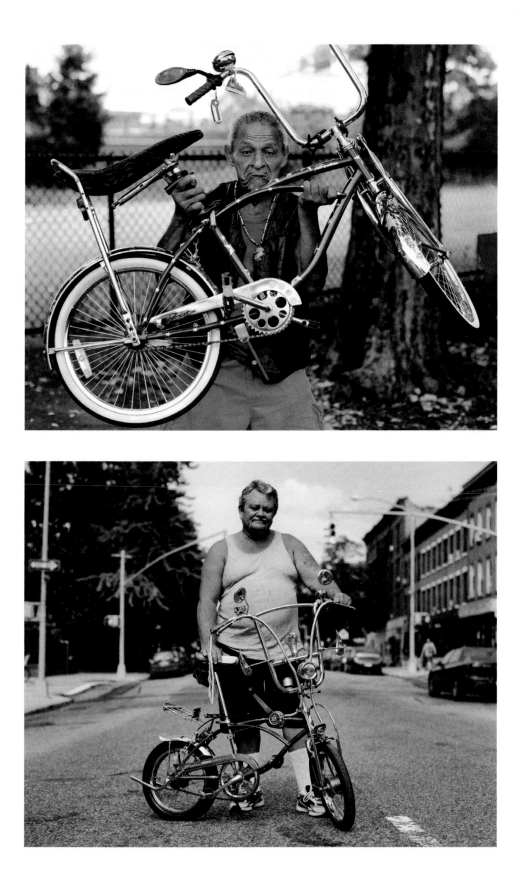

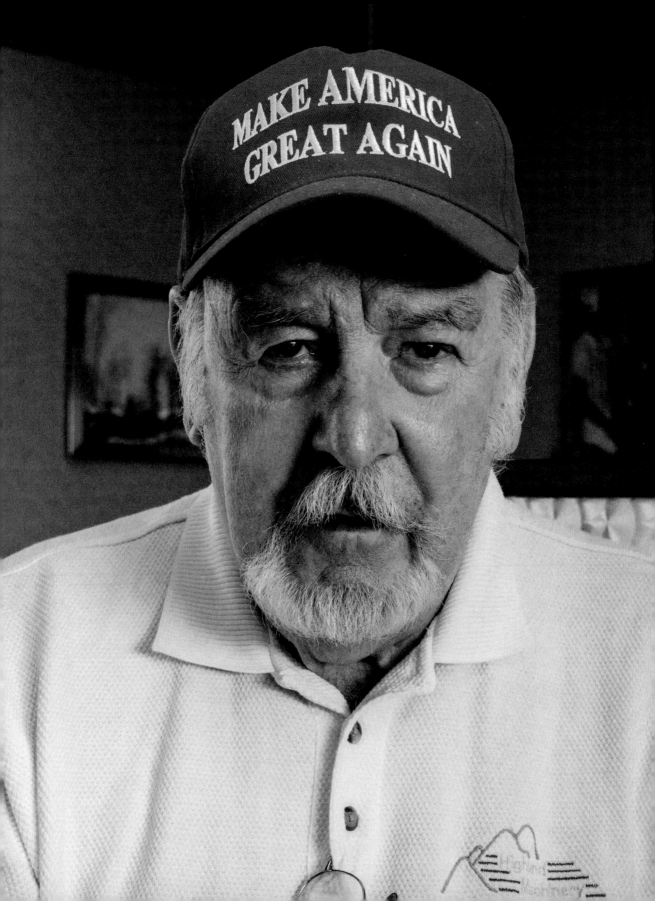

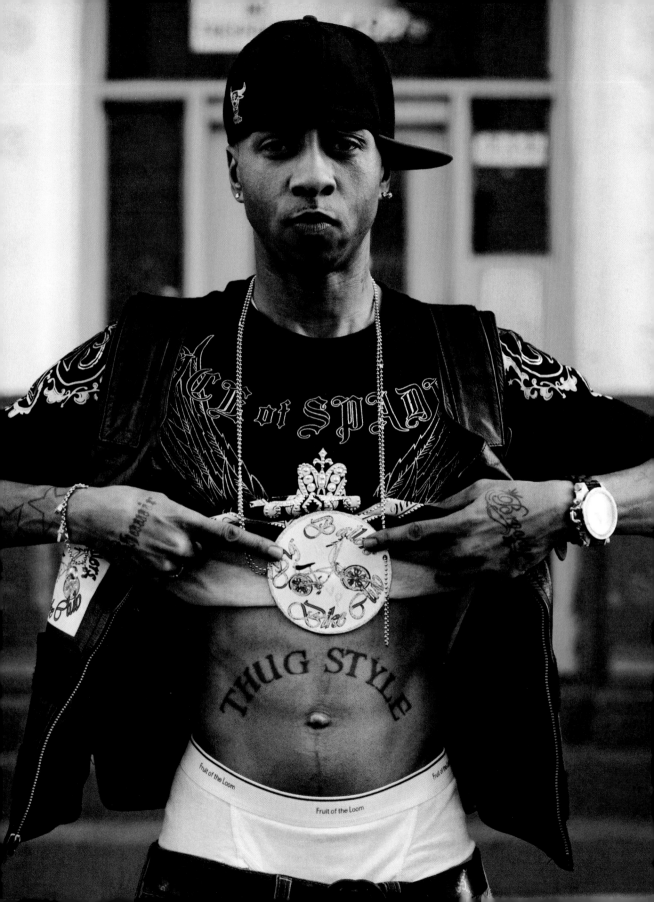

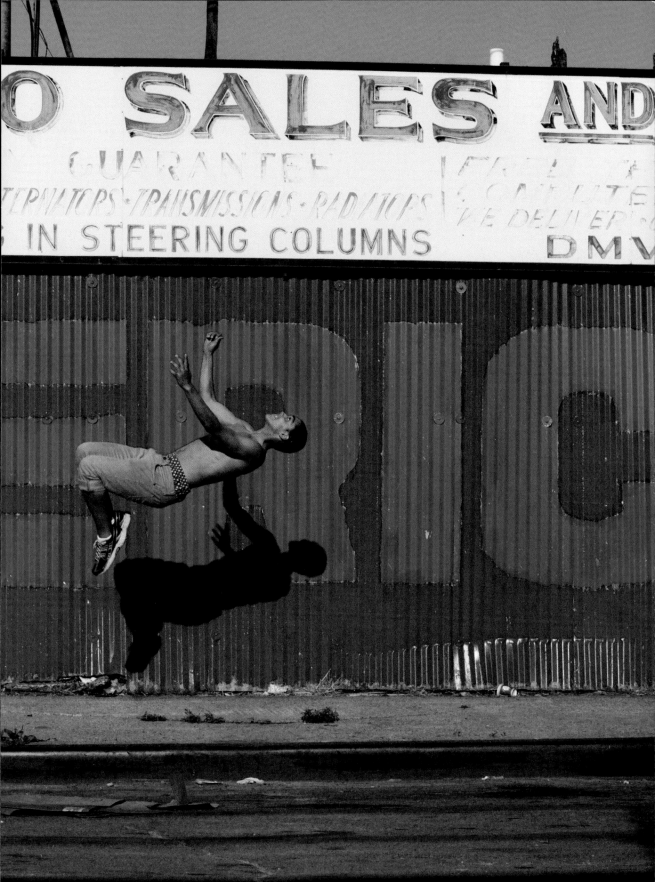

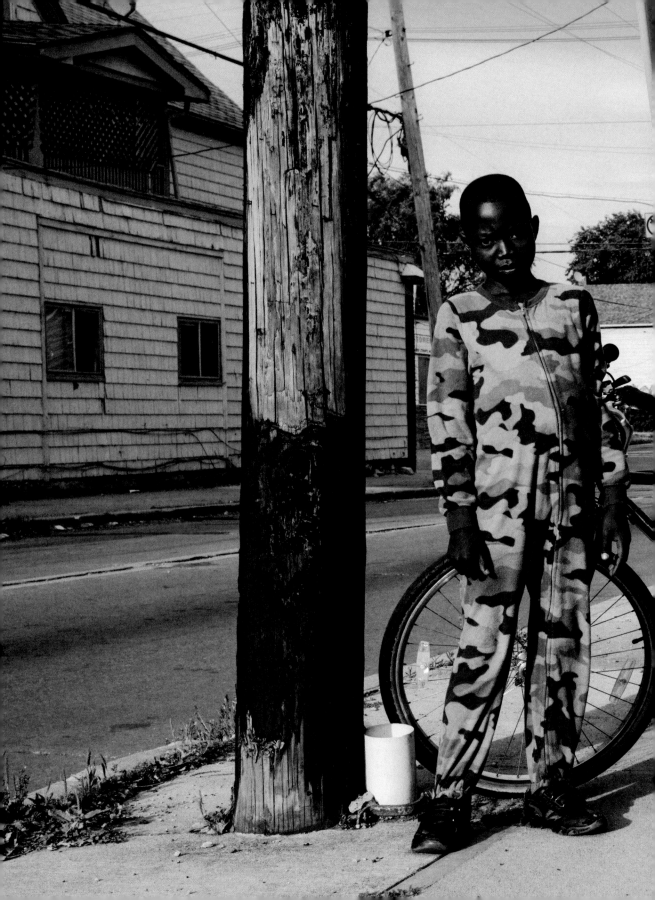

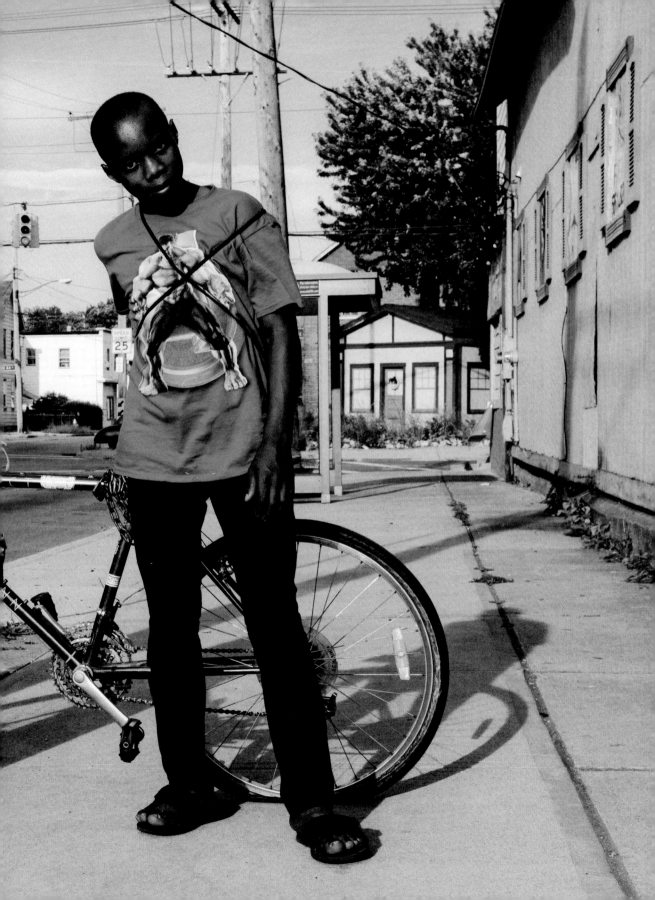

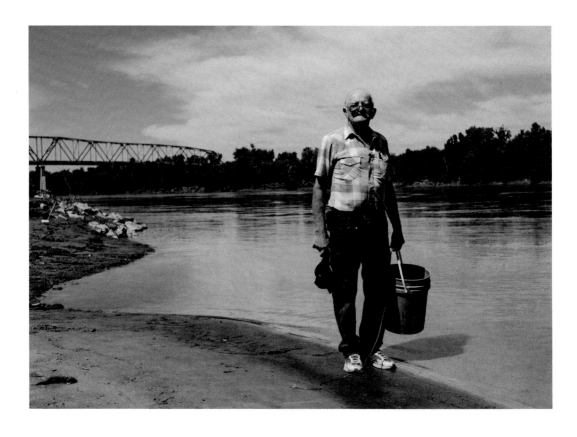

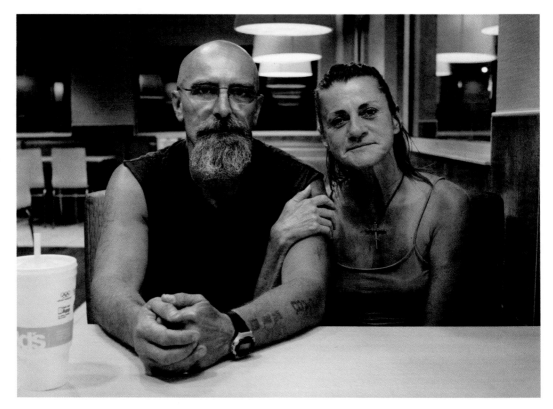

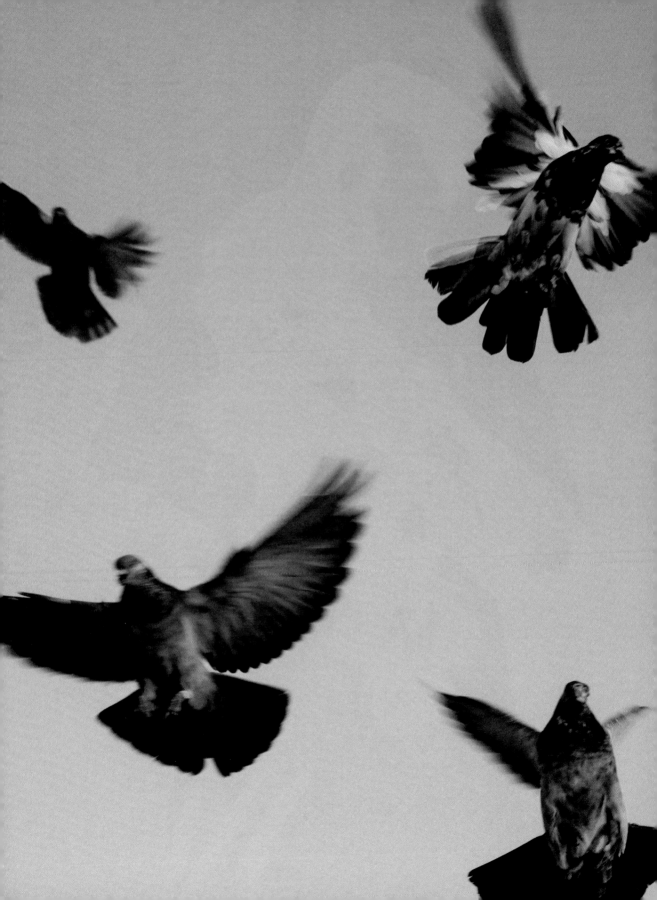

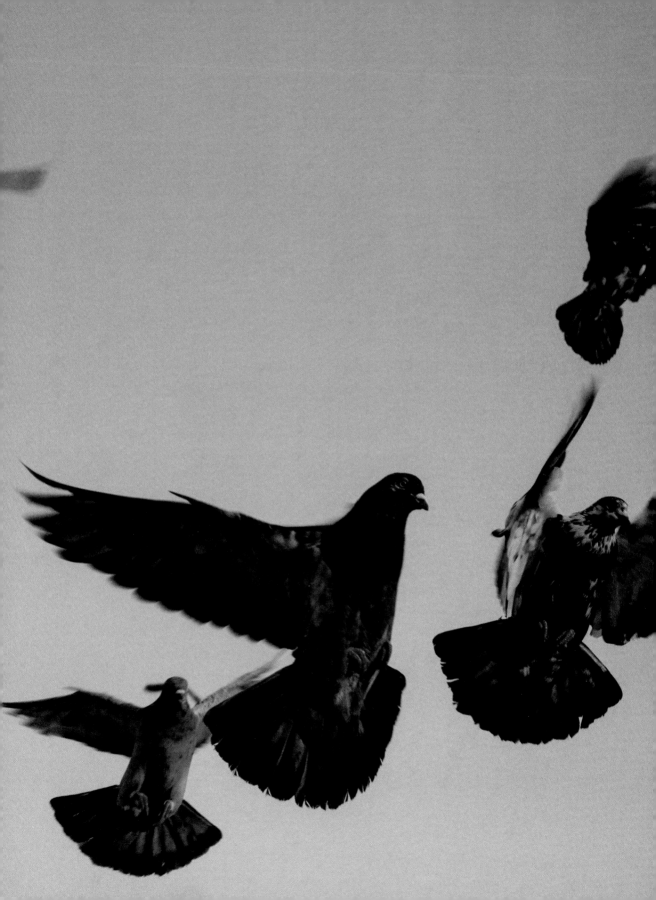

Conclusion

I was depressed, standing in a particular neighborhood I hadn't been to in more than thirty years, not far from my old high school. It was weeks before the election of Donald Trump, toward the end of my two years traveling around the country, almost four years since I had walked into the South Bronx. I had intended to come back earlier—if I was going to try to understand all of our country, no place was better than my hometown.

I was depressed because little had changed in the neighborhood or the entire town, and what had changed was for the worse. The two orange juice factories that dominated the area and made it smell of burnt pulp were gone. One was replaced by homes, the other relabeled as an industrial park but with little industry.

The grand movie theater built in the thirties was gone, replaced by a chain bank. The old downtown, where I had spent my childhood

shopping with my mother, had far more energy than most small towns (population seven thousand), but the stores were mostly filled with knickknacks catering to older tourists. The Walmart plaza at the edge of town was where locals did their shopping. It is always busy, including overnight, when some used their car as their home. In the dark corners of the parking lot, trucks, vans, and sedans cluster, their windows covered by hung clothes and cardboard.

What hadn't changed was the poverty and segregation. There were still three largely separate parts to the town—the white part, the poor black part, and the very poor Mexican part.

In the black part of town the poverty wasn't as in-your-face as it had once been, but it was still bad. The shotgun shacks had been replaced by projects of ranch-style homes, which, although depressing, at least had running water, heat, and electricity.

I used to go to that neighborhood when accompanying my father to see his friends. It was part of his social and political life, and I wanted to see if all the hard-fought changes the community had stood up for had brought much relief.

As I passed one of the older remaining wooden homes, a man sitting on his porch asked if he could help me. It was his polite way of saying, "What the hell is a white guy I've never seen before doing walking around here with a camera?" I didn't have a good answer at that moment, so I offered up the first name I could remember from the neighborhood, an old friend I had spent summers working with. I said, "I am looking for Stephon C. I am an old friend and want to say hello to him." I hadn't seen or heard of Stephon since the last summer we worked together more than thirty years ago. I hadn't ever searched for his name on Facebook, seen any news about him, or asked about him. I had no other reason to talk to Stephon beyond curiosity.

The old man didn't miss a beat, didn't pause, just said, "Oh, Ste-

phon's people are over on Goldenrod, about four blocks that way. You can't miss his house, at the back end of the circle with a blue Olds in the driveway. Say hi for me."

In five minutes I was talking to Stephon on the phone. When I found the house his people stayed at, a young mother came out. When I asked if Stephon was around, she dialed her phone and handed it to me before I had a chance to say who I was.

STEPHON: Hello, who is this?

ME: Hey, Stephon, this is Chris Arnade. We used to work together back at St. Leo Paint Crew for Bob. Way back in the early eighties.

STEPHON: Who?

ME: Chris. The tall, skinny white guy. We both almost got our ankles broke by the forklift when we were stoned?

STEPHON: Chris?

ME: Peabody. You called me Peabody.

STEPHON: Oh yeah. Peabody. Damn, man. Long time. What can I do for you?

ME: I just was in town and wanted to say hi and see how you're doing. I was over your way, near your place in Dade City. You OK?

STEPHON: I am OK, over in Z-hills right now, staying here for a bit, juggling some things. [Yelling in the background.] Hey, I was running out. Can I call you back? Maybe I see you around.

ME: Sure. Just wanted to say hi.

I handed the phone back, sinking into an even deeper funk. I had come back to my hometown because if I was going to document the

back row, then I needed to look at my own town. Yet it took more than five years after I started my project before I had gotten around to doing so. I had stayed away despite an affection for my old neighbors, childhood friends, and others in the community because I didn't feel I belonged there.

After I finished high school, I left, escaping into a series of colleges that ended with me working on Wall Street. In that time, I didn't look back, didn't care to look back, didn't understand why anyone would want to look back. I had left because my hometown wasn't for me. I was bookish, politically liberal, into science and math, and my hometown by and large wasn't and made it clear that I was different.

When I was a kid I joined in, going to the Catholic school one block from my house. I had been an altar boy and loved church, because everyone around me did. As I grew older, I read more and more, studied more and more, and I ended up leaving the Church, escaping into what I then saw as the truth: science and history books.

During those first few years of college, I came back for summers to live in my old room and work at my old job on the paint/custodial crew at the local Catholic college. It was a crew of about thirty people and, despite being in my hometown, I was the outsider. I was the white kid saving money to pay for my escape while everyone else was older and black. More important, I had a future that didn't include this job, this town, or this place. The others on the crew were working to feed themselves, to feed their kids, to pay for the basics of life.

That is where I met Stephon. We bonded over smoking weed, drinking, and making fun of the Bible-thumpers in the crew. Mostly that meant teasing Preacher Man, who was a minister and a custodian. He was the leader of a group who used their free time to pray. During our short breaks or when work got slow, he put on his tiny round glasses and

read from the Bible to others sitting on bare mattresses, crammed into half-painted dorm rooms, or on upturned buckets around a custodial closet.

Preacher Man tried to get me to join, asking me daily. I wouldn't have any of it, declining each time politely, preferring to spend it smoking or doing whatever.

Preacher Man sometimes got frustrated and questioned me. He saw me as a smart kid, and with the right training he felt I could become a good preacher like himself. He couldn't understand why if I read so many books I wouldn't take the time to read the Bible. I declined and told him the Bible wasn't for me. He shot back, "What do you believe in?" I smiled and told him I was busy or that I preferred my science or history books. He kept pressing me until one day I finally broke.

That day we were sitting around during our lunch break, all of us just shooting the shit. Preacher Man was trying to convert those of us who didn't join his prayer group. He singled me out to pick on, pestering and pestering me. After five minutes of ignoring him, I said, "I am an atheist. I don't believe in a God. I don't think the world is only five thousand years old. I don't think Cain and Abel married their sisters!"

He said, "You don't believe in God? You don't believe in the Bible? Did I understand you correctly?"

I said, "Yes. Yes. Yes. I don't believe in God or the Bible."

Preacher Man's eyes narrowed, and he pointed at me. "You are an APE-IEST. An APE-IEST. You going to lead a life of sin and end in hell."

By then I was done with my town, done with the closed-mindedness, and I wanted out and I did get out. Although I didn't hate on Preacher Man, didn't spend much time arguing with him, didn't try to put him in his place, I did feel sorry for him. Living such a shallow, closed-minded

life, so I thought. Simple man wasting his life away with gobbledygook and hocus-pocus.

Thirty years later, standing in that neighborhood, I look back and see Preacher Man and the others praying and see people striving for dignity in a harsh world. I see mothers working minimum-wage jobs, trying to raise three children alone. I see a teenager fingering a small cross and see a young woman abused by a father addicted to whatever. I see Preacher Man living across the tracks in a beat-up shotgun shack or low-income housing or whatever, desperate to stay clean, desperate to make sense of a world that has given him little.

My teenage self had been a judgmental know-it-all, yet even understanding that now, I was right to have left my hometown. I wouldn't have been comfortable living there. It wasn't about Preacher Man, who had been the least of my frustrations. It was the broader community and what they valued and how they saw themselves and me. The back row wasn't for me, and it just wasn't who I was. I valued science, and I valued different living experiences, and I believed I valued the true equality of all races.

A community built on non-credentialed value—place, faith, and race—didn't work for me and excluded me. It excluded and excludes many, many others in far worse ways, many in the neighborhood I was now standing in. My hometown was still deeply segregated and divided by race. Sure, New York City was racially divided; sure, my wealthy neighborhood in Brooklyn was exclusive, but it at least strived for racial inclusion.

Put simply, my hometown's intolerance didn't fit my intolerance. My intolerance, like many in the front row, was credential-based.

Standing there in my old hometown was also depressing because thirty years later there didn't seem to be much hope or optimism. Certainly not compared to how I remembered it.

After getting off the phone with Stephon, I went to a local bar to watch a football game. I sat for three hours sipping Cokes, listening to people weaving tales of their pain. These were deeply depressing stories wrapped in drugs, jail, death, and despair. The young woman next to me did five shots, offering me one each time. Each time I declined, telling her, "I have been sober for over a year now." Each time she didn't listen or understand. Her story was about a boyfriend who had recently been murdered. She said others said he had it coming because he had murdered someone else for stealing his drugs, although she didn't buy that.

She was twenty-two and didn't know what she wanted to do with her life, although she already had "a few kids." Her father was watching them. He had come from Mexico forty years ago and worked his way up to a decent job and was a man of Jesus. She wasn't. She thought Jesus was just for old folks.

That night I sat outside of a McDonald's, eating an ice-cream cone, lost in thought. Five minutes after I sat down, an older man came out of the dark part of the parking lot and asked me if he could hitch a ride to Tampa if I happened to be going that way. He explained he had lost his job a few months ago and was now sleeping in a friend's house but that the friend was done giving him a room for free and now he had to get somewhere else.

I gave him $10 to buy some food, and when he left, a young woman approached me and asked to use my phone. She was dressed in sweat pants and a hoodie, her large fabric purse spilling makeup, powder, socks, bras, and notes onto the table. She was tweaking, withdrawing from some drug, picking at sores on her arms. She explained she had come to meet a guy in town to stay with him for a bit, but it had gone bad and she had to leave quickly, without any money or minutes on her phone and now she just wanted to get home, mentioning a town that

was two hours away. She dialed someone on my phone and walked out into the parking lot, pacing up and down, smoking, explaining her desperation, snippets of which I caught: "I ain't owned by nobody, specially not you."

When she came back, I asked her if she was OK, if there was anything she needed. She said she was good but could use $20 if I could spare it. I asked if she needed food, and she said, "Naaaw. Just $20." Fifteen minutes later, my phone beeped with a text—"I am coming"— and a beat-up car with expensive tires and rims pulled up to pick her up. Once she was inside, it sped away.

Early the next morning, before sunrise, I got a text from the number she had dialed. It asked how many hits I needed to buy. An hour later I got in my car and drove twenty-three hours straight to go back to New York. I had intended to stay two weeks, trying to understand my past, but I just couldn't. Once again, I fled.

After five years documenting addiction, poverty, and pain, after the election of Donald Trump, after the explosion of drug deaths, I get asked: What are the solutions? What are the policies we should put in place? What can we do differently, beyond yell at one another? All I can say is "I don't know" or the almost equally wishy-washy "We all need to listen to each other more."

It is wishy-washy, but that is what I truly believe, because our nation's problems and differences are just too big, too structural, and too deep to be solved by legislation and policy out of Washington.

We need everyone—those in the back row, those in the front row—to listen to one another and try to understand one another and understand what they value and try to be less judgmental.

While the back row is certainly judgmental, certainly intolerant (often cruelly), certainly guilty of excluding others and damning people based on differences, those of us in the front row have a special obligation to listen because we presently are the in-group. We are the ones who have spent our lives with the goal of making this country a better place. We are the ones who get paid well in money and status because we claim to know what is best. We are the ones who asked to be in control. We are the ones who moved from our hometown (sure, sometimes we were forced to leave by an intolerance) to have a larger voice in shaping our country.

We have an outsize voice, and many of us have the noble goal of using that voice to build a more inclusive society, to fix the ugly racism, sexism, and inequality. Yet we have created a status quo that is often inclusive in name only. We have created a system that still excludes far too many people, mostly minorities but certainly all of the poor.

While this is partly a failure to have our vision implemented and partly due to the intolerance, racism, and rigidity in the back row, at a larger, deeper level, it is also our fault. Not necessarily out of bad intentions but because we have lost sight of our own privilege and our own worldview, which values only what we value and have. We have done this because we have removed ourselves from those we believe we are trying to help.

We have removed ourselves physically and in spirit, and when we do look back, it is through papers and books filled with data. We study poverty and those we left behind with spreadsheets and statistics, believing we are well intentioned, believing we are really valuing them. Instead, we are diminishing them by seeing them as simply numbers to be manipulated.

We have implemented policies that focus narrowly on one value of meaning: the material. We emphasize GDP and efficiency, those things

that we can measure, leaving behind the value of those that are harder to quantify—like community, happiness, friendships, pride, and integration.

We have created a system with economics as the central form of meaning and material goods as the primary form of valuation. In this system, education and credentials are central to economic success. We have created a society that is damningly unequal, not just economically but socially. We have said that education is the way out of pain and the way to success, implying that those who don't make it out are dumb, or lazy, or stupid.

This has ensured that all those at the bottom, educationally and economically—black, white, gay, straight, men, and women—are guaranteed to feel excluded, rejected, and, most of all, humiliated. We have denied many their dignity, leaving a vacuum easily filled by drugs, anger, and resentment.

ABOUT THE AUTHOR

Chris Arnade is a freelance writer and photographer whose work has appeared in *The New York Times*, *The Atlantic*, *The Guardian*, *The Washington Post*, *Financial Times*, and *The Wall Street Journal*, among many others. He has a PhD in physics from Johns Hopkins University and worked for twenty years as a trader at an elite Wall Street bank before leaving in 2012 to document addiction in the Hunts Point neighborhood of the Bronx.